The Shadow
On The Path

The Shadow
On The Path

*Clearing the Psychological Blocks
to Spiritual Development*

V J FEDORSCHAK

HOHM PRESS
Prescott, Arizona
1999

Library of Congress Cataloging in Publication Data:
Fedorschak, V J, 1954-
The shadow on the path: clearing the psychological
 blocks to spiritual development / VJ Fedorschak.
 p. cm.
Includes bibliographical references and index.
ISBN 0-934252-81-5 (alk. paper)
1. Spiritual life. 2. Psychology, Religious. 3. Shadow
(Psychoanalysis) 4. Spiritual life.
I. Title.
 BL624.F42 1999
 159.1- - dc21
 99-24840
 CIP

Cover design: Kim Johansen
Layout and design: Shukyo Lin Rainey

HOHM PRESS
P.O. Box 2501
Prescott, AZ 86302
800-381-2700
http://www.hohmpress.com

This book is printed in the U.S. A.
on acid-free recycled paper using soy ink.

For anyone who struggles on the path

Acknowledgments

I never imagined the time or energy that would be needed to complete this book. And so, I am extremely appreciative to those who have been with me through the process, especially my wife Karuna, who provided editorial assistance and emotional support, and my children Kena and Lalana. I need to thank Gary Mueller for his therapeutic help that initially opened me to the importance of psychological clearing on the spiritual path. Gayl Welch provided significant feedback for the original draft of the manuscript. Regina Sara Ryan made the major editorial changes, spending many hours ruthlessly refining the work to its present form. Sylvan Incao, Jaya Hoy, Rabia Tredeau, Shukyo Lin Rainey and Denise Wong were available at key points in the process, and their work has been appreciated.

In the end, this book is a synthesis of the contributions of a great many individuals. I have attempted to compile it in a manner which hopefully underlines the need for shadow work on the path. The sources referenced are accurate to the best of my knowledge.

Finally, for myself, I must acknowledge the obvious fact that through his life, my Teacher, Lee Lozowick, has shown me and many others the Way—the impossible challenge which, when all is said and done, will not be denied.

Contents

Foreword

by Robert K. Hall, M.D.
Lomi School Foundation

Perhaps the defining myth of our times is the story of Adam and Eve's banishment from the Garden of Eden. In that story everything was going nicely for our first ancestors until the temptation to have knowledge of good and evil betook Eve.

I don't think we should blame her. Someone was bound to look into that dark corner eventually.

After the apple was eaten, innocence was lost, and they both became self-conscious, the story goes that God banished them from perfection, cast them out into a world of work and suffering. We have all been laboring in that world ever since. It is a world where wholeness and unity have been lost, where all manifestation in consciousness is bathed in duality, which means that every appearance, whether of matter or concept, is joined in existence by its opposite.

Every thing that *is* must be accompanied by what it is *not*. Good and evil are the prime opposites in dual consciousness. That world that Adam and Eve were exiled into is a world of opposites. For every good there is evil, for every up there is a down, for every bit of light there is its partner,

darkness. We humans live in what the Navajo legends call the "land of shadows." Everything that manifests in this world casts its shadow, including our thoughts, and even the most noble of our intentions. For every force there is an equal and opposite reaction. In the Buddhist teachings it is said that everything that arises must pass away, everything that rises up must descend, everyone born must die. It is a harsh world, this place that Adam and Eve led us into, but it is straightforward and uncompromising in its basic structure.

The division in our consciousness manifests soon after we are born here. While still infants, our awareness begins to replicate the original pattern described in the story of the fall from paradise. We become aware of a distinction between self and other. We start to become self-conscious at about age six months. Then, the existential condition settles into place and the adventurous journey on Earth as a human being really begins.

Fear arises in the mind when a sense of being a separate self (in distinction to what is outside of self) appears in consciousness. For when there is a self, divided from the other, there is an inherent possibility of harm at the hands of that other. As soon as there is self and other, we have something to lose. A profound, perhaps unconscious, longing for union, for completion and for wholeness is also born in that vulnerable small self. But it is destined to feel separate and isolated from the world it is born into, and that sense of difference from the "outside world" brings anxiety and the constant need to seek security and consolation. As children growing in awareness of ourselves, we experience both the exaltation and the deep discomfort that comes from realizing how alone we are on our journey.

The Tibetan Buddhist teacher, Chogyam Trungpa, spoke often of the psychological strategies created by the developing ego-self in its attempt to cope with the horror of "falling through empty space." He called those strategies the normal personality. He called the fear "basic panic." Over time we identify ourselves as this personality. We come to think we *are* our strategies for managing fear. The truth about ourselves—that separate self is simply an interpretation of reality having no basis in fact—is relegated to the unconscious, along with all the turbulent emotions that arise in reaction to such unacceptable information.

I am reminded of that famous photograph of the Earth turning in the blackness of empty space. It was taken by the astronaut crew who first orbited the moon in 1968. It is a shot of the Earth rising into view from the perspective of the moon, just as the moon rises above the horizon for all of us living on the surface of Earth. How poignant and alone, somehow beautiful, our green-blue planet appears as it floats in emptiness. Each of us, abiding in our separate delusions of individuality, must appear just as poignant to a consciousness that remains undivided.

And what is the spiritual path, if not the journey we all must eventually take from the isolation of separate self to realization of a consciousness that remains undivided? The path of spiritual discipline and discovery is a great healing of the original wound in consciousness, the knowledge of good and evil. The split is a veil thrown over all perception, rendering the world to our senses as something *other* being viewed by a separate observer.

Any genuine healer will tell you that a healing, in order to be complete, must begin with acknowledgement of the problem. When we step onto the spiritual path, we do so

because we have recognized our suffering and a longing for relief. We are willing to take part in the healing process.

In spiritual life, that process involves a thorough cleaning and draining of the wound of separation. Little do we know, when we begin, still excited by the prospect of freedom from suffering, that the draining procedure involves unrelenting exposure of noxious material to the light of conscious awareness. There is no spiritual growth, no genuine freeing of the heart, without willingness to deal with the dark side of our nature. The shadow, those aspects of the ego-self relegated to the unconscious because they are repugnant to our self-image, arises out of its hiding places whether we like it or not. All our intentions to do well, to be good, to aspire to compassion and wisdom have cast a shadow just as dark as our secret selfish thoughts and perverted fantasies. We are undone in the process of becoming one. That is the way the healing works.

Vijaya (VJ) Fedorschak has written this book about the shadow on the spiritual path, and it is a gem. Within these pages, he has described beautifully the nature of the shadow, how it emerges, its effects on the spiritual pilgrim, including all the humiliating contortions so many of us modern-day travelers endure while attempting to avoid its terrible truth. If the truth is what liberates us, *The Shadow on the Path* is a consolation much needed these days when spiritual teachings are found in the marketplace of any town. I am grateful for VJ's labors in producing this important and timely book, but even more, I am honored that he asked me to write the Foreword, even though my words can never convey the brilliance of the chapters that follow.

Introduction

The Need Today

Many people in the contemporary Western world are in touch with an acute emptiness: the sense that they have sacrificed the life of the spirit for a life of comfort, apparent security, stimulation, and personal attainment. Yet, in essence, the existential struggle is no different today than it has ever been. Spiritual aspirants throughout time have asked the questions: Who am I? and What is my purpose in life? Such individuals have made the intention to live an examined life their focus, through honest struggle with what they discovered in both the outer and inner worlds. Similarly today, many who have experienced the inability of status-quo education or philosophy to address the real issues of life are moved to work on themselves in a search for truth. Many of these are people who seek help and refuge within age-old religious traditions, or with popular spiritual groups or movements.

On a spiritual path, practitioners are inevitably brought into contact not only with the "higher" but also with the "lower" aspects of themselves, which usually remain hidden from awareness. The need to consider these hidden as-

pects of self, assessing the enormous impact they make upon the individuals spiritual quest, is the subject of this book.

Three basic premises underlie all that follows:

1. Everyone has a shadow. This intrinsic aspect of the human psychological system, which has been described by Jung and others, accompanies each person who sets out on a spiritual journey. Involvement on a spiritual path does not magically purify one of the shadow or dark side of human nature.

2. We cannot go beyond a certain point on the spiritual path until we have explored the shadow in a significant way. This is a tricky matter because we have a vested interest in deceiving ourselves around the sensitive issues and feelings that have long been repressed, and which we unconsciously seek to avoid at all costs. Such issues and feelings, however, continue to be provoked in our lives. Coming to terms with such weaknesses is not a common occurrence—even for those on the spiritual path. Years of preliminary spiritual and psychological work may be necessary before we are ripe for contact, relationship, and direct struggle with the shadow.

3. Exploring the shadow involves opening to "negative," disturbing, and unpleasant forces that motivate human affairs. This opening is an essential element in unraveling the primal blocks to spiritual development. Preferring the idealized view of ourselves and the path, we often find that we have warded off these aspects of ourselves unconsciously, until at some point the dam breaks and we are in over our heads, enveloped by these forces. It then becomes evident that the path was not at all what we assumed it to be. At

this point, an entirely new and more profound relationship to ourselves and the path becomes possible if we are able to accept the reality of our primal feelings and weaknesses, and relax the sophisticated defenses we have developed to keep ourselves protected from such harsh truths. This book is written for those who are in touch with the reality of this often slow, painstaking, but necessary, process.

The idea for this book arose from my observation of the power of the human shadow in both the contemporary spiritual scene and my own personal life. It was obvious to me that the abuses and hysteria that had occurred within many of today's spiritual communities reflected shadow features of both leaders and members that, once exposed, could not be integrated. At the same time, my own experience and my knowledge of traditional spiritual approaches had convinced me that all these occurrences were not necessarily indicative of a negative situation. Rather, such circumstances were part of the evolutionary process obviously required for primal issues to be brought to the surface. Additionally, it became apparent to me that by placing the spotlight of blame primarily on individual teachers for abuses within their spiritual organizations, attention was diverted from the potentially useful consideration of *practitioners'* own shadow issues.

To elaborate upon the second premise, I assert that without dealing with the shadow in the ways in which it exists in the Western cultural psyche, it is impossible to fully align with the aim of essential spiritual teaching and practice in more than a conceptual way. *The need today to bring the purity and power of real spiritual understanding into our world*

requires that we acknowledge and work with our shadow sides. In the long run, of course, we cannot avoid confrontation with whatever darkness and confusion lie dormant within us. Thus crisis situations, which may arise in both individual and collective processes, have the power to bring unexamined issues and feelings to the surface. Crises tend to shatter the illusory mental constructs we have defensively erected around our definitions of self and our situation on the path.

My contention is that whenever a real spiritual crisis arises, it is *always* about being forced to interface directly with primal feelings that are rooted in an early childhood difficulty. While we may be highly accomplished in many ways, and facile in our ability to grasp and communicate spiritual teaching, at some level we all experience a unique type of primal or chief weakness (that is, the fundamental defensive way in which we relate to life) stemming from some form of early trauma or instinctual deprivation—a condition that is epidemic in Western society. At some point in the spiritual journey, we are bought to a crossroads at which we can either undergo the suffering of authentically relating to the shadow aspects of ourselves and integrate what we learn from this, or decide to avoid such intensive personal work and thereby discontinue the possibility of any unified spiritual transformation—perhaps for a lifetime. Leaving one's current spiritual path or remaining within one's same general circumstances may follow upon either choice.

My Encounter with the Shadow

At the outset I should say that I am a psychotherapist, and that I came into this role quite unexpectedly after being dragged into relationship with some of my own shadow features due to the influence of my spiritual teacher and community. Years of spiritual practice and self-development had not directly addressed the primal issues and feelings that lay hidden within my personal shadow. The cumulative effect of rubbing up against long-denied pain through spiritual work over many years produced a major internal crisis for me. My emotional life was no longer manageable and a strong problematic mood dominated my awareness in daily life. The ways I had unwittingly used spiritual practice as a means of suppressing undesirable aspects of myself were no longer possible. Apparently, an intense inner conflict could no longer remain buried below the psychological surface.

To some, the use of psychological therapy within a spiritual discipline may seem regressive, as the usual progression involves jumping from an ego-oriented psychological view of life into the embrace of the more unitive spiritual perspective. My experience, however, which I think is relevant to many on the path, is that at some point it becomes critical to deal with a particularly deep-seated psychological block in order to allow for a more significant level of spiritual transformation to occur. In my own case, spiritual work brought me to the place of being able to acknowledge that I needed help in releasing and coming to terms with tightly-bound primal energies and feelings that had remained hidden in shadow. At that time, "spiritual psychotherapy" was a godsend, helping me to learn to open

doors that had long been locked from the inside.

My own spiritual journey began seemingly by accident in the 1970s. Having been groomed for success in mainstream academia, I emerged from a well-regarded college and graduate school with letters after my name, but without a sense of inner direction or purpose. Shortly before graduating I came into contact with a remarkable man who was to become my spiritual teacher. Upon graduation, when I entered the conventional work force, I was shocked by the contrast between the sterility of a mundane nine-to-five existence and the brilliance and richness of my teacher's company. His provocative mood, moreover, constantly challenged me to examine my basic assumptions about life.

After three years of successful but unfulfilling employment as a city planner, I found myself unable to continue in an environment that contained no support for personal and spiritual growth. I needed a situation where I could explore the reality of my own instincts and unconscious motivations, as well as my own suffering. In 1980, then, I left the drudgery of a respectable career for the unknown and suspect experience of direct work with the spiritual teacher and community of practitioners with whom I had been involved since 1976.

In retrospect, the choice to abandon my career was the first heroic gesture I had made in my life. At the same time, I felt as if I had no choice in the matter—my teacher's silent support made the decision for me. I was starving for something that would feed my hunger for a genuine, personal spiritual quest. I wanted to know who I was and why I was here—I wanted answers to all the questions I had pondered as a child. During my early Catholic education, from grade

school to high school, I had been taught by individuals who were obviously afraid of damnation. The beliefs they attempted to indoctrinate me with never seemed grounded in experience or reality. While I was not sure *what* God was, or if in fact such a thing existed at all, I knew I did not believe in mainstream religion's concept of a God who lived in the sky. In my teacher's presence, therefore, I was startled and heartened by exposure to a world that offered the opportunity to genuinely explore the nature of reality and the truth of existence.

I had found my path. Walking it, however, presented a whole new set of challenges. I gradually came to realize that no one could provide the answers for me. Although I desperately wanted my teacher to tell me what to do, in the end he would not. Instead, I had to look directly at myself and undergo whatever unique process of learning and self-unfoldment life presented for me. I had to become responsible for what I discovered. I had to discriminate between my conditioned responses and the objective reality of life situations, cultivate openness to varied sources of wisdom (even those that were previously unfamiliar to me), and be willing to learn in a different way in order to grow. Along the way I encountered inner obstructions, things about myself that I hid from, situations that I had never been able to really handle and that I was unable or unwilling to work through.

While immersed in my own process of struggle with shadow feelings, some of which I will shortly describe, I also observed the crises that were occurring in many spiritual organizations at the time. Various groups were regularly sent reeling by revelations about some activity of their

teacher. These people were not all "crazies" waiting to be picked up by a UFO out in the desert. Some were followers of respected teachers within traditions like Zen and Tibetan Buddhism. The sensation-hungry media hyped the assumed hypocrisy of such teachers, blaming them for having taken advantage of others. Mature voices speaking to the complex variety of issues were often lacking. For example, few if any of the commentators or the people involved acknowledged how the shadow of the individual gets projected onto the authority figure of the teacher. There was little understanding of the fact that it is part of a genuine teacher's job to provoke the student's hidden issues, and that this provocation is both necessary and valuable for those ostensibly seeking transformation.

With extreme resistance to looking at some of my own areas of darkness, I learned why many individuals decide to leave the path when such inner conflicts are in their face. Over time, my struggle with a variety of work tasks given by my teacher magnified my shortcomings, until I really had to choose between remaining stuck and possibly leaving the path, or dealing with my shadow side. Remaining stuck could allow me to rest on familiar psychological turf, and I craved this inner safety. But, to do so would involve relinquishing the possibility of further growth, which I longed for. I experienced more than a little anguish as I gradually agreed to look at primal issues that threatened to expose not only the pain of my early childhood, but also the illusion of my self-concept and worldview.

Association with a spiritual school and a teacher precipitated a deeper investigation into my assumed self than I ever would have engaged on my own. For me, contact with

a transformed teacher has been the greatest source of help in making an experiential shift from a life exclusively motivated by ego's survival strategy to the possibility of a life of surrender to a higher spiritual purpose. Developing the ability to face and work with the shadow has been a key element in this process.

Everyone's journey is unique, and my intention in this book is not to advocate spiritual work of one specific form, i.e., within a community or with a teacher. Regardless of the form, however, I assert that the development of self-awareness must at some point involve relating with psychological hurt that is so critical that it has been repressed. Like most individuals, I was willing to do *anything* to keep from relating with the shadow until I found that there was no way around it. Before then, my psychology on the path was predominantly employed in the service of spiritual self-deception. Spiritual teaching was used to circumvent the tragedy of my early childhood hurt.

The first formal group meeting I attended with my teacher was so challenging and uncomfortable for me that I felt compelled to leave the room, yet I was temporarily frozen and unable to do so. When I finally leaped to my feet and blurted out that I needed to go, I took off running down the street—10th Avenue in New York City. Someone followed to make sure I didn't get hit by a bus! Despite my initial recoil, I nonetheless made the fateful decision to return and receive more teachings. I myself am responsible for the consequences of that decision.

For several years after meeting my teacher I found myself on a spiritual honeymoon. I was opening up to a part of myself that had lain dormant since childhood—a part

that felt deeply, a part that loved and reveled in life. Like a newborn, my new life needed coddling and nurturing in order to grow—and I fully expected this nurturing to continue forever. It did not happen that way.

In 1980, less that four years after my initial affiliation, our entire spiritual community moved over 2,000 miles across the country. Shortly after the move was completed, my teacher asked me if I wanted to begin outreach work—to give talks on spiritual practice—and I said yes. This process proved agonizing, for both myself and for the others who had to sit and listen to my halting presentations. I squirmed as long-defended parts of myself were challenged to risk exposure in a public forum. The only one who seemed relaxed about this whole painful experience was my teacher. One day, he asked with a broad smile if I wanted to go to Los Angeles and start a spiritual education group there, and once again following his lead I said yes. I left on my own, excited yet scared, leaving my female partner behind with the understanding that she would join me at some future time. Long-term plans were discussed with our teacher. My partner and I maintained contact and I never questioned our intention to reunite.

Several months into this new assignment, my partner called me late one night to inform me that she wasn't coming out to California. She had decided to stay in residence on the ashram, close to our teacher, thinking that this was the place for her. I slept miserably that night, and for many nights afterwards. While I had skirted shadow feelings before, I was now thrust deeply into my inner darkness—feeling betrayed by my partner and my teacher.

For over six months, while in the midst of profound

inner turmoil, I still continued to present talks on spiritual topics. A sense of duty drove me, which I soon began to question. Violent dreams and feelings of anger and despair consumed me. My facade was cracking. Trudging through daily life, with no other tools to deal with my emotional reality, I held firmly to spiritual practice. My attempts to consider the illusion, emptiness, or insubstantiality of the mind amounted to suppression and denial.

My teacher maintained contact and support, and answered all my questions. He even visited regularly. But I was in bad shape. Spiritual teaching was just rhetoric to me now. Forced to relate directly with my shadow, I didn't know what to do or how to cope with the level of tension I was experiencing. Locked in the prison of my own mind, I wasn't open to anyone. Pain and confusion obscured the possibility of implementing the spiritual solution—letting go.

As it turned out, I was saved by the bell. One evening, I got a call from my beloved, saying she would like to be reunited, if I would have her. I was speechless. It was as if the suffering of the past months was just a bad dream. I was far from resolving my relationship to the shadow, but the situation had forced me to grow in my relationship to reality. The experience brought me into contact with aspects of myself that had been hidden from conscious awareness, aspects that I had previously not had to deal with. I was no longer naive about the powerful forces involved in spiritual transformation. This had been my first profound plunge into my "underworld." The second was not far behind.

In 1986, only two months after my partner and I were married, we were invited to accompany my teacher and

twenty community members on a three-month pilgrimage to India. While we had little money, we had no question about making the trip. Our entire group stayed in the most humble lodgings—living as most Indians did. My health was bad—I was having trouble with asthma, which was aggravated by breathing in the dust stirred up on India's primitive roads and by the exhaust from dilapidated buses and trucks. Yet, the experience was unforgettable and exhilarating, full of impressions of ancient knowledge.

One day, during this eventful trip, my teacher offered *malas* (prayer beads) to several of us. We readily accepted, realizing that in some way he was empowering our practice. Upon discovering that the price he asked for the beads was exorbitant, given what they had cost, I was thrust again into doubt and confusion about the validity of the path and the integrity of my teacher. I was angry, distrustful, and tense. Apparently, I had thought that I was someone special. *Hadn't I given everything to the community? How much more did my teacher want?*

This sore point alerted me that while I was undeniably drawn toward spiritual life, I also had denied many of my feelings and desires in an unconscious drive to adapt and feel safe. I was still being the dutiful student I had been in Catholic grammar school. After ten years of participation in this spiritual way I still hadn't honestly examined—let alone broken through—my own childish relationship to life.

I confronted my teacher. Surprisingly, his answer was clear and open and utterly convincing. "The money means nothing," he candidly told me. It was really okay for me not to pay anything for the beads if the cost was a problem, he explained. Nonetheless, I had been faced with the prin-

ciple of needing to give something of myself in order to receive spiritual teaching.

On returning home I was still overwhelmingly confused. So much had been churned up in me by this trip! While I had experienced profound growth on the path, I realized that I had always been a follower. Life was too big, too threatening, and I had remained safe by following the rules. On occasions, when I childishly began to show my rebellious side, which had formerly remained hidden, I felt rebuked by my teacher. I then wallowed in guilt and self-pity. Much of this was my own projection, my own interpretation of his communications as colored by a primal issue in my psyche. In retrospect, I see that he allowed me to work through the distortions and find my own way out of the dilemma.

My teacher continued to offer opportunities for growth, one of which involved being the director of our community theater company. This new task served to bring me closer to the brink of despair. A Pandora's box of feelings had been opened within my psyche and could not easily be closed again.

Although I had a natural ability for acting and directing, my fellow actors and actresses gave me strong negative feedback about my overall approach to the work. I was angry, and in denial of my feelings. I grew isolated and withdrawn from the troupe members who wanted to have more input into the theatrical process. I felt I needed to control the whole show! Closed to ideas that differed from my own, I had difficulty accepting and integrating their feedback. I refused to accept that my approach to the stage, as well as to life, was extremely limited.

Midway into our third full-scale production, I became so distraught by the upsetting feelings that arose in me that I quit as the director. Shortly thereafter, I moved out of state, ostensibly to take another job for the community. Once again, my shadow problems dogged me relentlessly. As the coordinator for a large spiritual conference, I couldn't control the way the event was coming together. Its failure would be *my* failure. Every step of the way was a struggle as I pushed to have each detail conform to my standards.

At the same time, I began hearing feedback from other community members about the dysfunctional nature of my relationship with my wife and young son. It was apparent that I was unable to balance work and family responsibilities. The need to control was evident in other areas of my life, and was becoming clearer to me in the spiritual study groups that I continued to lead. I now know that I had a fear-based relationship to life, and was isolated, angry, rigid, and aggressive in my pursuit of goals, which, if reached, would allow me to maintain my image of myself. Thus, after years of being heated in a spiritual cauldron, I was reaching the boiling point. I reacted, at least internally, with the defenses of a mad dog.

There was no escape from the inner turmoil. I either blamed my teacher and others in the community, or wallowed in self-defeatism, not understanding why I was in such pain. Finally, I received a message from my teacher—a strong message that jolted me with its content and urgency. He firmly recommended that I enter into some form of body-oriented psychotherapy as soon as possible. "Talk therapy" alone, he asserted, would only feed my ability to

talk my way out of anything without dealing with the reality of my difficulty.

With a mixture of anger, hope, and trepidation I determined to follow his instruction, and set out to interview a variety of body-oriented therapists. The experience was startling. One was much too friendly, and I felt as if I was a stray animal that he might like to take in and keep as a pet. (I'm sure he had many.) Another seemed to examine me in a cerebral way, which made me feel like I was another life form, an alien specimen of some sort. Most left me with the feeling that there was indeed something wrong with me. I didn't trust, in the least, their abilities to correctly identify the ailment, much less perform surgery. Finally, I stumbled into the office of a Gestalt therapist who was fluent in energetic work and who taught at a Buddhist college. He himself was not a Buddhist, but seemed to demonstrate the qualities of both insight and compassion that are intrinsic to an authentic Buddhist path.

Whether it was just the right timing for me, or the mood of acceptance that I felt in his office, I found myself as never before at the point of extreme necessity to deal with my situation. I blurted out my conflict. What I told him, in essence, was that I had felt the weight of a great many real or imagined "shoulds" in my spiritual community. Deeply blinded by the distortions of my own projections, I had not allowed myself to truly experience the openness and help of my teacher. He had always represented the authoritarianism of my father, and my need to defend, adapt, achieve, and seek for acceptance was extremely strong and primal. Yet my neediness was also covert, since I had learned well how to present an image of a dutiful and hard-

working spiritual practitioner. In this therapist's presence, I was finally able to admit that I was utterly frustrated in my teacher's company and did not know where to turn.

All of my years of repression, reflecting the painful early experience of a fearful and unhappy family, the dogmatism of a moralistic Catholic upbringing, and the discouragement of facing an unattainable goal in the spiritual community were regurgitated in that office during our first meeting. I was an emotional mess, but at least I was in touch with the fact that I was a mess—I had my spiritual path to thank for that awareness. Indeed, my breakdown was a blessing, though I did not think so at the time. Without uncovering the shadow feelings that tormented me, I was destined to live a mediocre life.

After the better part of an hour, my therapist pulled his chair closer to me and began to speak. "Your personality features and defensive habits are not wrong. As a child you undoubtedly needed to find ways of protecting a very innocent essence which, instead of receiving mature nurturing and love, felt alone and scared. Your defenses arose rightly out of a creative process of ego development that was needed at the time. The challenge is to accept and become responsible for them now, trusting that through exploring your worst fears about yourself and about life the way will become clear." Feeling acceptance, compassion, and support for my work, I wept deeply.

Thus began my exploration into spiritual psychotherapy—which has saved my life, my marriage, and my work in relationship to my spiritual teacher. Having engaged this profound exploration I can say from experience that, in the end, there is no way out but to face and accept our reality,

as it is. From this place of acceptance, the possibility exists for something we have not imagined to arise. Having genuinely engaged such practice, walking the path takes on new meaning—as the immense responsibility for ourselves and all existence dawns on us in an experiential way.

How This Book is Structured

In order to consider the "shadow on the path," we will first need to have clarity about what is meant by "the shadow" and "the path."

Chapter 1 is an overview of the findings of major contributors (Freud, Jung, Reich, and Miller) who have studied the phenomenon of repression and the shadow in the West.

Chapter 2 encapsulates a few of the ideas of the major traditional paths (i.e., Hinduism, Buddhism, Sufism, Judaism, Christianity, and Tantra). Distilling core elements that these traditions have in common, we will draw distinctions about those trappings that have nothing to do with the essential path.

A variety of ways in which we typically try to avoid shadow manifestations on the path are presented in Chapter 3.

In *Chapters 4* and *5* we examine the shadow as it shows up in those who claim to be spiritual teachers, and in contemporary spiritual organizations and communities. The examples used throughout are meant to raise considerations for anyone who senses the presence of primal obstruction in his or her spiritual work—for anyone who is, has been, or will be stuck at some time on the path. (I think that this may be all of us.)

The Gestalt, Energetic, Enneatype, Family Constellations and Lyings methods, described in *Chapter 6*, are brilliant applications aimed at encouraging the spiritual practitioner to open up to his or her primal issues.

Descriptions of work with individuals in *Chapter 7* is meant to give the flavor of various therapeutic approaches used in working with primal issues that may be recognizable to the reader.

Finally, *Chapter 8* closes our treatment with a focus on the heart. My hope is that this synthesis will be useful for others on the path.

CHAPTER 1

The Shadow and
Western Psychology

In the course of twenty-five years on the spiritual path, virtually every major spiritual crisis I have observed individuals undergo has arisen around some unresolved shadow issue. One of the major shocks I faced in the early period of my own involvement in a spiritual school came when a hard-working and highly regarded woman student suddenly decided to leave our community. Isabella had a strong influence on me at the time—she had introduced me to many of the basic ideas of spiritual work. I couldn't understand how she could leave. She seemed irrevocably committed to her work and our teacher, and held an important post in the spiritual organization—her powerful presence arose out of a strong practice and undeniable understanding of the teaching. Yet, Isabella had a particular

1

weakness that became more apparent over time—it showed up in a compulsive need for male companionship.

Certainly everyone has a need for relationship, but the desperation Isabella exhibited in this regard grew consistently with a strength that indicated that repressed shadow issues were finally erupting for her. Buried feelings that had been primed through her experience with marriage, motherhood and then divorce, now began to surface with an intensity she had never experienced. Several factors heightened her current situation, especially the growing number of her close women friends who were becoming involved in relationships with men as her own needs continued to go unsatisfied. Isabella felt there were no options for her, that she was stuck in a lifestyle of emptiness and despair. As no man in the school had been right for her during the entire length of her involvement, the pain that her friends' partnerships brought up for her was overwhelming, and its source could no longer be avoided.

Isabella wrestled with her dilemma in conversations with her teacher, who repeatedly discouraged her from partnering with the men that she would regularly speak about with him. Even while part of her seemed to realize that she was "pushing the river," trying to make the universe conform to her needs rather than surrendering to the flow, she was so preoccupied with filling a hole in herself that she saw her teacher as a "denying force."[1] She began to fight with him, even while she realized that it was her "cramp," something inside her and not the external situation, that was so troublesome.

Isabella had not the slightest idea of what to do about her hopelessness, except to try to surrender. But she could

not relax her powerful primal feelings; she could not be stronger than her psychological truth. Allowing such painful feelings to arise seemed unbearable to her, however, and she did not view this as a viable option in the situation. Isabella—like most of the members of the community who attempted to offer help through insight, confrontation, and support—was inexperienced in working with the level of repressed feeling that had been aroused. The idea of opening to, going more deeply into, and ultimately coming to accept the depth of her primal weakness and negative, psychological feelings was not integrated into her spiritual approach. Isabella believed that something was wrong—either with her teacher and community, or with herself. Her feelings remained largely unworkable since she was unable to explore them with a non-judgmental attitude. Because she couldn't feel them, she couldn't heal them. There was thus little or no chance for Isabella to relate directly with the repressed part of herself, rooted in early childhood hurts, which was being provoked by her circumstances. Backed into a corner with her own shadow, she felt trapped by a seemingly unresolvable crisis.

Working at cross-purposes, Isabella attempted to surrender, while also struggling mightily to find a way to remedy her situation. But the more she tried to change, the more she remained the same. Since her strong shadow feelings were not acceptable to her (and perhaps to the community-at-large), Isabella was regularly catapulted into moods that precluded the possibility of working through them. She did not have enough familiarity with her primal energies to be able to apply an internal practice to them— a practice that might allow for spiritual alchemy and surrender.

Though she was extremely intuitive, able to provide insight and inspiration for many others on the path, she was blind when it came to relating to her own shadow, as we all are. Eventually, seeing no resolve for herself, Isabella departed amidst a river of her own tears and those shed by many others. Ostensibly, she left her teacher and school to engage in relationship with a man who was a member of another spiritual group. In this new situation, however, the same dynamics came into play. With little objective evaluation of what she was doing, she quickly adapted to her new partners path, thereby avoiding having to face her primal issue more deeply. Predictably, the relationship soon fell apart.

Everything that Isabella had been convinced of concerning her path had been called into question in an unconscious effort to avoid the deepest areas of primal hurt in herself. She had not been able to see that freedom can express itself only when the way is cleared (i.e., after working through primal blocks), and that the way this happens is through the conscious suffering involved in acknowledging and accepting the shadow, even when enveloped by it, rather than by struggling to avoid it.

Following Isabella's departure, many practitioners in our spiritual community were unable to understand what had caused it. Some blamed her for abandoning them, or for not living up to their expectations of what a spiritual practitioner should be. But years later, having been thrust into the intensity of my own shadow on the path, I could more directly understand the dynamics behind Isabella's departure. I had hung on by my fingernails, because I knew there was no other path for me, and that "the world" bereft

of real spiritual perspective was desolate, offering no more than aimless, purposeless suffering. The difficult experience of my friend and fellow practitioner was undoubtedly necessary for her ultimate spiritual process. At the same time, Isabella served as an example for those of us who were touched by her ordeal. Just when and how shadow issues come to light on the path is unpredictable, and unique to each person. That they will erupt sooner or later is a fact that most of us—who knew Isabella and had watched her struggle—did not yet know firsthand.

No one can "handle" the shadow—just as no one can handle the anguish of the early childhood hurt they have experienced. Central childhood issues characterized by deep-seated primal feelings become the axis around which our personalities unwittingly turn. Before we come to some reconciliation with these feelings, not necessarily in terms of clearing them away forever, but in terms of beginning to accept, suffer, and "make friends" with them so that they become workable, we are stuck—on the spiritual path or any other path we might pursue—even if we do not know it. Until then, the help that we can offer others is also significantly limited. So let us consider the shadow, and the path, in more depth, so that we have a clearer idea of the aspects of consciousness that we are dealing with. The following section will lay a foundation for that understanding by tracing the progression of human psychological development.

The Fundamental Assumption

The fundamental assumption that we as human beings make about life is that we are separate, individual

beings. We may be connected and related in many ways, but a physical distinction between what is "us" and what is "not us" is central to our experience of reality. This assumption of our existence as separate identities appears to be a visceral conclusion, one that provides the ground from which all of our knowledge about ourselves and the universe is gathered. Aligned with this premise, Western psychology has thus focused on work with thoughts and feelings from the context of the assumed reality of what we may call the ego—the individual self-sense that we identify as. This context allows that the experience of life can be improved within the parameters of mortal separative reality—i.e., that psychological work can be a useful tool in attaining the potential for a full life. Even the more progressive, holistic and humanistic psychologies basically operate out of the assumption of the reality of the separative ego as being the essence of a person, despite assertions about the interrelatedness of all things.

THE FORMATION OF SELF IMAGE
(POSITIVE AND NEGATIVE)

The physical, mental, and emotional components that together fashion the self-image of the ego combine at birth and evolve through various developmental stages. "Object relations theory" yields insight into the process of ego identification that occurs in early life. As child psychiatrist and researcher Margaret Mahler has observed, the biological birth is not the same as the psychological birth of the infant. Psychological birth occurs through the process of object relations, as we adopt the sense of our identities in relationship to the objects in the environment. At the same

time, we are also genetically predisposed in ways that affect our relationship to life. We obviously learn from our experiences and undergo changes as we grow, but a basic psychic structure is fixed at an early age, and then built upon.

Initially, the infant does not appear to make distinctions between him- or herself and the outside world. In particular, the child relates to the mother as a virtual extension of self. A self-referencing ego sense develops over the course of the first three years of life in a process that Mahler (1972) has described as "separation-individuation." This phase in the early life of the child may be divided into four sub-phases. In the first sub-phase, called *differentiation*, bonding between mother and child creates the ground from which the child's healthy psychological development and "expansion beyond the symbiotic orbit" (p. 53) can occur. The second sub-phase, or *practicing period*, is marked by the recognition of distinction between bodies and the "growth and functioning of the autonomous ego apparatuses in close proximity to the mother" (p. 65). As a toddler, during the third sub-phase of *rapprochement*, the child makes greater and greater use of the awareness of physical separateness. The ability to actively approach the mother is accompanied by anxiety about the mother's presence. Mahler notes that, "it has already begun to dawn on the junior toddler that the world is *not* his oyster; that he must cope with it more or less 'on his own,' very often as a relatively helpless, small and separate individual" (p. 78). This is the point at which the Garden of Eden begins to be lost—as over time the child becomes identified as an isolated individual. *Consolidation of individuality* occurs in the fourth sub-phase.

The Shadow On The Path

Western psychology, generally, and object-relations-theory, specifically, view the developmental process as one leading to the growing awareness of the reality of ego, with a fixed sense of "object constancy." When fully developed, object constancy refers to the capacity to experience oneself as a whole person and relate to another as a whole person, based on the positive inner representations of mother and father.

Although the formation of a separate self sense seems imperative to a child's developmental process of separation-individuation, a spiritual perspective nevertheless asserts the fundamental insubstantiality of the egoic self-image. The interpretation that Almaas (1988) offers is that "the sense of being an individual is not only a developmental achievement, but is a feeling that results from identifying with a certain structure in the mind . . . Regardless of how completely the self-image has become part and parcel of one's sense of self, it is nevertheless simply a construct in the mind" (pp. 25-26). The spiritual path asserts the possibility of returning to the state of a merged existence—not from the infantile state, but from a mature state beyond the phases of ego development—and emphasizes that without this perspective on the non-dual nature of existence, attempts to fix or enhance the ego are partial measures rooted in a false assumption of who we are. Psychotherapy based on the reality of ego is thus doomed to failure, since the cause of our suffering is confusion about who we are in truth, beyond the psychic structure of the mortal ego identity.

What we identify *as* begins with the mysterious ways in which a newborn absorbs stimuli from the people and things in the environment. Internal images of self and other

form a psychic structure, or ego identity, developing out of the immersion of a vulnerable, innocent being in the emotional experience of infancy primarily with his or her caretakers. The parents' relationship to the child and their expectancies are assumed (or "introjected") in a way that can only happen in a free and open mind, through a process of subtle osmosis. Components of the caretakers' psyches are thus passed on to the infant, as he or she grows out of the experience of merged consciousness within the orbit of the mother. Since these psychic components become deeply embedded in the unconscious, they will powerfully motivate the individual throughout his or her lifetime. Part of this process is the internalization of the positively regarded image of the mother in a way that, over time, seems to provide the developing separative ego with the comfort and support of the actual external mother. The process of identification itself may thus be viewed as a defense, allowing one to relate to reality with less anxiety. In this way, then, deeper layers of the psychology are inherited and basically set by the time a child is three years old.

As the child grows, the features of the internalized positive aspects of object relations become more visible in the personality's expressions. Yet the central feature of the character, which might be described as the habitual attitude towards life, may be much less obvious. A primal issue develops in response to the painful, negative aspects of object relations. The child adopts a defensive characterological stance towards the world to protect him- or herself from a specific kind of early hurt.

The perspective taken in this book is that the sense of self or psychological ego identity is comprised not only of

the positive internalized self-image, but also of the shadow aspects. This is because the psychic structure of the person is a combination of both features we have identified with and those that we have disidentified from.

The Shadow

The shadow arises out of the deeply distressing emotional experiences of childhood, and is actually unavoidable as part of the developmental process. As the child leaves the merged state of the Garden of Eden, separation anxiety from the mother (and from the totality of existence) is inevitable. Despite the efforts of well-intentioned, conscious parents, absolute love and nurturance can no longer be the child's continuous experience since he or she relates to the rest of the world as separate, distinct, and unreliable.

Separation anxiety is felt as part of the grievous and irresolvable hurt that each child endures—not only in the developmental process, but also in recurrent painful experiences catalyzed by the parents' shadows. Parents' own hurts are brought to the surface by circumstances such as their child's separation experience. They may then attempt to eliminate certain of the child's emotional expressions in any variety of overt or covert ways to keep from feeling their own primal pain. (This is meant to be distinguished from establishment of firm boundaries from a nurturing context, which is a critical element in supporting the child's psychological growth.) Parents are commonly oblivious to the effect they have on a child's inner psychic process—since they are often not in touch with their own shadows.

The psychic structure develops its shadow aspects as some essential need of the child is left unsatisfied. The child

commonly believes that something about him- or herself is wrong or bad; otherwise, how could this extreme crisis of unfulfillment occur? He or she has a great need to maintain a positive, idealized image of at least one parent, to hold onto the belief in the existence of total and unconditional love. When the child does not feel this, the intensity of pain becomes unbearable, as the undeveloped ego's ability to cope is extremely limited. Perhaps experiences of family conflict (or even of "subtle" neglect) are too distressing and therefore become utterly overwhelming for the child. Genuine instinctual expressions that are repudiated, and feelings and needs that are unacknowledged, are then suppressed until they become repressed as a means of childhood defense. After all, if a child does not adapt to his source of emotional or physical nourishment, that nourishment may be withdrawn. At the same time, primal rage is generated when legitimate needs are not met, and when there is no recourse but to submit to the demands that he or she abandon essential feelings and expressions.

The child's decision to disown parts of him- or herself through repression is not made consciously; but a primal issue develops around the particular way this occurs and becomes a central characterological feature of the child's personality, although shrouded in shadow.

Throughout life adults find themselves in situations that dredge up the feelings associated with these childhood hurts, though they may not make this connection. Generally they are out of touch with these disowned shadow aspects, and do not want to know of their existence. Our self-image does not allow for acknowledgement, much less acceptance, of these emotional weaknesses and primal nega-

tive feelings, and we habitually and defensively do our utmost to keep them barred from conscious awareness. These are the parts of our psychic structures with which, consciously or unconsciously, we have the greatest difficulty and which we inevitably contact on the spiritual path.

Zweig and Wolf (1997, pp. 39-41) describe how we come into contact with the shadow: through our secret sources of shame; in emotionally-charged projections about the features of others; in addictions that disguise our needs; in slips of the tongue; in humor at others' expense; in physical symptoms that reveal the effects of negative emotional patterns; in midlife awareness of urges that have been neglected or ignored; in dreams that reveal unknown aspects of ourselves; and in creative works such as writing and art. As we have learned to relegate much of our feeling about the body into the shadow, the authentic spiritual path will need to account for the spiritual nature of the body as well as for mystical experience.

Freud, Jung, Reich and Miller

Jung first used the term shadow, yet the theoretical image of shadow had long been pointed to in poetry and literature. Freud, who was Jung's mentor for many years and who may have catalyzed Jung's need to explore his own shadow as a result of the painful emotional nature of their relationship, had previously identified the concept of repression. Jung expanded on this idea, as did other innovators in the field of Western psychology. In the following sections, the impact of the work of Sigmund Freud and Carl Jung, as well as that of Wilhelm Reich and Alice Miller, will be briefly considered as it relates to repression and the

concept of the shadow. A careful look at the forces at play in the formation of the negative self-image (or shadow) will help us understand the power of the unconscious in our pursuit of spiritual ideals.

FREUD (1856-1939)

Sigmund Freud

The knowledge that there are thoughts and strivings that individuals are unaware of, that live a hidden life, that are unconscious, did not begin with Freud. But he made this idea the center of a psychological system and investigated the phenomenon deeply. Fromm (1980, p. 23) observes that, "Freud's discovery was that what we think is not necessarily identical with what we are; that what a person thinks of himself may be, and usually is, quite different or even completely in contradiction to what he really is, that most of us live in a world of self-deception in which we take our thoughts as representing reality." He asserts that Freud expanded the concept of truth tremendously in that "truth referred not only to what one believes or thinks consciously, but also to what one represses because one does not wish to think it" (p. x).

In *The Interpretation of Dreams*, written in 1900, Freud asserted that mental life consists of an ongoing conflict

between the unconscious level of mind, rooted in the biological instinctual sexual drives pressing for discharge; and the conscious level of mind, which is logical and rational and seeks to integrate the ideals and values of society. But even before the formal explication of a "topographic theory," in which mental functioning was conceived in terms of layers of accessibility to consciousness, Freud linked the idea of the unconscious and the phenomenon of repression. At an early phase in his work, he noticed how distressing psychic elements were barred from awareness.

In the late 1800s, Freud had an important association with Josef Breuer, a physician and researcher from Vienna, through whom he became familiarized with the now famous case of "Anna O." As Breuer worked with this patient, her talking "proved cathartic as it awakened important memories and disposed of powerful emotions she had been unable to recall, or express, when she was her normal self" (Gay, 1988, p. 65). At this time Freud declared, "I looked upon psychical splitting itself as an effect of a process of repelling which at that time I called 'defense,' and later 'repression'" (in McGrath, 1986, p. 148). (In 1894, he introduced the term "defense," but substituted use of the word "repression" ten years later.) Free association, a method through which individuals are asked to report on whatever thoughts come to mind without censure, became the psychoanalytic vehicle for attempting to undo repression by bringing the unconscious into consciousness.

Freud saw repression as the keystone for the understanding of neurosis—the mental distortion of reality. In a 1915 publication entitled *Repression*, he stated that the "essence of repression lies simply in the function of rejecting

and keeping something out of consciousness" (in Rickman, 1957, p. 89). Repression involved the efforts of an individual to render inoperative an objectionable instinctual impulse. In 1926, in *Inhibitions, Symptoms, and Anxiety*, Freud again reconsidered his use of language and chose to designate the term *defense* to signify all such efforts of the ego. Repression was seen as one of the methods of defense. A partial list of other defense mechanisms includes *denial*, the attempt to avoid the reality of a disturbing event; *rationalization*, the process of justifying unacceptable thoughts or actions with acceptable reasons; *reaction formation*, the substitution of diametrically opposed behaviors to block recognition of the actual wish; *projection*, the act of attributing qualities, feelings, or intentions to others that actually originate in oneself; *regression*, the reversion to an earlier level of development in order to avoid anxiety; and *sublimation*, a process of redirecting unacceptable wishes towards more constructive, creative and socially acceptable ends. Nevertheless, Freud seemed to feel that *repression*, the pushing of unacceptable impulses into the unconscious, was the basic defense mechanism because it is the goal of the other types of defense.

In addition to rethinking his use of the terms defense and repression during the course of his professional life, Freud also reversed his idea about the relationship between repression and anxiety, which arises in response to the attempts of unconscious wishes to enter into consciousness. Initially, he had believed that repression preceded anxiety, and that anxiety appeared only if repression failed to keep out unwanted psychic elements. In his later theory, he considered anxiety not only to precede repression, but to be

the prime motive for this method of defense.

In Freudian psychoanalysis, the personality is divided into three structural components. The *id* refers to the sum total of biological instincts; the *ego*, defined in a different sense than in this book, serves the function of mediating between the external and internal worlds; and the *superego* is a split-off part of the ego that develops from early moral training. Instinct is seen in terms of human "drives," impelling the mind into activity. In *Beyond the Pleasure Principle*, written in 1920, Freud expanded his view of a single instinct into the "notion of two instincts, libido and aggression, both derived in turn from broader, all-pervading biological principles—an instinct of love (Eros) and an instinct towards toward death and self-destruction (Thanatos)" (in Arlow, 1989, p. 26). Whatever one thinks of this tenet of psychoanalytic theory, Freud's research on the repression of the instincts seems to have forced the Western world to, in his words, "take the concept of the 'unconscious' seriously" (in Gay, 1988, p. 128).

The implication in Freudian theory seems to be that the unconscious is self-contained, defined within the static boundary of an individual psyche; and that by becoming aware of one's relationship to instinctual elements one may come to exercise greater control over them. A different context of psychological approach, incorporating aspects of traditional spiritual understanding, may consider psychic structures as permeable and perhaps illusory mental constructs. Additionally, instinct may be conceived in a much broader and more life-positive manner. In their own ways, Jung, Reich, and Miller advocate a view of the human being that is based on trust in an innate instinctual or intui-

tive wisdom that was not shared by Freud.

In a way that had not been done before, Freud explored the significance of early childhood development and its impact on the personality of the individual. Within his postulated *Oedipus complex*, for example, is the revelation of the intensity of the young male's attachment to the mother figure. (The *Electra Complex* is the female equivalent, referring to the young girl's attachment to the father.) Regardless of one's position on the value of Freud's emphasis on the erotic nature of these dynamics, and on the innate hostility hypothetically directed at the parent of the same sex, the theory focused attention on several important matters. The wish to be loved and cared for, to be sustained and protected, and to see others in this potential role throughout life may be seen as extensions of the Oedipal theory. At an early age, we are totally dependent on the mother or other caretaker, and the scars of not receiving genuine and appropriate nurturance during early developmental stages may remain throughout the lifetime. As adults we are often unaware, in more than an intellectual way, of the power that this unfulfilled need plays in our lives.

Freud posited oral, anal, phallic, latency and genital stages of child development. During each stage the sexual energy of the *id* (libido) is centered on a different part of the body. Incomplete development, or deprivations that occur during these stages, are the source of various characterological issues associated with different personality outcomes. Some of these issues will be noted later in relation to psychological dynamics that commonly present obstructions for practitioners on the spiritual path.

The concept of *transference* arose from Freud's observation that analysands developed strong emotional ties to the analyst during psychoanalysis. He concluded that these attachments were of the same nature as those experienced toward one's mother or father. Until Freud, no attention had been paid to the attitude between patients and physicians.

Transference, of course, does not only apply in the analytic situation. The tremendous role that it plays in all aspects of our lives is unmistakable—from our likes and dislikes of people in everyday life, to our perceptions of major public figures. Of considerable interest to our investigation is how spiritual teachers necessarily become the objects of transference for their students.

Among other concepts postulated by the founder of the psychoanalytic movement is that of *narcissism*. This may be defined as an excessive self-absorption, self-concern, or self-love that has become habitual during the course of developmental adaptation. An individual's interest may therefore be directed toward himself or herself, or outwards toward others. Fromm (1980, p. 45) points out that Freud did not "define narcissism in terms of its being the opposite pole of love." Largely due to the nature of his times, and the social filters he was inculcated with, Freud "could not have done so because . . . love for him did not exist except as the attachment of the male to the feeding woman. For Freud, *to be loved* (i.e., the male by the conquered woman) gives strength, *to love actively* weakens." (This is obviously in contradiction with the esoteric focus of many traditional spiritual paths, such as Sufism and devotional Hinduism, in which one is drawn toward all-consuming love for the

"other." Narcissism is of considerable interest on the spiritual path, in terms of the many masks that it wears, and in terms of how it may reflect incomplete development in the early stages of life.)

Though Freud regarded the central concept of repression as his own discovery, he later acknowledged the similarity of his finding with the work of the philosopher Schopenhauer, whose ideas he had been unaware of. In *World as Will and Idea*, Schopenhauer explains insanity in terms of a struggle against accepting a distressing piece of reality. In a review of the developments that led to his understanding of repression, Freud wryly noted that, "Once again I owe the chance of making this discovery to my not being well-read" (in McGrath, 1986, p. 148).

The concept of repression, then, has brought attention to the fact that there are aspects of the psyche that are hidden in order to defend one from the pain of early childhood hurts. Associated primal negative emotions lie dormant, ready to be triggered by the appropriate circumstantial catalyst or figure of transference. In part, this book will consider situations on the spiritual path in which hidden repressed parts of the psyche have been aroused.

JUNG (1875-1961)

Jung conceived of the *collective unconscious* and of its repression in the developmental scheme of the human being. Some of his differences with Freud, on both a personal and theoretical basis, will help to illustrate his understanding of the psyche. In particular, Jung believed that working with the shadow aspect of the personal unconscious (which corresponds to Freuds view of the unconscious) is essential

for what he called *individuation*.

In his early professional years, however, Jung's original ideas lay dormant. His writings were openly psychoanalytic and he developed a close relationship with Freud. During the early 1900s, he wrote of the unconscious mind and its repression, of free association as a link between the con-

scious and the unconscious; and he gave experimental proof to some of Freud's theories. Jung developed a word association test in which he observed that patients would not react to certain words for a lengthy period of time, and often would then forget the word, even after being reminded of it. In *Experimental Researches*, Jung (1973) described his findings as

Carl Jung

being consistent with Freud's ideas, noting that "the phenomenon that we observed is a particular case of a general tendency to repress and then forget the unpleasant image" (p. 272). Jung noted that responses of this nature were obviously related to patients' *complexes*—the definition he gave for thoughts that are emotionally charged by virtue of their association with primal issues.

The relationship between Freud and Jung has been the subject of much study. What seems apparent is that, due to the dynamics of transference that took place between them, their relationship deteriorated. Jung probably ideal-

ized his mentor early in his professional career, and may be said to have experienced a "father complex" in relation to him. He experienced a very painful personal and professional loss when he broke with Freud, writing that he felt disoriented after this parting. But this created the possibility for growth and maturity into a new sense of himself separate from Freud. In the process, Jung came to articulate a creative system of psychological ideas, including a broadened perspective on the concepts of repression and the unconscious. Jung's unique expression flowered with his own individuation process, which included work with his repressed, shadow issues. These came up, at least in part, in the transference that he experienced with Freud.

Through exploration of the abstract realities of human consciousness as alluded to in mythology and Eastern religion, Jung's work addressed the limitations of Freudian theory. He presented an alternative view on libido, expanding it beyond its sexual meaning. For Jung, libido encompassed the psychic energy of the life force in any manifestation occurring as one moves toward some higher purpose. He also disagreed with Freud's emphasis on analytical-intellectual understanding, by which one may deceive oneself that the mystery of life can be reduced to the mental grasp of theoretical principles. Jung believed that neurosis was essentially a positive attempt to construct the meaning of life. In this regard, psychic distortions seem to be the way one creatively copes, attempting to find wholeness within the reality of the life circumstance into which one is born. Jung's method was based on the receptive, feminine principle and on the belief in the potentially healing capacity of the psyche, which could function in a kind of partnership

with the shadow side of the Freudian unconscious. Barbara Sullivan (1989), a Jungian psychotherapist, explains that the Jungian approach invites us to "take an attitude of humility toward life and to recognize that in relation to our inner selves as well as the outer world, we are not in charge"(p. 42). The therapeutic aim arrived at by Freud, on the other hand, was masculine: the control of the instinctual drives.

Jung did not think that the unconscious was limited to only those parts of the individual psyche that we have denied due to factors of upbringing. Jung saw the mind or psyche as consisting of three structures: consciousness or ego, personal unconscious, and collective (or transpersonal) consciousness. *Consciousness* is the part of the psyche containing conscious memories, perceptions, thoughts and feelings. The *personal unconscious* contains individual thoughts, memories, and experiences that have been forgotten, repressed or suppressed. These unconscious memories and experiences, according to Jung, become grouped into *complexes* or patterns based on common themes. And lastly, the *collective unconscious*, Jung believed, contained not only the repressed contents of the personal unconscious, but also memories from the cumulative experience of past generations.

Archetypes refer to the universal, primordial images or thought forms that serve as the building blocks of the collective unconscious. The unconscious, in his view, contains many elements that could not have been arbitrarily repressed.

According to Jung's theory, the infant, who does not yet have a differentiated, conscious ego, is in touch with

the collective unconscious. The content of this aspect of the unconscious contains archetypal imagery common to all humanity. As the being grows, consciousness differentiates from the collective unconscious—i.e., the collective unconscious is repressed. This element of Jung's theory took Freud's essential discovery and added dimension to it. He stated that "repression of the collective psyche is the first major stage in the development of the individual personality" (in Homans, 1979, p. 100). The individual *persona* develops—a disguised or masked attitude—conforming to the social definition of the person. In a therapeutic context, or in personal life, Jungian work may effectively trigger a breakdown of the *persona*, letting in a flood of collective material. The assimilation of collective material allows for a deeper sense of individuality and understanding of self to develop. If this does not happen, lasting identification with the *persona* often leads to psychological crisis in midlife.

The natural, spontaneous process of the psyche that leads the person towards self-fulfillment and self-revelation was described by Jung as *individuation*. This is a process of integration, unfoldment, and maturation, parallel to the physical process of growth and aging. "Individuation means becoming a single homogenous being, and in so far as 'individuality' embraces our innermost, last, and incomparable uniqueness, it also implies becoming one's *own self*" (in Jacobi, 1973, p. 106). In Jungian terms, the archetype of the Self is the archetype of wholeness; and it is the Self that leads or pulls one toward transformation or "union with God," as it is described in some spiritual traditions. Paradoxically, in the process of individuation one finds one's unique expression of the wholeness of the Divine. A person

does not become selfish or narcissistic, but instead embodies his or her unique nature as related to the whole.

The initial work inherent in Jungian psychology requires one to recognize the superficial nature of the *persona*; later, one needs to come to terms with the shadow. In this regard, every archetype that Jung found to appear in dreams and myths has a particular shadow expression that arises when the qualities of the archetypal energy are repressed or denied. While he observed that the shadow includes "contents of the personal unconscious that derive from one's relationship to one's parents" (in Homans, 1979, p. 104), he also perceived it as a collective phenomenon. Jung, therefore, made the distinction between the personal shadow and the collective shadow, something that may be discerned within the culture-at-large.

Facing and integrating one's shadow is a process of some proportion. Such integration involves acknowledgement and synthesis of negatively perceived parts of oneself, the withdrawal of projections, and the allowance for greater openness to the collective unconscious. The shadow is a split-off part of one's being that still remains attached—like a shadow. It is our dark side, which develops as we disown the parts of ourselves we learn are unacceptable (e.g., through object relations).

But the shadow may also refer to positive qualities that have been disowned, and which may allow for increased expression of a persons innate potential if acknowledged and integrated. Jung states (in Jacobi, 1973, p. 113):

> If the repressed tendencies, the shadow as I call them, were
> obviously evil, there would be no problem whatever. But the

shadow is merely somewhat inferior, primitive, unadapted, and awkward; not wholly bad. It even contains childish or primitive qualities which would in a way vitalize or embellish human existence.

Work with the shadow may take place through the archetype of the *anima* and *animus*—the feminine and masculine images, respectively, of the other sex that we carry in us. Since the unconscious contents of the psyche are always projected, we experience our shadow and our contrasexual components through others. We gravitate towards others who can receive our projections, and who embody contrasexual traits that we have disowned. (Therefore, we may end up marrying our own chief weakness.) Jacobi (1973, p. 120) says that as long as a man does not know his own shadow, his "whole unconscious will be predominantly feminine, and the converse is true for a woman; everything in it seems to be colored by contrasexual qualities."

Much of Jung's thought is consistent with the understanding of the traditional spiritual path—although he seemed to draw the line at the Eastern notion of non-duality, the non-acceptance of the idea of the ultimate illusion of individual existence (Coward, 1985).

Reich (1897-1957)

Wilhelm Reich was another major innovator who began his work within the theoretical framework created by Freud, later breaking ranks with him. While psychoanalytic technique relies on the method of free association, Reich's discoveries about the functional unity of body and mind

Wilhelm Reich

broadened the understanding of the phenomena of repression. Reich believed that repressed experiences could be accessed through the body. Therefore, his study of repression and its relationship to character can be particularly useful in work that integrates psychological and spiritual approaches.

In *The Function of the Orgasm*, Reich contends that the body produces excess energy, and that emotional health requires that this energy be released through sexuality. Undischarged repressed sexual energy, in his view, is the energy source of anxiety, resulting in neurotic symptoms. In a meeting Reich had with Freud in the psychoanalytic founder's apartment, Freud rejected this idea, as he had by that time altered his theoretical views and now held that anxiety was not the result of (sexual) repression but the source of it. Regardless of which comes first the chicken or the egg, perhaps Reich's great contribution was the demonstration of the biological relationship to psychic processes. He brought psychology to the *body*, and is therefore renowned as the pioneer and father of all contemporary body-centered therapies involving breath-work and hands-on bodywork. He associated pleasure with the unrestricted movement of energy in the body, and unpleasure with its obstruction by repression.

The neurotic symptom is the manifestation of a repressed impulse appearing in a disguised form. Reich proposed that no neurosis could exist without a disturbance of the genital function—a contention that met with great professional criticism. "Surely there were any number of neurotic individuals without such difficulties," his detractors argued. But Reich had a loftier view of what constituted genital health than mechanical functionality. His definition allowed for surrender to the flow of biological energy, free of inhibitions and emotional blockage. Reich noted that his patients' fantasies had a non-genital goal, undoubtedly based on their repressed emotional needs. Reich argued that, for many people, sexuality was accompanied by the fantasy, motivation, or psychic urge to have early-unmet needs fulfilled. This understanding afforded him a useful approach in working with his patients' unconscious conflicts. (In my opinion, the crises that have erupted within contemporary spiritual communities surrounding sexual issues are in part indicative of the emotional-sexual shadow issues of members. This is not surprising given the nature of the emotional deprivations that are commonly experienced as a part of Western cultural upbringing.)

In working with patients, Reich (1973) made a distinction between their neurotic symptoms and the idea of character in a way that Freud did not. With respect to psychoanalysis, Reich said:

> The individual neurotic symptom was explicitly regarded as an alien element in an otherwise healthy psychic organism My later theory of character, on the other hand,

maintained that *there cannot be a neurotic symptom without a disturbance of the character as a whole.* (p. 34)

Character is defined by Alexander Lowen (1958), a student and associate of Reich, as "the basic attitude with which an individual confronts life . . . a typical pattern of behavior . . . a mode of response which is set, congealed or structured. It has a characteristic quality which always stamps it as the mark of the person" (pp. 120-121). In his work, Reich (1973) observed that every individual desired to be free of neurotic symptoms, but resistance developed when the character was challenged. It was as if "the patient's whole personality, his *character*, his individuality resisted analysis. But why? *The only explanation is that it fulfills a secret function of defense and protection*" (p. 148). He states that "economically, the character in ordinary life and character resistance in analysis serve the same function, that of avoiding unpleasure, of establishing and maintaining a psychic equilibrium—neurotic though it may be—and finally that of absorbing repressed energies" (in Lowen, 1958, p. 139). Reich further distinguished an individual character structure that "armored" individuals from the external and internal world, and embodied the neurosis of each individual within it. This armor in turn warded off fear of the reactions incumbent with spontaneous living, and fear of sensations. Yet, Reich did not originate the idea of character. Freud himself had proposed the idea in a 1908 publication entitled *Character and Anal Eroticism.*

While Freud opened the idea of instincts for psychological consideration, Reich's was a voice calling for the natural relationship to them. He believed in replacing moralistic regulation with "sex-economic self-regulation" by

naturally and responsibly allowing for instinctual gratification—rather than struggling against it. To Reich, the "asocial impulses which fill the unconscious are vicious and dangerous only as long as the discharge of biological energy by means of natural sexuality is blocked" (1973, p. 175). (Some traditional approaches hold that spiritual realization occurs through the natural relationship to the body; and that sex, as the most powerful energetic force available to the human being, is potentially transformational in its ability to draw the individual into communion beyond the separative ego state. Reich's belief in a relationship to sex that was free of the suppression of the sexual drive, was the most controversial and "dangerous" part of his theory. To adopt such a view requires a fundamentally different perspective on oneself and the world, which Reich believed was terrifying for the masses. It requires a trust in the basic goodness of the life process—a perspective of the traditional spiritual path.[2] A precept of Buddhism, for example, is that everything has Buddha nature. A full understanding of this principle is not possible in areas where repression functions—i.e., when we are not able to relate with and accept shadow aspects of ourselves.)

As a result of his disagreements with Freudian theory, Reich was expelled from the International Psychoanalytic Association in 1933. In that same year, Reich noticed that a man with homosexual tendencies experienced severe bodily reactions in the course of relaxing his psychic defenses. Reich realized that the man's musculature, in the form of a stiff neck, had maintained inhibition, and that sexual life energy, as well as anxiety and anger, could be bound in chronic muscular tensions. His understanding

of the principle of mind/body unity coalesced in the recognition that physical rigidity represents the most essential part of the process of repression—i.e., that the secrets of the unconscious are held within the body. From this point on, Reich utilized this principle in working with patients. If a patient's psyche would not relax, he worked with the body; and if the body would not relax, he worked with the psyche.

After this discovery, the goal of Reich's work remained the same as it had been before: the awakening of the earliest childhood experiences. However, his method had changed. He was no longer practicing psychoanalysis, but character analysis. He no longer had his patients talk about their hatred, but experience it. He directed them to use deep, rhythmic breathing, and applied hands-on pressure to the musculature in a systematic way, believing that entire muscle groups, not just individual muscles, were affected by the tension from holding repressed feeling. Reich found that loosening the muscular tension not only released energy and emotion, but also memories of the childhood situation in which the repression had its roots. He noted that "every muscular rigidity contains the history and the meaning of its origins" (1973, p. 300). When the armor was dissolved, patients often had an immediate grasp of the historical basis for their feelings and actions, as opposed to the mental understanding offered by psychoanalytic interpretation. He explored the dark side of human nature with clients, and behind it found a "self-evident, decent core" (p. 174).

A further evolution of Reich's concept of character is the system of *types* developed by his students Lowen and

Pierrakos (the founders of Bioenergetics and Core Energetics, respectively). Both approaches may be particularly useful in understanding different kinds of defenses, all having their source in the pain of early childhood. A brief overview of Lowen's and Pierrakos's five main character types follows, offered here to aid in an understanding of different kinds of defenses that may be encountered in the process of spiritual psychotherapy.

Lowen and Pierrakos—The "Types"

The *oral type* develops in response to continuous childhood deprivation, and manifests in the adult as certain excessive needs, such as extreme loneliness, inner emptiness, fear of separation, efforts to gain attention, dependency, and desire for physical contact. These are called oral needs because they arise during the Freudian oral phase, when oral activity dominates life.

Oral characters may feel as if the world owes them a living, and may animate an exaggerated narcissism. In their interpersonal relationships, the other cannot possibly satisfy these oral demands, and so this character may develop feelings of resentment, rejection, and hostility. The repression of hurt and longing in the child whose oral needs are not met often results in premature maturation and early independence. However, the emotional roots of the child are weak. The inability to stand on one's own feet is characteristic of this type.

The *masochistic character* structure commonly forms when the child has been deeply humiliated through suppression of his or her developing independence by the parent's overprotectiveness and over-concern. The child's

ego has been crushed, although not through a form of outer hostility. Masochistic individuals have been more covertly invaded and controlled. For example, they may have had their sentences finished for them. Only when the struggle against such outside interference is given up can the masochistic character develop. With submission, all activity becomes oriented toward gaining approval.

The masochistic person often feels worthless. His or her fear of self-assertion and reaching out is generally accompanied by feelings of self-doubt that result in withdrawal before an objective is reached. This type may be a hard worker, owing to the deep need for approval, but his or her efforts generally collapse in failure.

The concept of the death instinct came in part from Freud's observation of masochistic tendencies. Reich, however, rejected this theory, believing that this type does not truly wish to be beaten or defeated, but instead longs for release. The musculature holds back energy and feelings, and tension increases to the point of bursting. The masochistic individual seems to want to be beaten so that he or she can get relaxation without having to be responsible for it.

While oral and masochistic characters are referred to as pre-genital types, since the major determining influences have occurred before the phallic stage of development as defined by Freud, the dilemma of the *rigid type* is rooted in the Oedipal period. The rigid individual's issue often develops as a result of the frustration of strong feelings of love for the parent of the opposite sex. Having been somehow rejected and hurt through the need to experience love, the child stiffens and limits openness. The child reasons

that if one does not give in to feelings of love then he or she cannot be hurt. Other character types may experience a great amount of muscular tension, but the rigidity of the chest and abdomen, according to Pierrakos, determines the armor of the rigid type.

Pride and determination act as protective masks covering early childhood pain, defending against the possibility of being hurt again. Rigid types may be successful achievers, but authenticity is generally lacking. The denial of emotional needs manifests as an emotionally-repressed deadness, isolation, and lack of contact with oneself and the world. Pierrakos (1987, p. 99) notes that "the pattern of defense in this character formation rests on a denial of the receptive operation."

The *aggressive type* expresses himself or herself with tremendous intensity. The characterological posture is one of superiority, an illusion behind which lurks the fear of collapse and defeat. The aggressive person experiences the strong need to subdue as a means of defense. Betrayal is a main theme for this character type, which usually has its roots in the seductive manipulation and inconsistent behavior of parents. The child may have aligned with and fought for the "good" parent of the opposite sex, against the "bad" parent of the same sex. But the parents may have been using the child to fulfill their own needs. Relationships with the opposite sex for the aggressive type often involve betrayal.

Aggressive characters often feel that they are fighting for what is right, but "their aggressive behavior brings aggression back to them wherever they turn ... These people erroneously think that their life task is leading the fight

for some great cause" (Brennan, 1993, p. 229). Often they take on more responsibility than they can handle, which is something that they learned to do at an early age. Working long hours and assuming massive responsibility becomes necessary in order to control others—which is something they are driven to do.

The *schizoid type* often comes from a disturbed home environment in which the child feels an unconscious hatred from the mother. Lowen (1967, p. 38) states that the effect on the child is "one of fear that any demand it makes could lead to abandonment or destruction. In turn, the child develops a murderous rage against the parent, which is equally terrifying." The distortion of self-perception is one of the dominant features of this type. The schizoid state denies reality, which is unbearable, and involves the loss of body feeling and retreat into a world of images and fantasy. In adult life, such individuals may retain the illusion that their existence depends upon finding a loving mother figure. Such illusions—like the Cinderella fantasy in which a woman obsesses over a male Prince Charming whom she hopes will recognize and save her—may offset painful feelings of worthlessness in the schizoid individual, and the conviction that no one would want to be in relationship with him or her.

Like every psychological or spiritual system of "types," the Core Energetics/Bioenergetics model describes each character as a distinct and pure type. The reality is that any given individual can have several of the character types at play in their psyche, although one will generally predominate. Knowing one's predominant character type can be very useful in objectifying the struggle with character distortions

that can feel *entirely* personal. We realize our psychological defense was formed in reaction to a specific hurt, and that there are many others in our shoes. The next step is to be able to distinguish *who* we are from *what happened* to us.

ALICE MILLER

Alice Miller, trained as a psychoanalyst, is a contemporary author who has written groundbreaking books on the subject of child abuse and the profound repercussions of repression in adult life and in the world-at-large. In *The Drama of the Gifted Child* (1981) she outlines some of the fundamental assumptions of her work, which are largely consistent with the ideas of object relations theorists.

According to Miller, the child looks to his or her parents to receive the love, guidance and validation of existence that he or she needs and rightly deserves. Miller calls this need of the child "healthy narcissism." If the parents are to provide this for the child, they ought to have received such regard and respect *themselves* as children. Parents who have not experienced this will not only be unable to give it to their child, but will, in fact, be looking to fulfill their own early unmet narcissistic needs through their children. The shadow of such parents can show up in beating or seducing a child in the attempt to have repressed needs met. Physical and sexual abuse is extremely prevalent (and widely under-reported) in our culture—evidence of aspects of the collective shadow prevalent in Western society. Since a child's survival is dependent on the love and care of his parents, the child will adapt and do whatever is required to avoid losing his or her very sustenance.

Miller contends that psychoanalytic theory is entwined

with the cultural belief that the child, and human nature in general, is inherently wicked and must be mastered "for its own good." She disputes central tenets of Freudian theory, including concepts of the death instinct, Oedipus complex, and infantile sexuality; and contends that children's innate desire for physical closeness, caressing, touching, warmth, and pleasurable physical sensation does not equate with sexuality. Miller's observation (1990, p. 48) is that "we have learned to feel guilty about our desires and needs, and we introduce this fundamental perception into our theories."

Alice Miller renounces the value of psychoanalytic theories, which she believes are used as protective shields—preventing necessary confrontation with the reality of child abuse in its many overt and covert forms. She asserts that explanations offered by psychoanalysts keep patients from the potential healing of acknowledging the feelings associated with their childhood traumas. Psychoanalytically-trained individuals themselves, in her view, unconsciously conspire in this way to keep from being reminded about their own pain.

Miller observes that as long as "feelings can be talked *about*, they cannot really be felt" (p. 183), and states that through his method of free association, Freud created a technique that effectively reinforced repression. She concludes that, since the experiences of early childhood occur as physical sensations and feelings, it is critical that these sensations and feelings be accessed before therapeutic work can be integrated into one's life. She contends that a therapist can most usefully function as an "enlightened witness," providing a safe space for emotional growth to occur, rather

than by teaching or supplying theoretical interpretation.

In *Breaking Down the Walls of Silence* (1991, p. 86), Miller describes the horror of the early lives of various criminals, including Hitler, Stalin, and Ceausescu. She argues that "the unconscious compulsion to revenge repressed injuries is more powerful than all reason," and believes that every murder inflicted on innocent people is an expression of this compulsion and the need to keep the associated feelings in a state of repression. Murderers almost always describe the sadistic acts they perform, and the horrific experiences of their childhood, without feeling—i.e., devoid of emotional involvement. Therefore, she contends, "millions of people had to die so that Adolf Hitler could keep his repression intact . . . millions were humiliated in camps, so that he should never feel how he was once humiliated" (p. 92).

Being cut off from what Miller terms one's "authentic self" results not just from physical violence, but also from the psychic and emotional anguish that children often suffer silently within their family systems. She writes that for a child, "accusations against parents are often associated with mortal fears, not only because of real threats but because a small child feels he is in deadly danger if he loses the love of the person closest to him" (1990, p. 99). Miller describes the individual's need to idealize his or her parents, clinging to the illusion of a happy childhood even when that may not have been the case. She states that legitimate anger towards parents, when repressed, may show up in the forms of disease and addiction; and notes how aspects of religious teaching also support the function of repression. For instance, one may learn that sexuality is to be suppressed and that feelings should be denied in order

to honor one's father and mother. When criticism of parents is considered sinful and inappropriate, strong feelings of guilt will naturally result. The message that is communicated is, "Thou shalt not be aware." Miller, a former psychoanalyst, notes the absence of psychological literature on the subject of parent's need to beat their children in order to keep their own trauma repressed. She regards "the moral demand for reconciliation with parents as an inevitable blocking and paralyzing of the therapeutic process" (p. 154).

In her professional work, Miller has found it unusual for individuals to directly experience the repressed emotional hurts of childhood through memory. Instead, this pain is generally provoked through the process of transference. Individuals we relate with in present time stir up early childhood feelings by nature of the way that they represent significant figures from our past. Reliving these emotions, without idealizing those who were instrumental in calling them forth by inflicting wounds unjustly, is an essential part of the process.

Alice Miller brings the consideration of repression into the present, and spotlights the current forms of the shadow within Western culture. In applying her theories to the spiritual path, it can be seen that one may use spiritual ideas as a defensive shield that keeps one away from repressed pain. If repression of deep emotional hurts is a strong motivating force in the unconscious, psychological frustration on the spiritual path is probably inevitable.

In my opinion, psychological disturbance may be a gateway to the spiritual—to something beyond the fixed way we view ourselves and experience life. Although individuals seem to turn to or stumble upon spiritual traditions and communities because of something they did not receive in the early years of their lives through their families or the culture, I think there is also an archetypal quality to the spiritual search (beyond the psychological issues we seek to unravel), which has to do with the deep unconscious need to discover who one is and why one is here. Despite resistance to the obvious pain of the discovery process, something in us will not rest until, organically and non-conceptually, we uncover the truth.

CHAPTER 2

Traditional Spiritual Paths

Even if the shadow of repression is brought to light and addressed therapeutically, the underlying dilemma of the impermanence of human existence always lurks in the background of individual awareness. Psychotherapy can address many problems of the ego, but it cannot resolve the problem of the death of the ego identity itself.

While it is evident that anyone born is destined to die, we generally do not look directly at the reality of death. When we are forced to face it, we sometimes wonder how life can be so cruel. Death is rarely confronted honestly and openly in Western family systems, and shadow feelings form around the existential dilemma that humans have for aeons sought to ameliorate. We basically live in illusion— we obsess about ourselves as the center of the universe, yet avoid dealing with the significance of mortality (a subject that has propelled mystics into an unqualified spiritual search). Through the belief systems, achievements, children,

or noteworthy contributions we attempt to leave behind, we hope to give our lives some lasting meaning and permanence.

Mainstream religions more often provide a buffer against the unrelenting pain of this human dilemma. They teach that we can be saved, and that heaven can be attained through linear adherence to doctrines and ethical codes. For his part, Freud felt that doctrinal religious ideas were grounded in the fears and wishes of childhood. As Wulff (1991, p. 17) renders Freud's view: "God the Father is a re-creation of the omniscient and omnipotent father of infancy, who first inspired the love and fear that characterize the religious devotee's attitude toward the divine." Freud thus theorized that we are moral and obedient in the hope that an imaginary God will take care of us if we are good children. In *The Future of an Illusion,* he observed that religious dogma concerns facts that are unrelated to scientific reality, about things individuals have not personally discovered. Here he referred to the conventional view of an afterlife with a Supreme Being who is separate from us.

The Mystical Path

In contrast to the doctrinaire approach, a different perspective is provided by the spiritual path as it is traditionally understood. In this context, spiritual path refers to the mystical side of a religion, and is based on a core understanding that is common across many varying traditions and cultures. This understanding involves the absorption of apparent individual consciousness in a state of being that transcends the ego function.

Some mystical paths hold that God exists in both

personal form (as the individual teacher or guru who has been fully transformed, and therefore is identified with the universe, not just the separative ego), and impersonal form (as the totality of the cosmos on all physical and subtle planes of existence). Other traditions, such as Buddhism for example, do not speak about God at all. Some teachings describe existence or reality as illusion, as an infinite variety of impermanent phenomena that we become fascinated with when we become identified with the separative ego. These may speak of the need for "detachment" on the path. Others hold that the world is real, the sole form of the Divine that we must relate with directly. These may suggest that we are irrevocably attached to the Divine, and that practice involves surrender to "what is." Some mystical approaches refer to the process of becoming Divine, while others emphasize the importance of becoming completely ordinary in the human sense. Most traditional spiritual paths hold that our separate ego identity is a passing illusion, yet they assert that who we are prior to the ego identity of this life *has always been* and *will always be*. Spiritual realization has historically meant the experiential (as opposed to theoretical) knowledge of the illusion of the separative ego identity, and the simultaneous identification with the inherently divine totality of existence.

Freud called the mystical experience "oceanic," saying that it represented a desire to return to the womb. But, while it is true that comfort may be sought through a naive and superficial approach to the mystical understanding of the spiritual path (and that this is common today), nonetheless, the burning mystery of traditional spiritual life is not so easily dismissed. Those who traverse the path deliberately

invite the undoing of the illusory "I" by being willing to grapple with the ideas of the teaching that undermine their basic assumptions about who they are. Individuals whose lives bear witness to mystical experience—of merging with God and/or seeing the perfect nature of all existence—have appeared in every tradition.

In *Magical Child*, author Joseph Chilton Pearce describes the hologram as "a kind of photography that contains the entire photograph within any part or piece of the whole" (p. 6). If a holographic image is broken, each piece contains not a part of the whole, but the whole picture itself. Likewise, mystical adherents of various spiritual traditions have asserted that we are not ultimately independent, mortal entities, but inseparable from the whole of creation. This paradoxical, abstract view of identity, which some realized persons have expressed in terms of their oneness with God, is beyond what the mind can grasp.

Maslow (1964) states that the nucleus of the known religions has formed around the private, lonely, personal illumination, revelation, or ecstasy of some acutely sensitive prophet or seer. Each religion then draws its validity, its function, and its right to exist from the codification and the communication of this original mystic experience or revelation from the prophet to the mass of human beings in general.

Unfortunately, the masses are generally unable and unwilling to understand the communication of mystical experience—as such understanding would be utterly threatening to the ego's presumed existence. The essence of the religion is therefore distorted, as beliefs and codes of conduct replace the deeper context.

Most religions, therefore, evolve both an exoteric and an esoteric perspective. The common exoteric path consists of belief systems and practices based in the assumption of separation from God, and the necessity of being saved. The esoteric path, which belies such separation, considers that God or ultimate truth is found in the often painful reality of life "as it is." Feuerstein (1990, p. 175) observes that:

> Death . . . is the termination of the mind-created illusions by which we maintain ourselves throughout life. It is the end of all meaning, because it is the obliteration of the subjective source of that meaning—the ego-personality. To face this irrevocable fact squarely is the challenge on all genuine spiritual paths.

Evelyn Underhill (1974, pp. 416-443) describes two forms of mysticism: impersonal, or deified—a state in which a transmutation of the self through union with God occurs—and personal, in which the self is lost in love for the Other. The fourteenth-century Christian mystic, Meister Eckhart, exemplifies the former type when he says, "If I am to know God directly, I must become completely He and He I: so that this He and this I become and are one I" (in Underhill, 1974, p. 420). The latter type is illustrated in the bridal mysticism of Teresa of Avila, who expresses the mysterious delight of feeling one with God. "He has thus deigned to unite Himself to His creature: He has bound Himself to her as firmly as two human beings are joined in wedlock and will never separate Himself from her" (in Underhill, 1974, p. 139).

Mystics in many different times and places have been martyred for expressing their experiential understanding

of unity. In contemporary Western culture, where mystical reality is commonly lacking, variances from the conventional religious norm are more likely feared, perceived as evidence of madness, labeled "cultic" and broadcast on the evening news like a sideshow spectacle. This perspective is reinforced by certain deluded individuals who have gathered followers around extremist spiritual beliefs, sometimes engaging in violent or suicidal activities.

Nonetheless, the core understanding of the mystical traditions has endured, namely that the ego cannot be saved because the ego is an illusion—a mental construct with no fixed existence. According to mystical understanding, the illusion of ego is the case not only for the great teachers, but for everyone.

Beneath the psychic structure of the mind is pure consciousness, the constant, eternal ground of all phenomenal experience. Those who realize their *real I* communicate an inherent love for all creation (i.e., for other aspects of self), along with their context of surrender and service to the life process as it is. On the spiritual path, the way of realizing that we are "everything" is to realize the emptiness of ego identity—i.e., that we are nothing, not in the sense of having a poor self-image, but rather that the separate self that struggles to survive is an illusion.

Spiritual "Work" is Work!

The esoteric spiritual traditions hold that identity with God is already the case, and that nothing needs to be attained. Salvation exists for us *as we are* in the present. Therefore, all of our efforts to survive are confused and misplaced, as our continued existence is assured—though not in the

egoic sense. Since the ego is not something substantial, death as we normally conceive and fear it is an illusion. This ecstatic realization of transcendent, "immortal" identity through union with God has characterized the origins of many spiritual traditions, and has re-enlivened the path throughout history when affirmed by subsequent realizers.

The bad news is that *we must work* to uncover such existential truth for ourselves, and that the illusion of egoic identity and accompanying primal drives must first die in order for us to tacitly know who we are. This is no hollow philosophy, but a discomforting approach to egoic life that requires an uncommon type of personal work that we can gradually mature into. As aspirants on the spiritual path, we grow in relation to understanding the projections of ego by acknowledging and then inquiring into the nature of our self-referenced emotional realities. We cultivate the ability to be with "what is" by the ongoing practice of openness and surrender to life. We learn that it is not a matter of killing the ego and our various urges, which continue to have their place, but of relaxing and trusting the unfolding life process—accepting that things *are* as they should be. We allow the basic goodness of our intuition to lead us into the unknown. Transformation, then, refers to a metamorphosis of being, whereby we become who we are in truth—not by the manipulative manufacturing of what we *think* we need, but by allowing life to design the work that is needed in the moment. The person dedicated to transformation will endeavor to bring awareness to all ongoing work, whatever it may be. At the same time, we remember that we are complete just as we are in the present. The fact that we experience times in which we may not know ourselves

is just as much "God" as moments of pristine clarity and knowing.

But this is more easily said than done. The raw power of ego's identification with the self-concept (and disidentification through the shadow of repression) cannot be denied, although we may notice the mind's attempt to do so at times, presuming Self-knowledge through spiritual self-deception. We must work consciously to not fall asleep within the illusion, once we have intuited or genuinely experienced something beyond it. Furthermore, as our commitment and intention on the spiritual path grows, challenging circumstances seem to conspire to bring us into more direct contact with the pain of attempting to maintain or inflate the impermanent ego. In terms of object relations theory, the need to maintain the fixed definition of ourselves, constructed upon the foundation of a psychic structure formed in childhood, is the basic misunderstanding of identity and the source of suffering.

Only experience can give the individual the tacit knowledge that the attempt to fix the ego identity obscures the truth. In my experience, this knowledge is most readily acquired through human contact with those who have undergone a genuine spiritual process of transformation themselves. Association with such rare individuals is not a matter of adopting a comforting philosophy, but about a probing inner examination that challenges our notion of who we are. From many different traditions it is obvious that genuine teachers, by the nature of their understanding, will catalyze a confrontation with primal issues in students in various ways. Some teachers will undertake this confrontation in more conventional ways and others

in less, depending on the way their personalities and dispositions are used by the spiritual process. Furthermore, I think it is reasonable to conclude that less-transformed teachers exist who can still provide useful and important influences on the path, while a wide variety of pseudo-spiritual teachers offer only more confusion and examples of separation as they parade in the self-deception of shadow motivations.

Teacher-less paths are popular too. Despite language that asserts esoteric rhetoric, some such paths may subtly affirm the hope for ego existence and survival in an ethereal form; while others may be the vehicles for practitioners to enter into a more profound relationship to self. In all cases, there is the calling to work through the shadow as a primal block to continued spiritual unfoldment.

On the path, everything must be tested, and nothing taken for granted if we are to truly prove the validity of the teachings for ourselves. Along the way, as we have previously noted, we are certain to encounter our childhood-rooted shadows. However, some Eastern spiritual approaches hold that our primal issues go back much further than the events of childhood experience. The concept of *samskaras*, for example, refers to memories of former lives that are impressed in consciousness, and draw us to seek resolution in our present circumstances. Regardless of the origin of the shadow, we must honestly and courageously acknowledge the truth of whatever we discover on the path.

A consideration of various teaching elements within several of the great spiritual traditions, which follows, will hopefully yield some insight into the esoteric view of identity on the path.

The Traditions

HINDUISM

Hinduism encompasses a wide variety of religious beliefs and practices. Unlike most of the other world religions, Hinduism is not based on the life and teachings of a single individual. The universal truths of Hinduism, named for the people and culture of the Indus River region in India, have been passed on orally for over 10,000 years. Eventually, sacred teachings were written down and compiled into the world's oldest spiritual texts, known as the Vedas. The *Rig Veda* is said to have been written in about 1400 B.C.E., and another collection of Vedic philosophy, the *Upanishads*, was compiled between 500 B.C.E. and 200 C.E. Spiritual texts known as the *Sutras*, containing directions for Hindu priests on how to conduct religious ceremonies, and the *Sastras*, ethical considerations of spiritual conduct, were also written during this time. A trend towards devotional practice or *bhakti* developed and was outlined in writings known as the *Puranas*. The great Hindu epics, including the *Mahabharata*, the *Ramayana* and the *Bhagavad-Gita* contain this devotional attitude toward God in the personal form (e.g., Ram or Krishna).

Because of the purity of their lives and their spiritual power, numerous individuals have been recognized as God-realized beings within the Hindu tradition, which also worships thousands of gods and goddesses as aspects of the One.

In Hinduism, Brahman is generally understood to be the absolute Reality or God, manifesting through every form, and in formlessness. *Maya* refers to the mind's illusion of the phenomenal world; to the assumptions we make

about the appearance of the universe that are superimposed onto Brahman as the play of the Divine. What we see as "the world" is really only an interpretation we make through the *maya* of ego consciousness. The Hindu metaphor utilized by the seventh century adept Shankara in his *Crest Jewel of Discrimination* illustrates this principle: In looking at a coil of rope, we imagine that we see a snake. Beneath this illusion of a separate ego relating to differentiated phenomena is the truth of non-duality, of merged existence with Brahman.

Hinduism regards only one thing as eternal—the deep consciousness present throughout all experience in time and space. This is known as the *Atman* or the Real Self within the individual being, and is realized when the *maya* of ego disappears or is transcended. Tradition holds that the *Atman* is purely evident in the case of an infant, or in deep sleep when the experience of an individual self does not exist. Enlightenment occurs with this tacit, waking realization of one's true identity, the Real Self. The *Atman* within is then known as Brahman without—"one without a second"; the personal merging with the impersonal. Of course, we can only imagine what this experiential state is like, but esoteric Hinduism asserts that this Self-Knowledge is our destiny, and the current fact of our true identity beneath the *maya* of ego.

Traditionally, there are many paths to God in Hinduism: *bhakti yoga*, *jnana yoga*, and *karma yoga* among the most predominant. *Bhakti yoga* involves realizing God through devotional love for the "other," for the ego can be lost in true and consuming love. Working selflessly, by regarding all efforts as service for God (who manifests as all beings),

and without concern for personal success or failure, praise or blame is the way of *karma yoga*. *Jnana yoga* is the path of knowledge, in which the reality of union with all phenomena is considered ongoingly in the midst of the *maya* of mind's dualistic experience. *Raja yoga* is yet another way—one that combines elements of the other paths and uses meditation and psycho-physical exercises to tame the mind and realize the Self. In practice, the path may include many different yogas, although one generally predominates. As in other traditions, the most transformative element is often one's ability to open to and receive the transmission of a real teacher's organic understanding, which deeply challenges the ego's assumptions.

Concerning the realization of our union with the Self (i.e., our non-dual identity), *Katha Upanishad* states:

> He is one, the lord and innermost Self of all; of one form, he makes himself many forms. To him who sees the Self revealed in his own heart belongs eternal bliss—to none else, to none else!

BUDDHISM

Buddhism is founded upon the life and teachings of the Buddha—Siddhartha Gautama—who was born in Nepal around 563 B.C.E. He was born as a prince, into a situation in which all of his worldly needs were satisfied, and was shielded from the world during his early years. Legend has it that when he finally came upon the reality of suffering in the world he was so moved that it catalyzed his search for truth. At about the age of twenty-nine he left his abundant life behind, including his wife and child, and took up the extreme ascetic practice of a forest dweller, in the hope

that it would bring about enlightenment. When the futility of this exceedingly austere discipline became evident to him, he abandoned this approach and practiced according to what he came to describe as the "Middle Way"—characterized by neither extreme asceticism nor indulgence.

One evening, sensing that the moment of truth was near, Gautama sat underneath a tree along the bank of a river near Gaya in India and vowed not to get up until he experienced enlightenment. At the age of thirty-five, the transformation he had been yearning for completed itself, and thereafter he was known as the Buddha, the "Enlightened One."

Buddhism had its roots in Hinduism, but much of what Buddha taught was in response to distortions and adaptations of true spiritual understanding that had become prevalent in conventional Hindu practice. He denied the existence of an *Atman* or soul which continued as a separate entity between lifetimes. Nevertheless, he also agreed that there was a karmic causative factor behind patterns of activity that occur in the present. Buddha spoke about the state of nirvana, in which the boundaries of the finite self are extinguished, describing it as "incomprehensible, indescribable, inconceivable, unutterable."

Buddhism affirms no God—at least not in the dualistic way in which God is commonly imagined. Esoteric Buddhist practice examines life and exhorts individuals to find the truth for themselves. On his deathbed, the Buddha is supposed to have said to his disciples, "Work out your enlightenment with diligence."

Buddha's first teaching after his enlightenment was that of the four Noble Truths—*the truth of suffering*, the *origin of*

suffering, the *goal*, and the *path*. Suffering refers not only to the painful experiences of life, but also to the subtle underlying sense that something is not quite right. The origin of suffering has to do with our misidentification with the ego and its desires, struggles, and dissatisfactions. The Buddha taught that the ego is composed of five *skandhas* or aggregates—body, sensations, thoughts, feelings, and consciousness—but that it is nothing substantial or permanent. Our attempt to make it so is suffering. The *goal* of this spiritual tradition is the realization of an intrinsic state of consciousness—an all-pervading "buddha nature"—which is seen along with the illusion of the limited ego identity. The *path* refers to the transformative process, which ultimately relaxes the ego's primal drives for survival—in accordance with right views, intent, speech, conduct, livelihood, effort, mindfulness, and concentration (i.e., the Eightfold Path).

Several different forms of Buddhism took shape after the Buddha's death, and are practiced today. These include Theravada, Mahayana, Zen, and Tibetan Buddhism. Theravada is a discipline in which the emphasis is more on one's individual practice. Mahayana combines compassion and wisdom in *bodhisattva* practice, through which one vows to forego *nirvana* in the interest of serving other sentient beings. Zen, heavily influenced by the Buddha's way of having silently communicated and transmitted enlightenment, is characterized by sitting practice that reveals the teaching of inner emptiness. Tibetan Buddhism, which contains several "vehicles" or paths—like the *mahayana* approach of compassion—also has a strong *tantric* branch, commonly called *vajrayana* practice. The path of *tantra* will be discussed

later as a prime example of a path that deals directly with shadow elements.

In the *Diamond Sutra*, Buddha states: "The distinguishing of an ego-entity is erroneous. Likewise the distinguishing of a personality, or a being, or a separated individuality is erroneous. Consequently those who have left behind every phenomenal distinction are called Buddhas all."

<h2 style="text-align:center">JUDAISM</h2>

Jewish mystics throughout history—from the prophets of the Bible to the Jewish Sufis of the thirteenth century, the Kabalists, and the Hasidim who arose in the eighteenth century in Eastern Europe—have sought union with God.

The ancient people living in the land of Israel produced scriptures based on the mythology revealed by the Torah, which initially referred to the five Books of Moses (Genesis, Exodus, Leviticus, Numbers, and Deuteronomy), and later to the whole body of accepted written and oral revelation. A defining moment in Jewish history occurred with the destruction of the capital city of Jerusalem in about 586 B.C.E. by the Babylonians. Many Jews resettled in Babylonia, which shortly fell under Persian rule. Some Jews returned to their homeland, and the Temple was rebuilt. But the Romans, who by the time of Christ ruled the entire Middle East, put down a Jewish rebellion and destroyed Jerusalem again in 70 C.E. This second destruction marked the Jews as a distinct religious and social group without territorial boundary, living within Christian and Islamic lands. With the conquest of the Near- and Middle East and North Africa by the Muslims around 640 C.E., the Jews were a tolerated minority within various countries, free to prac-

tice their religion and maintain separate group values.

From the eleventh to the fourteenth centuries Jews with mystical orientation gravitated toward Sufi writings. Jewish mystics within the Sufi tradition became known as *Hasidim* (devotees or pious ones). This movement, and the Hasidic Ashkenaz movement that arose in thirteenth-century Germany was not, according to Caravella (1989, p. 14) "connected historically with what later became known as Hasidism—the ecstatic religious movement which began in eighteenth-century Poland." Caravella notes that they foreshadowed many of its elements, particularly the emphasis on devotion, spiritual inwardness, and personal experience of God.

Kabalah, which means "receiving" or "tradition," refers to certain Jewish mystical writings dating from about the thirteenth century. Surprisingly, this system is the focus of Freemasonry and other secret societies, which believe in a mystical knowledge handed down over ages. Most Kabalistic work reflects a cosmology of the nature of God and the structure of the universe, as opposed to a devotional approach in seeking the knowledge of the divine.

Robinson (1994, pp. xvii-xviii) discusses Kabalistic ideas, noting that God is fundamentally unknowable to humans. Eyn Sof ("without limit") is the name given to this fundamental Divine Reality. Emanations issued from Eyn Sof, producing a system of ten *sefirot* (personal aspects of hidden God), which taken as a whole, describe God as experienced by human beings.

> The first sefirah to be emanated, called Keter ("crown") marked the transition point between Eyn Sof and the sefirotic system. The next two sefirot, Hokhmah ("wisdom")

and Binah ("understanding"), represented a male and female principle, respectively. Hokhmah and Binah, in union, produced the seven other sefirot, Gedulah ("greatness") or Rahamim ("mercy"), Gevurah ("might"), Tiferet ("glory"), Nezah ("triumph"), Hod ("splendor"), Yesod ("foundation"), and Malkhut ("kingdom") . . . Though the Kabalists asserted that all of the sefirot were interrelated and, indeed, that all were One, nonetheless they tended to concentrate their attention on the relationship between two sefirot in particular: Tiferet and Malkhut. Tiferet was seen as the central sefirah and a male principle. Ideally, it was to enter into union with Malkhut, a female principle which marked the point of transition between the realms of the sefirot and the created universe. Through the union of Tiferet and Malkhut flowed the divine energy which created and sustained the universe.

Judaic mysticism was revived in Eastern Europe at the end of the eighteenth-century with the growth of Hasidism. This occurred during a time of persecution, when a great yearning for divine revelation existed among many Jews. Many *zaddicks* (masters) appeared and attracted disciples. The first Hasidic master was the Ba'al Shem Tov (Master of the Good Name), an uneducated man, in contrast to the traditional rabbi who was typically an intellectual and scholar. The Ba'al Shem Tov taught the importance of attachment to God at every moment of life. Ariel (1988, pp. 175-176) states that:

> Hasidim promoted a new human ideal, the Hasid, as opposed to the scholar, who is intoxicated with the presence of God and who becomes illuminated with God's presence through ecstatic prayer . . . It teaches that only God is truly real. All the phenomena of the world are only vessels that

contain the divine light and have no independent reality of their own . . . Hasidic teaching asserts that there is nothing that truly exists except God's being. The world is really a veil that, if removed, leaves only divinity.

Writings of Martin Buber and Isaac Bashevis Singer have brought recognition to mystical Judaism. Yet the Hasidic movement fragmented, and many centers were destroyed by the Nazi-directed Holocaust. Several small communities relocated and were transplanted to countries such as the United States and Israel.

CHRISTIANITY

Christianity has been in existence for two thousand years, and is based on the life of Jesus, who is believed to have fulfilled a Jewish prophecy by being born as the Messiah. The events in the life of Jesus as they have been written about in the New Testament are well known to most Westerners, and most exoteric practice is drawn from dualistic interpretations of the teaching of Jesus. According to mainstream Christian views, the Kingdom of Heaven is attained by accepting Jesus as savior and following God's law as revealed in the Bible, mediated by the guidance of legitimate Church authority.

By contrast, the mystical aspect of Christianity holds that Christ communicated the same nondualistic truth as all realized beings in the other great traditions, but did it in the unique way demanded by the culture and time in which he appeared. Christian mysticism, therefore, arose out of the contemplation of the life and death of Jesus— who is held to be both God and man. It illuminates the spiritual journey that each soul must take in order to real-

ize its already perfect union with the Divine—a union that has been obscured by "sin" (i.e., the individual's ego-based desires and attachments). The Divine Spirit, which inhabits all form, realized itself in perfection in Jesus. His purity from attachment stood out in stark contrast to the limitations of the ordinary men and women around him at the time, as he showed the way to the Father in Heaven not through commandments and proscriptions, but through an all-embracing teaching of love. His death, a model of the death-to-self that all spiritual practitioners will have to endure in one form or another, "marked the point of transcendence of the human consciousness to the Divine; the point where the human being was totally surrendered, body and soul, to the divine being" (Griffiths, 1982, p. 188). The fact that his disciples deeply suffered with the crucifixion of their Master and underwent their own transformation as a result of their bonded association with him bears witness to the necessity and value of this stage in the spiritual process. After enduring the loneliness of his absence, and living in terror of their lives, his closest followers were "filled with the Holy Spirit" (the manifestation of Divine Love) on Pentecost, approximately fifty days after Easter. As a result, they were endowed with the gifts and fruits of the Spirit, enabling them to eschew old patterns of behavior, and to do the work they had been commissioned to do before their Master's death—to spread his gospel of love to all nations.

The monastic traditions within Christianity have been the primary means of preserving the essential teachings. Jesus began his ministry after having spent forty days in the desert, and he retreated into solitude at different points

in his work. Some believe that he studied and even lived among the Essenes, a monastic community that lived near the Dead Sea during Jesus' time. Apparently, after the death of Jesus, these groups provided many converts to Christianity during its early years.

In imitation of their Master's withdrawal into silence and solitude, as well as a means of escaping the death-dealing influences of a poisonous cultural milieu, the eremetic traditions (solitary hermits in the desert) and the monastic traditions (in communal monasteries) flourished. Such radical lifestyles were oriented toward the realization of union with God, and participants occupied themselves in prayer, fasting, and good works—praising the One through contemplation, chanting the psalms, and practicing charity toward others. Thomas Merton explains:

> We listen to the depth of our being, and out of this listening comes a rich silence, the silence of God, which just says "God" or "I am." Now this is something! (1992, p. 15)

The Benedictines, the Cistercians (Trappists), the Franciscans, the Dominicans and scores of lesser-known orders of monks and nuns have each undertaken various roles in the preservation and celebration of the Divine mysteries initiated by Jesus. Contrary to the understanding of many Christians, numerous concepts and rituals of the religion have deep esoteric meaning. For example, Father Thomas Keating, a Cistercian monk, defines "original sin" as "a way of explaining the universal experience of coming to full reflective self-consciousness without the inner conviction or experience of union with God" (1994, p. 165). The Holy Sacrifice of the Mass, still enacted today, is rife

with profound mystery, most of which is probably lost on attendees. In Catholicism, the doctrine of Transubstantiation explains that the literal *substance* of the bread and wine used in the Eucharist (Holy Communion) during the Mass is changed into the *substance* of the body and blood of Christ, even though the forms of bread and wine remain. After all, Jesus himself had instructed: "Truly, truly, I say to you, unless you eat the flesh of the Son of Man and drink his blood, you have no life in you" (John 6:53). This transformative possibility of relationship to the God-man, and his ability to imbue rituals and artifacts with his presence have been similarly communicated by adepts in others traditions throughout history.

A mystical interpretation of Christianity holds that the Gospels can be read on many levels, and beyond instruction on practical charity contain encoded teaching about the nature of the inner life. Some scholars have wondered if the *Gospel According to Thomas*, discovered in Egypt and identified in the 1950s, might not contain a more authentic version of some of Jesus's sayings than similar quotations contained in the four Biblical Gospels. Some of the material in Thomas, which is a compilation of quotes, not a narration as are the other Gospels, was probably written before 120 c.e.—and is thought to be based on more ancient sources. In it, Jesus says:

> The Kingdom is within you and it is without you . . . When you make the two one, and when you make the inner as the outer and the outer as the inner and the above as the below, and when you make the male and female into a single one . . . then shall you enter the Kingdom.

It is apparent in the Gospels that his disciples did not understand much of Jesus' nondualistic language at the time that he spoke. But Jesus said, presumably regarding the spiritual process, that "there is nothing hidden that shall not be revealed and there is nothing covered that shall remain without being uncovered." From the esoteric perspective, the Kingdom is not a place, but the context in which one is merged with God. When asked when the disciples would be able to see Him, Jesus remarked, in the Gospel of Thomas again, that this would occur when they were able to take off their clothes, put them under their feet as the little children do and tread on them. These words capture the essence of mystical Christianity in that the innocent egolessness of little children is the key to knowing God.

Sufism

Sufism is considered to be the mystical teaching of Islam—which was founded on the revelations which the prophet Muhammad received during his lifetime, beginning in around 610 c.e. Idries Shah (1970) mentions the existence of an esoteric group—which formed about ten years before Muhammad died in 632 c.e.—as possibly having been the first Sufis. The mystical perspective on Islam seems also to have been enlivened a century or two later. The root of the word "Sufi" probably comes from a term that means "wool"—a reference to the coarse clothing that Sufis wore in contrast to finer silks worn by wealthy Muslims. But Shah also notes that, given the Sufi penchant for symbolism, the term may also allude to a contextual distinction between those who have an inner necessity to search for

truth and those who become part of a spiritual movement within a herd. Sufis have given more consideration to the subtleties of inner life, and have drawn their inspiration from the Koran itself—in which Allah reveals Himself as All in All: the outer and the inner. They hold that many levels of meaning are transmitted in the Koran. In Sufism, this seems to be reflected in an esoteric style of teaching in which jokes, tales, and legends with various meanings require "decoding" in order for one to uncover spiritual knowledge of and for oneself.

According to the Sufis, "a certain kind of mental or other activity can produce, under special conditions and with particular efforts, what is termed a higher working of the mind, leading to special perceptions whose apparatus is latent in the ordinary man" (Shah, 1970, p. 14). In particular, Sufis have made use of *longing*, allowing the pain of separation to deepen their love for the "Beloved"—thereby attaining divine union through love. As in other traditions, however, attainment of a higher knowledge of relationship to God requires the transformation of one's assumed identity. Once such knowledge reveals itself, the path involves a return to the ordinary world of duality—but from a different understanding of oneself, so that the teachings can authentically be made available and brought into the world.

Rumi, the thirteenth-century Sufi mystic, extemporaneously recited poetry at times when he experienced being consumed by love—a state which he compared to drunkenness. Much of his poetry is an expression of devotion for the dervish Shams-i-Tabriz, his teacher and link to liberated consciousness.

I drained this cup;
there is nothing, now,
but ecstatic annihilation
were I ever other than this
I regret being born
if forever it is this,
I'll trample both worlds!
and dance
ecstatic
forever!
O, Shams,
I am so drunk!
what can I say,
but I am so drunk
 on love—Rumi
 (In Liebert, 1981, p. 45.)

FOURTH WAY WORK

While not considered a traditional religion, the principles of Fourth Way Work have had an enormous impact on the contemporary understanding of spiritual life and practice. George Ivanovich Gurdjieff incorporated his knowledge of many religious traditions into this unique system referred to simply as "The Work."

Born in the Caucasus region of Russia in the 1870s, Gurdjieff spent his early adult life engaged in the search for truth, although much of his travel and study was shrouded in mystery. In 1915 he began teaching publicly in Moscow and St. Petersburg. During the Revolution, Gurdjieff left Russia accompanied by a group of students and family members, and eventually settled in France where from 1922-1933 he taught a controversial and influential

method of work on self through his Institute for the Harmonious Development of Man. Following this period, he traveled widely and started new groups in several U.S. cities. Gurdjieff died in Paris in 1949. A few of his ideas are briefly considered here.

1. *Essence and personality.* A basic distinction between essence and personality is made by Ouspensky (1957, p. 79), who studied with Gurdjieff (but later left him and taught independently). Ouspensky defines these terms by saying that "essence is what is born into you, personality is what you acquire." Thus, along with physical qualities, certain predispositions, tendencies, and inclinations belong to essence. On the other hand, personality may be said to be learned or conditioned, so as to fit in with culturally accepted norms.

2. *Many I's.* We commonly believe ourselves to have a certain fixed identity—based on our name, the sensations of our physical body, and the crystallized habits we have adopted as parts of our personality. However, Gurdjieff observed that we have not one "I" but a myriad number of "I's" that arise mechanically in response to the surrounding environment. (Therefore, it is said within this system that "man is a machine.") In one manner of speaking, to find our permanent and unchanging "I" is the aim of the Work.

3. *Self-observation.* In the Fourth Way, the beginning of work on self involves self-observation—studying one's impressions and one's "machine" without judgement or analysis. Such observation makes apparent that we are "asleep," that we rarely "remember ourselves," and that we need help to "awaken."

4. *The centers*. Data related to the structure of man—the parts of the human machine—can be observed. Gurdjieff referred to man as a three-brained being, since man possesses an intellectual center and functions, an emotional center and functions, and a moving-sexual-instinctive center and functions. In ordinary man, the centers do not relate harmoniously—one center tends to predominate over the others, and one center often takes on functions that are not its own. For example, a person will often intellectualize rather than emote painful feelings. Gurdjieff taught many methods to effect the right working of centers and self-remembering, including a system of precise movement exercises.

5. *Chief weakness*. An aspect of Gurdjieff's teaching that is of particular interest in our consideration of the shadow is the concept of chief feature or chief weakness. Ouspensky (1957) discusses its place in the formation of personality:

> Chief feature or chief weakness is in false personality. In some cases it is possible to see definitely one, two or three features or tendencies, often linked together, that come into everything like an axis round that everything turns ... (p. 177). They enter into every subjectively important situation in one's life; everything passes through them, all perceptions and all reactions. It is very difficult to realize what this means because we are so accustomed to it that we do not notice it; we are too much in those features; we have not got enough perspective (p. 335).

6. *The fourth way*. Gurdjieff said that traditionally there have been three different religious approaches—the way of the fakir, the way of the monk and the way of the yogi. The

first involves physical mastery of the body; the way of the monk is a devotional or *bhakti* path that utilizes the emotional center, and the way of the yogi, the path of knowledge or *jnana*, works with the intellectual center. Gurdjieff stated that there was another way, a fourth way, in which work on all centers could be addressed simultaneously, within one's ordinary life situation. The Gurdjieff Work is thus considered a Fourth Way approach.

While the language and appearances of the above-mentioned traditions vary greatly, the essence of transformation which the paths all point toward is the same; namely, the realization of the illusory nature of the separate self, coupled with the imperative to grapple with that illusory one and hopefully realize the highest possibility of transcendence.

Mystical Approaches to the Shadow

Exoteric paths frequently view shadow features as bad, as coming from the devil, as needing to be controlled or eradicated rather than suffered. Such approaches assume that a dualistic God hates sin, and that we are inherently evil, and therefore have sinful thoughts and feelings. But the mystical arm of the traditions approaches the shadow from a different context—as something that needs to be tolerated, endured, accepted and transformed.

In the Christian tradition, for instance, St. John of the Cross was deeply concerned for those who were suffering on the spiritual path. In *The Dark Night of the Soul*, he speaks about different levels of darkness—one which applies as beginners come to work more genuinely with their weaknesses, and a more advanced and rare darkness that more

immediately prepares one for divine love. St. John states that at some point the spiritual process "causes deep immersion of the mind in the knowledge and feeling of one's own miseries and evils; it brings all these miseries into relief so that the soul sees clearly that of itself it will never possess anything else" (in K. Kavanaugh and O. Rodriguez, 1973, p. 336).

While realizing that distinctions would need to be made in comparing deep psychological shadow work and the Christian "dark night," there are nonetheless some strong similarities about the processes. Working through the shadow and experiencing the dark night are both rare experiences of extreme purification. Both events are profoundly disturbing—so much so that the individual involved may be uncertain of any remedy. He or she may feel abandoned by God, as the experience may seem interminable and with no way out. In both cases one can be stuck within a hopeless situation that can last for months or years.

If the individual continues in his or her work or practice, however, the degree of openness, freedom, and love which reveals itself when a primal block is finally cracked open, or when one emerges from the dark night, could not have been previously imagined. A life-changing experience has occurred, by the grace of the process. At its end, one's work is not done, but one *knows* that the path is true.

Perhaps the clearest example of a spiritual/mystical path that incorporates shadow elements into its practice is that of *tantra*. *Tantra* arose from within the traditions of Hinduism and Buddhism—although some of the essential elements of *tantric* emphasis, including the feminine nature of existence, sexual forces, fertility, and natural phenom-

ena may date back to prehistoric times. *Tantric* philosophy holds that the universe as a macrocosm is reflected in the microcosm of the human being. According to *tantra*, all the forces in the cosmos can be found in the body, and God or Truth can be known through it. ("As above, so below.") Toward this aim, relationship with all phenomena is accepted—including those aspects of reality that are ordinarily shunned.

In most traditional paths, the focus is on seeing through *maya* or the illusion of the phenomenal world of separative perception. The male aspect of the Divine (Shiva), the consciousness prior to all experience, is sought within oneself. But in *tantra* it is Shakti, the female aspect of the Divine symbolizing creative energy and manifestation, who is worshipped. The energies of the universe are reflected in the physical body, and "lower" separative experiences can be transformed into "higher" unified consciousness. (For example, the appropriate and rightly-intentioned use of the energy of lust can be transformed into love and the dissolution of self in the other.) At this level, *samsara*, or the world of illusion, corresponds to *nirvana*. Heaven exists in the here and now.

The way to realize this truth in *tantra* is through acceptance and work with the energies that are released by facing everything one encounters, including the shadow features on the path. The practitioner embraces relationship with worldly *samsaric* elements as the play of the feminine aspect of the Divine. The energies of sexuality, aggression, and the so-called "dark side" are experienced in a way that allows one to see the reality of his or her relationship to them. One then begins to work genuinely with what is

found. Such an approach can release a tremendous amount of energy that has been repressed on personal and collective levels. This energy becomes fuel for transformation on the spiritual path. Thus, *tantra* can be exceptionally dangerous, as one needs strength and discrimination to be able to handle the intensity of what is encountered within oneself. One must develop the ability to relate with these forces, befriend them by making them workable as opposed to turning away in fear or being seduced by the *maya* of their power. A teacher who has mastered relationship to such forces is generally a necessity for a practitioner to successfully traverse this path. *Tantra* may be an excuse for abuse of power if one becomes entrapped by such forces, if one is unable or unwilling to use these energies from the context of traditional spiritual intention.

Chogyam Trungpa Rinpoche (1992, p. 144), a Tibetan *tantric* master, states that "tantra is not telling us to cover up our pile of shit. . . .Tantra at last formally and legally acknowledges that we should put up with it." This does not mean that we should indulge or disregard our relationship to lust, anger, jealousy, greed, and the other shadow features of our character. But if we attempt to deny or eradicate parts of ourselves, we bypass an essential aspect of the spiritual path. We then do not acknowledge ourselves as we are, or see and appreciate the world as it is. From the place of being related to fully, the energy of the shadow transforms by itself, and the undifferentiated understanding of *samsara* and *nirvana* can unfold.

As an approach that challenges the ideas that practitioners have of themselves, *tantra* may generate great confusion—which may either be used for growth or to solidify

a defensive posture. We typically do not want to know about or have to deal with powerful buried feelings. Those unfamiliar with the path generally cannot fathom how shadow features could be expressed intentionally in a way that fosters spiritual growth, without an underlying selfish motive that uses others to our advantage. But *tantra* nevertheless attempts to open up energies that are bound by repression and access them in a spiritually useful way. There is no way for us to avoid our underworld and our dualistic relationship to the Freudian drives of aggression and sexual libido. Because of the power of such forces, *tantra* is a path that should not be entered into without a significant amount of experience in personal work, or without a guide who has successfully traveled on the path. The fact remains that transformation becomes possible through a deep acceptance of all of ourselves, reflecting life as it is.

While the *tantric* focus of some Hindu and Buddhist paths relates directly with the shadow features, these may be encountered and dealt with in similar ways within other traditions, depending on the contextual understanding of those who are responsible for the transmission of the esoteric teaching. Irina Tweedie (1986), for example, writes about her experiences with the Sufi Master Bhai Sahib in her autobiography *Daughter of Fire*. For years she struggled mightily with primal emotions of various kinds. At one point during this process, Bhai Sahib asked her, "Supposing there are four doors leading into the Spiritual Life: one of gambling, one of drink, one of theft, and one of sex. And supposing you are told that you have to pass through one of them in order to reach spirituality; what would you do?" (p. 105) Tweedie recounts her confusion, and of how Bhai

Sahib inferred that she might have to enter through the doorway of sex. Some time later, she describes contacting a desire, repulsion, and fear more extreme than she had ever known before. For several days she experienced this energy battle, nightly encounters with mind-forms of obscene shapes and activities, as she witnessed things inside her that she never knew were possible. But then she reflects, "Never knew? If I did not know it, how COULD I see it? It must have been in me." Shadow features, long buried, were revealed so that they could be purified. Her aim was strong enough to pull her through, as she was resolved to deal with whatever needed to arise in order for genuine love to be built.

Within my community over many years, our teacher has guided controlled experiments to allow practitioners to engage the underworld of their shadow features. One such project, for example, involved the creation of two professional music groups—one an all-male rock 'n roll band, and the other a female blues band. For the men in the rock band, situations frequently arose in which women would dance seductively, literally writhing in front of the stage to win the men's attention. In the women's band, competition and intense interpersonal conflict occasionally flared up between band members. Relationships between band members and their partners were sometimes strained, and in a few cases couples broke up. Audiences increased in size, and the power of playing before large numbers of people allowed band members to examine how readily they might be seduced away from their spiritual focus. Those not involved in the bands or as support staff also had primal emotions aroused—lust, anger, jealousy, feelings of abandonment and

being left out, and more. The whole community of practitioners needed to become more responsible for the shadow features this experiment revealed—a task that some felt incapable of at times, and everyone struggled with in some way.

This abbreviated overview of the traditional spiritual path has not considered many non-orthodox approaches such as shamanism, and traditions that have originated in the West, such as the spirituality of the Native American. Even in its limited form, however, this backdrop demonstrates the complexity involved in attempting to generalize about the spiritual path, and its contemporary adaptations by teachers or spiritual groups. Nonetheless, all of the groups and traditions that have offered an approach for those with the necessity to pursue some form of spiritual work have to deal with one common factor: the shadow features that show up for Western students on the path.

CHAPTER 3

Avoiding the Shadow on the Path

The extraordinary power of the shadow was obvious in the case of Paul, a long-time spiritual practitioner who for many years had been a personal attendant to a well-known, foreign-born Buddhist teacher. Feeling that it was time for him to move on and give to others something of what he had received on the path, Paul began to present spiritual teaching through his own public workshops. At the same time, he engaged in a friendly and respectful association with another teacher, a Westerner. In communicating his understanding of the *dharma* in his own unique way, Paul sought and received spiritual help and input from the new teacher. As a passionate writer, Paul showered appreciation on this teacher, whom he felt provided support for him and others in their work, and refuge in the living *dharma*, or teaching. This teacher even traveled some distance every

year to see Paul and other friends or students who lived in his area.

While mature and spiritually experienced in many ways, Paul had not resolved the pain of his childhood in an abusive family. He seemed preoccupied with the innocence of younger people—an innocence that was obviously robbed from him at an early age.

Paul had not been successful at coupled relationship. The abusiveness he and his mother suffered at his father's hands had undoubtedly colored the ways he as an adult related to women, making strong, healthy bonds improbable. Over the course of many years, Paul came to believe that the psychological difficulties he experienced, rooted in early childhood trauma, had created a barrier to further spiritual development. On one occasion, he dramatically articulated his personal struggle in the presence of the teacher by crying out: "The *dharma* is not enough. The *dharma* is not enough."

Paul was married, but had for years lived separately from his wife, Sarah, a student of the same Western teacher. During a time in her life when many things (particularly her health) were falling apart, the teacher offered his specially-trademarked brand of strong critical feedback to Sarah. In other circumstances, Paul had been able to see the value of and need for teacher-provoked shock in extreme situations—both through direct observation of other students on the path, and in his study of historical examples from his own Buddhist tradition. He knew that teachers use their personality features to bring awareness to areas needing transformation in the student. While he had honored this approach in the past, he now viewed it as indefen-

sible. His own shadow was currently involved—triggered by the teacher's seeming lack of compassion toward the wife from whom Paul was separated.

The love that Paul had previously expressed for this teacher turned to rage overnight. Letters of appreciation and respect were replaced by ongoing hate mail. In venomous notes, Paul vowed guerilla warfare with the teacher, declaring that he would aggressively fight him for personally misrepresenting the *dharma*. A short excerpt from one such letter reads:

> So Guru,
>
> I recently wrote you that I did not intend to extend out this Dharma Combat with you indefinitely but, like women sometimes say: "I changed my mind."
>
> Shakti does that very, very well doesn't she?
>
> Now as you know, you are, of course, not Jesus but, as you don't know I am your Judas. . . That is, I am going to do everything I can do to see you fully crucified.

Paul was in touch with the need for compassion on the path, but as he had not worked through his shadow feelings, he was unable to understand or make use of a mature tantric approach that stood on a ground of compassion yet appeared ruthless and shocking. To make food of that kind of offering from a real teacher would have required that Paul come to terms with his psychology, accepting his psychological reality "as it is," through acknowledging his own basic goodness.

Instead, through "spiritual bypass," Paul's shadow issues remained hidden to him and were projected onto the teacher. It might be mentioned that Sarah worked with her

teacher's strong communication, and maintained her connection to him.

There are numerous spiritual teachers who have abused power. I also believe that there are teachers with enormous spiritual integrity and transformational power, who suffer the outrage of students' projections as a sacrifice in the evolutionary process.

Spiritual Bypass

Before reaching the point of yielding our resistance and embracing the aspects of ourselves that we find most reprehensible, the work of the spiritual practitioner, though well-intentioned, may involve "spiritual bypass." It is simply too much for us to see ourselves as we are. *Spiritual bypass*, a term coined by Ram Dass (Richard Alpert), refers to the psychological ways of using spiritual teaching or practice to avoid deep primal issues. We skirt a direct relationship to the problematic feelings that have their roots in early object relations. Spiritual bypass, then, is the way that the shadow of repression is avoided on the path.

Spiritual bypass may involve any number of deeply-rooted characterological defensive habits or strategies that keep distressing feelings from surfacing, utilizing a remarkable degree of psycho-spiritual sophistication to allay the inner anxiety that accompanies such repression. This sophistication, however, is really a simple manipulation and distortion of traditional teaching, aimed at maintaining the safety of the presumed ego. Practices can be engaged in ways that suppress undesirable aspects of ourselves. But opening up to the primal emotions of the shadow is not only threatening from the standpoint of having to face in-

ner forces that have been utterly painful and unmanageable in the past; it also threatens to topple the artifice of the psychic structure of ego on which we have built our lives. Shadow work, then, puts us in touch with our deepest fears around annihilation of who we think we are. Some of the common ways in which we avoid going there on the spiritual path include defensive strategies of *discounting, judging, and interpreting* our primal feelings. Each of these mental tricks will be examined from the standpoint of how they can be used to avoid shadow features. Additionally, we will explore other common conditions that block our access to the spiritual path.

Defensive Strategies

DISCOUNTING

Shadow features are often *discounted* when exploration of primal feelings is believed to be unnecessary to the spiritual process. "After all," the practitioner reasons, "psychological work focuses on an impermanent and illusory ego structure. As the death of the ego idea is assured (its existence is imaginary to begin with), work efforts on psychological features are useless, and amount to a rearranging of the deck chairs on the Titanic." Another spiritual seeker may rationalize that his focus is more appropriately placed on God rather than on the ego's emotional expressions. In this way, he argues, he will not reinforce the confusion of where to place his attention, which he believes will be resolved by the process itself.

The increased strength developed through disciplined spiritual practice may serve to further wall off painful and childish feelings from awareness, and even mature spiri-

tual students may truly be in denial, unaware of underlying feelings and motivations that others may readily sense in them. This tendency to superimpose a philosophy of oneness on top of the repression of early childhood issues and primal feelings is an insidious trap of the path. It keeps us defended from intimacy with the most sensitive and painful parts of ourselves. Spiritual experiences and insights may arise despite such blocks, and may then be viewed as evidence of an advanced spiritual state or maturity, and in more extreme cases, as the presumption of enlightenment. Practice on the path requires that we not deceive ourselves about the work that needs to occur in order to know the truth of non-duality organically. The bodily integration of the spiritual experience that occurs along the way must include the integration of our shadow aspects.

In an unpublished manuscript entitled *From Duality to Oneness*, Sumongyal Prakash describes the work that the twentieth-century Indian Master Swami Prajnanpad engaged with students. One story highlights the kind of psycho-spiritual delusion that is possible, in the East or West, as a result of blindness around the shadow of repression. A student came to Swami Prajnanpad saying that he wanted to follow the path of truth; and that he felt inclined to follow the *brahmachari* way of one who leads a lustless, celibate life. Swami observed that the student's irritable and intolerant disposition was a symptom of a repressed sexual urge. He asserted that the student's strong sense of morality had no validity on the spiritual path, and that inner work would be an extremely dangerous matter for him. This was because the student would have to open up to whatever lay beneath his virtuous self-image—i.e., the most reprehensible

parts of himself which had been thus far unacknowledged. At hearing this, the student was surprised. But, because he was willing to consider the possibility of the truth of the matter, Swami Prajnanpad agreed to work with him, very slowly.

Prajnanpad gave the student a seemingly unrelated exercise of discipline to do on his own—a task that took the student a year to complete. After this time, the student returned to the Master, and soon began to recognize the hidden desires within himself. He started to have vivid dreams, which he related to the Swami. In one, a female image without lips appeared before him. Evidently the lips were denied because of the immoral nature of his desire to kiss them. A fierce conflict raged inside the man, but gradually eased as he became convinced that his feelings were not wrong, and that relationship to the woman he dreamed of might be consummated in a natural and appropriate way. Had Swami Prajnanpad's student not been helped to recognize repressed aspects of his shadow, he might have lived the life of a "spiritual" *brahmacharya*, which would not have been natural for him. The spiritual process will generally find ways to bring the features we are avoiding to our attention—this is a spiritual "law." Primal negative emotions may lie dormant, but can be activated in a moment—drawing power from the force of denial used to keep them out of awareness. We can never truly get away from ourselves. That we must inevitably deal with what we resist becomes evident as our shadow features become magnified as roadblocks on the path until we are able to accept them and work with them effectively.

Spiritual practices can be engaged in ways that either

suppress primal shadow feelings or support their integration. Meditation, for example, is a common practice that can be approached in a variety of ways. Goldstein (1993, p. 102), who cites his own therapeutic work involving exploration of the shadow side, states that the purpose of meditation is not therapy, but "to stabilize awareness and open to the essential nature of mind." But in my opinion, any approach to meditation that does not allow for *whatever arises* can encourage spiritual bypass, i.e., any preconceived idea of the purpose of meditation (or any spiritual practice) can be a serious limitation. Meditation may yield the experience of "no self" and egoic non-attachment to the content of mind, but at the same time perpetuate the avoidance of primal feelings. These may be "meditated away," or allowed to settle, as we rest in peaceful illusion.

The mind's self-deceptive propensity is one of the reasons why many spiritual paths involve not only contemplation, but also the agitation of the emotions. One of the functions of a teacher, for example, appears to involve bringing buried feelings to the surface so that the student can see the bottom line from which he or she unconsciously functions. The Lyings process, developed by Swami Prajnanpad, which will be discussed later in the book, is one such method of intentionally attempting to contact painful emotions, allowing the student to feel them and open up to whatever purification may be necessary in a psycho-spiritual context.

Spiritual practice can only truly deepen in conjunction with the awareness, acceptance, and subsequent relaxation of primal feelings that surface on the path. Kornfield (1993, p. 245), trained as a psychologist and a teacher of Vipassana

meditation, states that "what American practice has to come to acknowledge is that many of the deep issues we uncover in spiritual life cannot be healed by meditation alone." The trauma of childhood and the breakdown of the family structure in modern society have created a situation in which psychological healing may need to become an integral part of the spiritual path for many people. At the same time, this inner pain can be appreciated as the factor that has propelled countless spiritual seekers into the search for truth.

JUDGING

The harsh or negative judgment of shadow features keeps us at some distance from our repressed feelings. On the spiritual path, this frequently manifests as the sense that we "should" be beyond our childish emotional patterns. A sense of shame commonly accompanies our reflection on these deep human weaknesses and this shame may be so strong that it may be extremely difficult, if not impossible, for us to fully acknowledge its reality to ourselves, let alone to others. Furthermore, a critical form of self-judgment, learned and internalized in early childhood, keeps us from ever really dealing with the matter, from relating directly with our feelings. Once on the spiritual path, we may hope and assume that its transformative possibility will eliminate the need to confront the discomfort of our situation head on.

Because primal negative feelings are judged as unspiritual, not in alignment with the spiritual self-concept we are trying to adopt, many of us may attempt to imitate a holy or realized person—someone whose spiritual

qualities we admire. Whatever image we seek to embody, it certainly will not include our shadow features and primal emotions. To make matters worse, members of spiritual groups will often indict the "wrongness" of shadow features and expressions, not wanting to be reminded of their own weaknesses—which they (like everyone else) would prefer to ignore. In adopting a subtle spiritual self-image, what they may not fully recognize is that *any* fixed self-concept is an illusion, and that any attempt to establish a permanent identity only brings more suffering—even if the new identity is characterized by a loving and compassionate persona. While it is true that a loving and compassionate relationship to life may predominate when one has been transformed, this will occur only as an expression of one's unity with whatever arises—the light *and* the dark.

For most of us, feelings are not so readily accepted and released. The self-judging aspect of ourselves, which Freud called the superego, has learned to critically berate us for not living up to the internalized self-image. Feelings of inadequacy, worthlessness, and self-deprecation can be triggered as we find ourselves trapped in a vicious circle in which we are stuck believing that we "should" be able to transcend such "negative states," and yet find ourselves unable to. The highly critical superego will not accept aspects of ourselves that do not conform to the self-image learned through early object relations. Finally, we beat ourselves up and separate ourselves from our feelings.

Michelle McDonald (1995), a teacher in the Buddhist Vipassana tradition, observes that as one travels on the path it is possible to have many experiences of spiritual freedom; and, at the same time, undergo periods of regression into

childhood states. She recounts how meditation, along with therapeutic support for her process, has helped her to open to and work with feelings associated with early trauma. In this manner, she notes, we may find that we no longer fear or reject painful parts of ourselves. McDonald states that "we don't often talk about these things so much in meditation and often the more people practice, the more they hide them, because people who are advanced in their practice are not supposed to have unresolved difficulties" (p. 14). But we *do* have unresolved difficulties, and it is no disgrace. Epstein (1990, pp. 18-19) observes that:

> An assertion that spiritual work is only for those who have finished their psychological work, who have formed their cohesive egos, worked through their oedipal, narcissistic or infantile issues, found their identities or achieved an adequate sense of self, would likely exclude most of us.

INTERPRETING

The shadow may also be avoided through analysis and interpretation. We may mistakenly assume that if our strategies of defense and avoidance are fully understood, the transformational work will take place automatically. This viewpoint parallels Freud's initial belief that in free association he had discovered the means for the cure of repression—i.e., in making the unconscious conscious, the neuroses would be eliminated. While theoretically possible, this principle practically requires that we "see" with the whole of our being—not just through the intellect. The emotional and physical aspects of being contain the memories of early primal patterns that are not easily released. Although insights may create the potential for establishing a relation-

ship with and becoming responsible for the shadow, they also may be used to bypass the deeper necessity of working through repression on a bodily and feeling level. We would like to believe that our difficulty has been finally cleared because it has been figured out! Reich's discovery that repression is a somatic (bodily) issue as well as a psychic issue explains why such insights are frequently not transformative—although they may be indicative of an opening in the defense structure.

As spiritual practitioners we often have a good sense of the reasons for our problems. Therefore, some view therapeutic work as unnecessary. But spiritual psychotherapy is about something that frequently has not been encountered before, i.e., the *voluntary* suffering that accompanies the experiencing of repressed feeling. (In the context of his work, Gurdjieff referred to the transformational work-principle of *conscious suffering*.) Such work is not about understanding or talking *about* one's primal issues, although understanding and insight usually come as repression is explored and primal feelings are released. It is about being willing to stay with and experience uncomfortable, painful feelings related to early issues that we would like to avoid. The innate intelligence that becomes unbound through such suffering can then inform and direct us on the spiritual path.

But I think it is more common for people to spend a lifetime warding off early childhood hurt in characterological ways. In my experience, we earn the opportunity to face our demons directly through years of struggling to relax the defenses that we sense in the inner world. The ability and willingness to relate with the shadow generally develops

over time. It is a matter of an inner necessity to get through the sense that something is not quite right, and an underlying psychic distress, to the truth beyond.

The Roadblocks

LACK OF BONDING

Resistance to work with the shadow (e.g., through the defensive strategies of discounting, judging, or interpreting) indicates a fear of exploring those areas that lack developmental maturity. Regarding the biological plan for intelligence, Joseph Chilton Pearce (1977, p. 18) observes that it "is based on a series of matrix formations and shifts; that is, human beings are designed to grow in intelligence by learning about, and gaining ability to interact with, one source of energy, possibility, and security after another." As we move from early concrete matrices into ever more abstract ones, each shift is a death to the known, and a birth into the unknown. Pearce asserts that nature would never push a child into a new matrix without sufficient preparation; that we move from one matrix to another by standing on the ground of the old one.

The developmental plan has us moving through several matrices within our lives. From the womb we bond to mother as matrix, and then to the earth—at about age seven. In early adolescence, standing on the ground of having bonded to mother and the earth, we (i.e., our own body/minds) become our own matrix. Beyond this, the possibility exists to bond to what Pearce refers to as "mind-at-large"—which I interpret as the ability to rest within the divine unity of all creation. Pearce notes that we always have a new matrix to go to and that bonding establishes "points

of similarity with the next matrix" (p. 272).

Unfortunately, adequate bonding has not taken place for most of us, and the spiritual path may therefore be blocked by an inability to stand firmly within the matrix of our own body/minds. Without working through primal feelings around the shadow, our deeper spiritual intention may be obscured by more primal needs that have gone un-fulfilled, and which drive us in our daily lives. Pearce (p. 72) states that:

> The unbonded person will spend his life in a search for what bonding was designed to give: the matrix. The intelligence can never unfold as designed because it can never get be-yond this primal need. All intellectual activity, no matter how developed, will be used in a search for that matrix.

UNFAMILIAR "INNER WORLD"

One of the major achievements of object relations is the ability to make distinctions between the inner and outer worlds. The child thus comes to view him- or herself as an independent being through the process of ego develop-ment. From this dualistic context, the spiritual traditions assert the possibility of the realization of a fundamental prior unity of all aspects of creation—within both inner and outer worlds. Opening to this deeper context, however, is improbable as long as we are unable to fully relate and deal with aspects of our inner and outer worlds.

In this regard, Laing (1977, pp. 96-97) observes that "our time has been distinguished, more than by anything else, by a drive to control the external world, and by an almost total forgetfulness of the internal world." By "internal world," Laing means "all those realities that have no 'exter-

nal,' 'objective' presence—imagination, dreams, fantasies, trances, the realities of contemplative and meditative states, realities of direct awareness." He notes that in times past people did not believe in God, but they experienced the spiritual presence of God; and that while we have evolved greatly in our knowledge of the outer world, we have largely lost contact with the oneness of the inner and outer worlds.

By definition, repression goes on in the inner world, and the ability to navigate this inner world is necessary in order to learn its secrets, and thereby open to transformation. For most of us, even those on a spiritual path, this capacity for self-exploration is underdeveloped since it requires that we let go of the idea we have of ourselves. Yet, without the exploration of our shadow features through spiritual warriorship, we are blocked on the path. The shadow that arises out of early hurts forms an integral part of our assumed identity. It continues to linger and play a significant role in ensuring the fixed and unquestioned assumption of separative ego identification in our lives.

Ironically, "being with" and owning these shadow features and the depths of related feeling is the first step in the process of releasing them. Without this degree of acceptance, it is likely that the blocks to realization of the illusory nature of ego identification will remain firmly in place. Until the shadow is owned, there will always be something untrustworthy about our relationship to the path.

NARCISSISTIC PRIDE

Seekers on a spiritual path are subject to the same psychological dynamics as everyone else. It often happens, however, that instead of a kind of real pride in our work,

we develop a narcissistic pride. We feel special because our spiritual perspective differs from that of the common man or woman. We see that people are generally unwilling to self-observe, acknowledge, and consider ego's fundamental context of underlying anxiety and suffering, that most prefer to remain "asleep," disregarding the unspoken challenge of life: to deeply and honestly examine the inner and outer world in search of the truth. In contrast, the avowed intention of spiritual aspirants is to study and come to know ourselves, taking responsibility for whatever it is we find. Yet, we may discover that our presumed specialness is only more of the same—the illusory attempt to maintain a separate egoic identity, albeit now a spiritual one. Real spiritual understanding and freedom only arises as narcissism dies. Living an ordinary life within the extraordinary context of the spiritual path then becomes possible. In this ordinariness, we work to experience life-as-it-is. We learn that everything we do can be a form of practice and remembrance of the all-pervading truth of the present moment—taking out the garbage, paying the rent, and relating with the shadow.

The Need to Fix It

When primal feelings arise, we may feel that we have made some transgression and that we need to change or fix ourselves. We may want to return to homeostasis—in this case our "secure" spiritual *persona*—as quickly as possible, as opposed to bearing the discomfort of genuinely interfacing with the reality of the shadow features we have denied. But the heat of real transformation of the shadow can occur only with the acceptance of what is. We do not

need to unravel every psychological knot, becoming a "therapy junkie" for decades. Nevertheless, if we unconsciously keep trying to satisfy the needs that were not met in our early life, we cannot expect transformation in those areas. Deceiving ourselves about underlying motivations despite our spiritual intentions is not uncommon.

Shadow features that we sense in ourselves point us toward the psycho-spiritual work that has yet to be done. The recurring situations and emotional patterns that arise provide us with clues to follow. Where the exploration of these issues leads we do not know, and sometimes we will be surprised by what is uncovered in the process. In studying ourselves and underlying shadow motivations closely, we may find what Eva Pierrakos (1993, p. 96) has called "the compulsion to re-create and overcome childhood hurts." She observes that familiar patterns of conflict have their origins in the "attempt to reproduce the childhood situation so as to correct it." We try to work out the primal feelings, unresolvable in childhood, that have been relegated into the shadow. This is most apparent in the patterns of immaturity that show up within couples, but is also evident in how we relate to other specific aspects of life, including spiritual practice.

THE NEED TO "GO IT ALONE"

We are generally unaware of the scope of the shadow, and further unaware of the full implications of those shadow features that we do sense. We are, therefore, frequently unable to work effectively with the shadow by ourselves. Our awareness will bypass a blind spot, chronically and unconsciously avoiding the danger zone that is never

far away. While we may know something about the shadow, it is usually seen more clearly by others who are familiar with our individual emotional patterns. Because of this, companions on the path are in the unique position of being able to provide help for us in our shadow work.

Part of the function of senior practitioners—those who have weathered some degree of the transformative process—is to provide help and support for those who still need to come to terms with their own inner demons. But it is essentially the responsibility of the newer student to access help, as it is his or her decision to embark on the spiritual path, even if what this means experientially is not known. Asking for help and then being able to use it, however, may be particularly difficult for the Westerner. Western culture highly values rugged individualism, even in the modern age. We have been taught to value independence (perhaps to compensate for incomplete bonding), and turning to others (e.g., a spiritual teacher, other students, a therapist) for help is commonly seen as a sign of weakness, a reminder of an inner deficiency. This is especially true in relation to shadow feelings, which may be too difficult for us to accept. But this is precisely why help is needed in this domain. Our primal issues cannot be bypassed if we are to move through primal blocks on the path.

We are all connected, and both giving and receiving help is an essential part of the spiritual process. Help, of course, comes in many forms. A teacher or fellow spiritual aspirants can offer it in certain critical ways that encourage self-reflection. Spiritual psychotherapy can also provide a unique form of help—specifically related to working with primal issues hidden within the shadow.

TRANSFERENCE ON THE TEACHER

A spiritual student's shadow side may become particularly pronounced, and therefore potentially workable, in his or her relationship to a spiritual teacher. Historically, the purpose of the student-teacher relationship on the traditional spiritual path has been to provide the psychic milieu in which a teacher's understanding and context can be duplicated in a form that is unique to the individual student. But the nature of relationship to a teacher will vary depending upon the type of spiritual school being approached. In some, the teacher provides the central focus, while in others the technical approach of the path provides the central focus. Anthony and Ecker (1987) refer to *charismatic* schools, which focus on turning to the teacher's state as a necessary element in effecting the student's transformation; and *technical* schools, which emphasize technical practices as ways of realizing spiritual truth. Groups may combine both charismatic and technical approaches, though one generally predominates. In either case, dynamics of transference provide food for psycho-spiritual work, as the student comes to see the projections that he or she has made onto the teacher. Joseph Chilton Pearce (in Zweig and Abrams, eds., 1991, p. 130) describes a relationship of this type that he had with a female teacher:

> Every time I am around (the guru), some hidden child-part blurts out, some petty demon pops up to make an utter jackass of me in front of the one person I want to impress most. The guru exposes another of my fragments of self—not to make me look ridiculous, but to bring light to my darkness, my shadow-self—something I can't do for myself and resent anyone but her doing for me.

Because of the prevalence of early childhood distur-
bance in Western culture, it would be unrealistic to expect
that people's underlying unmet needs would not show up
in transference dynamics onto all types of authority fig-
ures—educators, employers, politicians, law enforcement
officials, therapists, and spiritual teachers. Practitioners on
the path may alternately view the teacher, through trans-
ference, as either a nurturing or a denying parent. Seeking
nurturance, they may look to be cared for, approved of, and
loved by the teacher, thus misunderstanding the teacher's
essential role. The teacher may be idealized, with students
imitating the personal traits of their spiritual hero or hero-
ine without embracing the process of psycho-spiritual pu-
rification that the teacher represents by virtue of his or her
own transformation. Feuerstein (1990, p. 160) states that:

> Unfortunately, today as in the past, childish devotees are in
> greater supply than mature disciples. Hence, critics of the con-
> temporary spiritual scene are justified when they refer to the
> groups that have formed around most modern spiritual teach-
> ers as idolatrous cults rather than true communities.

There is something valuable to be said for the role that
modeling plays in human development. But what the spiri-
tual adept more importantly offers is his or her own unique-
ness—arising from the acceptance of and unity with all as-
pects of the Self. We cannot copy someone else psychologi-
cally and realize the fruits of the path; but we can open to
the transformative power of the teacher or tradition and
come to animate the essential qualities in ourselves that
are forged as a result. A mature openness based on having

worked through early need systems is a prerequisite for receiving what the teacher has to offer. From this context, the student may eventually come to rely on his or her own inner authority, by merging it with the outer authority of the teacher.

Students may be unaware of how much their reliance on the teacher is based on spiritual receptivity and how much is based on childish dependence. Generally, I find that both aspects are operative. A fellow student who found himself in the midst of a spiritual conflict wrote to my teacher, asking for help. In a long note, he concluded by asking the teacher six questions. Shortly afterward, the teacher wrote back: "The answers to your questions are yes, yes, no, yes, no, no—in no particular order. I trust that you can work out the details." Upon closer self-examination this student realized that he was seeking advice about an area of his life that he simply needed to become more accountable for himself.

The teacher may also represent a negative or "denying parent" for the student. It is not uncommon for a student's underlying rebelliousness and hostility to reveal itself around a teacher. Primal reactivity can be activated when expectations are not met, or when a student feels wronged or abused, as some students have in the midst of personal or community crises.

Students have varied responses to personal or community crises—which in some cases are triggered by the activity of a teacher. Some students stick their heads in the sand, assuming that the teacher can do no wrong, and that his or her activity was imbued with a spiritual, if not moral, integrity—perhaps being divinely inspired. This strategy of

avoidance keeps practitioners out of touch with feelings in their inner worlds. Other group members may angrily assert that the teacher's untransformed shadow side has been exposed. These people experience outrage over the teacher's seeming duplicity when their idealized image of who the teacher should be is shattered. But in all these instances, it is wise to remember that while primal feelings may be catalyzed by the teacher, they are not created by the teacher. Whatever shadow feelings and expressions we manifest have been inside us all along.

While hard to realize in the moment, spiritual crises do provide us with a rare opportunity for growth on inner levels that are generally not accessible to us. Even if we recognize the potential value of crisis, it takes time and experience to develop the capacity to consistently assimilate and integrate primal feelings when they occur.

In my view, no amount of criticism or speculation about a teacher and his or her presumed wrongdoing will solve the problem. Phenomenological discrimination is advisable in any relationship with a teacher, and we ultimately may not know the legitimate or illegitimate basis of a particular teacher's motivations. What I am more concerned with (and something that has been overlooked in the public attention given to various teachers' presumed wrongdoing) are the shadow features that have come into play for *students* as a result of these controversies.

My aim is not to draw conclusions about the activities of teachers, as I think that such activities will speak for themselves within the context of the teacher's life work. Instead, my purpose is to support spiritual practitioners in their investigation of their primal psychological blocks that

are encountered on the path. Through exploration of the shadow, they may begin the difficult work of acknowledging and taking responsibility for their own distortions and self-deceptions, thus clearing their view and refining their own sense of discrimination on the path.

The Energetics Model

In Chapter 1 we looked at the character structures defined by Lowen and Pierrakos in energetic psychotherapy to demonstrate types of defenses that form in order to maintain psychic equilibrium and absorb repressed energies. Here we refer to them again to illustrate ways in which shadow features may surface for the student on the spiritual path. *Oral types*, who have nurturance as their main issue, may unconsciously seek to be taken care of—in their interpersonal relationships, by a group, or by a teacher. Having experienced a lack of bonding, accompanied by the recurrent feeling of emotional abandonment in childhood, a grounded sense of self may never have developed. Oral types may chronically look outside of their own matrix. Yet, in the attempt to mask a powerful emotional need from themselves and others, they may have developed a mature and independent *persona*. This character may be shocked or become resentful at discovering that the path is not leading where he or she expects it to. Individuals of this type may finally realize that they are not going to get what is wanted—i.e., to be taken care of or directed in the childish ways they have always expected. Instead, they come to realize that the deeper demand is to assume an awesome responsibility—to stand on their own spiritual feet in relationship to God or creation. The work of opening up to,

allowing, and finally accepting their buried childish feelings naturally leads such students into a new relationship with themselves, wherein this ability to face reality becomes possible for the first time. Responsibility such as this cannot come about solely through the ego's willful efforts.

Masochistic character types were invaded, dominated, and controlled in early childhood. Since expression was stifled, such individuals may become spiritual followers, hesitating and seeking approval for their actions. They often learn to accept subjugated positions and can be good, hard workers on the path. Yet, they resent feeling controlled, internalizing and holding onto primal negative feelings, which they suppress. The endurance of such pain may become so intense that they may feel as if they are about to burst, and any form of release may be longed for. The easeful expression of their feelings may be almost inconceivable to them. After all, they were not permitted to develop on their own, and have therefore been conditioned to protect themselves from the invasive, controlling responses that were anticipated and so difficult to bear in childhood. Shadow work for the masochistic type can involve their acknowledging and releasing feelings of rage and spite, and gradually assuming responsibility for the decisions that they have made about life on the path.

The inner feelings of *rigid types* were not recognized or permitted in childhood, as a false image of perfectionism was often maintained within the home environment. Such individuals may have coped with the painful and confusing disavowal of emotional experience in their families by distancing themselves from their real feelings, hiding their inner reality from themselves and others—i.e., living in denial.

Rigid types may be extremely competent and functional in their lives in general and within a spiritual group in particular, but they are adept at deflecting any attention on their problems away from themselves, while maintaining the appropriate spiritual image and behavior. On the path, they may be brought in contact with the mechanical and armored patterns that have frozen their ability to feel. The challenge of shadow work for this type involves the difficult process of acknowledging weaknesses, removing the spiritual mask, and becoming authentic through allowing the expression of long repressed feelings. Innate wisdom once released can then begin to transform the rigid student on the path.

Aggressive types may be involved in struggles for control and domination, often characterized as a fight for what is right within the spiritual culture they are in. Dogmatic judgments may be levied against those who do not line up with the aggressive's interpretation of righteousness on the path. As children, aggressive characters may have experienced manipulation in their families, perhaps having been forced to take sides for and against other family members. Thus they may have learned to protect themselves by becoming strong, aggressive, and invulnerable. This type of spiritual student generally has issues around trust, and may feel ultimately betrayed in his or her crusade because there is no one to fight against and no cause to be won. Their ability to assert themselves and influence other students can make them either strongly useful or quite dangerous to the process, depending on the degree of responsibility they have taken for their dark sides. Shadow work (for both men and women) seems to involve relaxation of the critical

superego and an opening to the feminine—a willingness to honestly explore the feelings of their own inner world and to accept differing expressions of others in the outer world.

The *schizoid type*, who experienced hostility as a child, may encounter deep-seated fear on the path. Such individuals have coped with emotional rejection in infancy and childhood by dissociating or "leaving the body," absenting themselves or refusing to be present—physically or emotionally—in circumstances that were overwhelming. Their own primal terror is easily triggered when others on the path have early feelings exposed. They may live in their heads—for example, through fantasies in which their longing for intimacy and affection is fulfilled. As with other types, relationships to various aspects of bodily experience (such as food and sexuality) may be distorted through denial or desperation. These practitioners may also be exceptionally psychic, possessing a strong sensitivity to the feelings and inner states of others—which may have been necessary to develop in order to protect themselves in childhood. Shadow work with this type involves grounding feelings in the body, as a means of building up inner "muscles" to create a matrix that can sustain the process of transformation on the path.

The sketches offered above are meant to illustrate some examples of ways that shadow features of certain character types may show themselves on the path.

CHAPTER 4

The Spiritual Teacher and the Shadow

In every spiritual tradition, extraordinary individuals have been recognized as teachers because they have experientially undergone the process of transformation, and have consequently assumed the legitimate spiritual authority to communicate their knowledge to others. In a letter to the editor published in *Yoga Journal* (1995), American teacher Andrew Cohen takes issue with the popular opinion that "a state of incorruptible purity is a mythical and seemingly unattainable ideal." He describes the meaning and significance of enlightenment as "coming to that point in one's evolution when one no longer causes suffering to others through acting out of ignorance" (p. 8). The recorded biographical information about these individuals, however, makes it apparent that despite the fundamental

deconstruction of their ego identity and their witness to a previously unfathomed orientation toward life, many of their basic personality characteristics have remained the same after the enlightened condition was realized. Nonetheless, such teachers have been able to use and communicate spiritual freedom through the medium of their personality features, without being run by underlying primal motivations. Former weaknesses have become eccentricities or idiosyncrasies, and have served to destroy commonly held myths of spiritual perfection, setting the whole subject of perfection in a different context. Feuerstein (in Zweig and Abrams, eds., 1991, p. 148) comments on the psychic structure that appears to remain for those who have realized the core understanding of the spiritual path:

> What these fully awakened beings have in common is that they no longer identify with the personality complex, however it may be configured ... Enlightenment ... consists in the transcendence of the ego-habit, but enlightenment does not obliterate the personality.

By definition, the enlightened state cannot be understood through the perceptual filter of ego identification. According to traditional understanding, all action originating from this non-dualistic context necessarily serves the highest good, since it arises from a spiritual ethic characterized by surrender to the movement of the cosmos. The enlightened state may be viewed as an absolute responsiveness to other aspects of "Self," or of the creation, providing what is "wanted and needed" (a term used by Werner Erhard) by the environment for others' spiritual growth and

ultimate relief from egoic suffering. In this, there have historically been the rare teachers who have authentically challenged the conventional moral ethic. Their actions have often had the effect of undermining ego's narcissistic assumptions about life. As such, a teacher's behavior may create unpleasant circumstances for others in the moment, but from a context of ruthless compassion grounded in the teacher's understanding of the work that needs to be done in the bigger picture. Our projections and illusions may be so thick that a teacher's seemingly inappropriate activity may precipitate an otherwise highly improbable opportunity for us to work through them. Such rare teachers' activities may be a sacrifice for others—engaged in because of others' needs and not theirs. Those who have no reference point for the teacher's context may view his or her activity as madness, and a violation of human integrity. Thus, many hold that the actions of a realized teacher will serve the process of spiritual unfoldment in ways that may not be seen, and therefore cannot be judged by conventional moral standards.

How can a student know if a teacher operates from the enlightened disposition? Is it possible for aspects of the shadow to remain untransformed within the basically transformed teacher? It is my contention that, ultimately, such things are not knowable from projections of the ego state, but that an intuitive or higher knowing can be uncovered when we have developed the capacity to recognize our own self-deceptions through shadow work.

By virtue of their expanded awareness and their freely motivated activity, realized teachers tend to catalyze repressed shadow features in students, bringing to the surface

whatever is unacknowledged in the psyche. Blocks in the areas of the Freudian instincts—the big issues of sex and power—are therefore provoked as *part* of the work teachers engage with students. Spiritual literature contains many accounts of ways that teachers have done this. The famous Tibetan Buddhist Master Marpa directed his all-suffering student, Milarepa, to build many houses for him—all of which Marpa found unsatisfactory. The teaching that Marpa promised to give Milarepa was denied again and again, in what could be construed as an abuse of power on Marpa's part. Yet, tradition holds that Marpa brought Milarepa to the point of spiritual realization through these extreme measures that effectively erased the *samskaras* (i.e., the accumulated habits of thought and action that keep the individual stuck in recurring life patterns) of many life-times. The Russian mystic Gurdjieff worked with students by exaggerating their false egoic selves, and by requiring efforts that sometimes stretched people to their physical and psychological limits. The Indian master Meher Baba, who did not speak for almost forty years, communicated his intention to break his silence on many specific occasions, but never did. Each of these teachers, whom many considered enlightened, and who were involved in the work of communicating their unique understanding of transcendence of the ego identity to the sleeping world, could be task-masters and apparent liars who made demands that would be considered intolerable in contemporary Western culture.

With respect to sexual involvement, Neem Karoli Baba, the subject of Ram Dass' book, *Miracle of Love*, is said to have occasionally had sex with female devotees. The

historical figure of Krishna, and the legendary Tibetan rogue-adept Drupka Kunley were particularly known for using sex in the expression and transmission of their enlightened influence. The Indian teacher, Upasani Maharaj, "caused a public outcry when he revived the ancient Vedic custom of 'spiritual marriage' (*brahma-vivaha*), marrying no fewer than twenty-five virgins." (Feuerstein, 1990, p. 25) Gurdjieff and many highly esteemed Hindu and Buddhist masters have purportedly used sex in their roles as spiritual teachers.

Many realized individuals, however, have had a teaching disposition far different from those "crazy wisdom" teachers who have challenged the conventional outlook through the more radical forms we have been considering. Zen Buddhist Master Suzuki Roshi, and the Indian saints Ramana Maharshi and Papa Ramdas are examples of individuals whose communications were extremely powerful, but less overtly disturbing of social norms.

While it is apparent that abuses of sexuality and power are common on the spiritual path, and that seekers should be cognizant of that fact if they consider work with a teacher, I also do not think we can always assume a lack of spiritual integrity on the part of a teacher who works with consenting and capable students in radical ways. In the remainder of this chapter we will look at some of the ways in which shadow features may manifest for those who claim to be teachers, or for those who are held as such by a group of followers or devotees.

The Teacher's Nemesis

INFLATION

The conventional mind does not question the assumption of ego identification, and cannot understand the intention of spiritual practice or conceive of the existence of the enlightened relationship to life. From this perspective, a spiritual teacher's motivations are commonly judged as coming from a desire to bolster ego through acquiring power and control over others. Understandably, this viewpoint is reinforced by the many individuals who assume the role of spiritual teacher and are motivated by shadow forces that they deny in their inner world. Counterfeiters, mired in self-deception, but with familiarity of the spiritual process, may think that they understand how a genuine teacher expresses him- or herself, and may therefore adopt a teaching *persona*. A key distinction between authentic and inauthentic teaching, not so readily discerned in terms of superficial external behavior, is that in the latter case, *the teacher's shadow has created the self-deception of the presumption of enlightenment.* For whatever reasons, the individual who presumes to have experienced spiritual transformation has either fantasized the condition of egolessness, or has not acknowledged that a mystical experience has faded. As with all of the forms that self-deception may take, I believe that the false presumption of enlightenment is rooted in early unmet needs—i.e., in the repression of feelings that unconsciously manifest through narcissism and the quest for power—and perhaps in past *samskaras.*

Claudio Naranjo (1987, p. 205) notes in an interview that "there seem to be degrees to which people get stuck in

their grandiosity: some live on it for the rest of their lives. Spiritual capital gives the ego credit." Naranjo has described his own short-lived saga as a teacher following an enlightenment experience. He recognizes the patterns of inflation that may occur with the return of separative ego identification—which may at some point have temporarily fallen away. Perhaps his integrity and previous experience with shadow features allowed him to acknowledge the transient nature of his experience. Interestingly, however, he recounts how Chogyam Trungpa Rinpoche and his own teacher, Tarthang Tulku Rinpoche, recommended that he continue to teach—as he could still provide something useful without functioning as a guru. But, unlike Naranjo, there are those who continue living in self-deception, involving others in it.

As an example of self-deception apparently unchecked, the following is an excerpt from an advertisement entitled, "An Invitation from the Supreme Being," which appeared in *Common Ground* in the early 1980s:

> This letter is an invitation to live with me. I am the Supreme Being, the sole source of everything and every one that ever was or will be . . . This is my first, only and last incarnation on earth. I am here, for a short time, to provide you with your only remaining opportunity to be unconditionally happy . . . A one-thousand-dollar ante is presently required of each participant which neither guarantees nor entitles one to receive anything in return . . . Your future is entirely in your hands. A perfect master is simply a doorway. You will recognize and trust what is written here to the same degree that you are willing to love yourself. Nothing stated here will fit within the context of what is known. You must read this letter with your heart to understand that it is the

> literal and irreducible truth . . . This is no joke . . . There is
> no longer any middle ground to stand on. If you are not
> formally living with me as my friend and disciple, you are
> choosing to remain a fraud and be at war with yourself.

Such ad copy intersperses *dharma* (spiritual teaching) with scam, and can attract people who approach the spiritual path with extreme naiveté. Nevertheless, real teachers sometimes actively attempt to dissuade students from involvement. By various means, such teachers often create a labyrinth that challenges potential students to more deeply investigate the transformational process, as well as to weed out individuals who are not ready to do so. The genuine spiritual path is both arduous and life-changing, and is not always timely or suited for everyone. A little knowledge of traditional spiritual understanding can, in this case, be a dangerous thing. On the other hand, the path does hold that the teacher may be a doorway into one's own deepest experience of the Self—but only if the teacher's condition is that of a transformed and not a delusional nature.

Gary Rosenthal (1987, p. 307), a Jungian psychotherapist, notes that "inflation seems to be an occupational hazard of practically all social roles and professions, from parenting fathers who know best, to doctors with their supposed 'God complex,' or movie stars, politicians, athletes, even the foreman on the job." In studying spiritual inflation, he recognizes five factors that are generally involved: (1) characterological predisposition, (2) transpersonal experience, (3) identification of the ego with the transpersonal experience, (4) impact of a teacher or group that supports the egoic identification, and (5) the absence or avoidance of disconfirming feedback. Therefore, a variety of factors

generally combine in an individual who is deceiving him- or herself with regard to the presumption of spiritual attainment.

SEX, ETC.

Rutter (1989, p. 8) makes some necessary psychological considerations with regards to sexual involvements, which I think could well be applied to relationships that occur on the spiritual path. He observes that "just as the woman in a relationship of trust may look to the man in power for an answer to what has been injured or unfulfilled in her, the man may begin to look to the woman as a source of healing for himself." With regards to men in positions of power, which would certainly include those who have assumed the role of spiritual teacher, he states that we have been raised in a culture that views many of the more feminine, vulnerable qualities as unacceptable. These feminine attributes are not killed off easily, however. Therefore, when males in power come in contact—in the form of a physically attractive woman (or man)—with these qualities that they have disowned, the drive to merge with the feminine can know almost no boundary. With regard to a woman—spiritual student, client, etc.—early wounds may make her vulnerable to the need for the male approval she may have been denied as a child. When such factors are operant for the spiritual practitioner (or the teacher), whether or not sex is involved, I believe that psychotherapy has the potential to assist the individual in reclaiming a "missing part."

It is undoubtedly the responsibility of the man or woman in power—the spiritual teacher in this case—to maintain integrity and not be a catalyst for the continuance

of patterns of early abuse or victimization. Another perspective, which I do not find contradictory, but compatible and equally compelling, is provided by Butterfield (1992, pp. 49-50) in addressing some of the crises that have occurred within Buddhist groups:

> Very few spiritual teachers who have slept with their students are tantric masters, and in most cases it may be accurate to claim that such behavior is a form of exploitation. But we must question what "exploitation" can mean in a context where two parties engage in sex by mutual consent. Let us assume that a student, of either gender, who sleeps with a spiritual teacher feels afterward that she or he has been diminished, alienated from self, abandoned, treated as an object, or used to enhance the teacher's power. These feelings have a twofold character; they may reflect insight into the real nature of the teacher's attitude, but insofar as they center on defending the self, they are also the ego-responses that Buddhist practice seeks to illuminate and undermine. An ethic forbidding the teacher to elicit such responses in a student assumes that self-clinging ought to be sheltered and protected. This is ultimately demeaning to the student; it turns the student into a kind of ward: "Yes, the teacher really is more powerful than you; because you are not adult enough to make your own decisions . . ."

Similar principles are relevant in the consideration of substance addictions. Issues surrounding teachers' and students' use of alcohol in some spiritual schools have provided practitioners with another arena within which to exercise discriminative awareness—which is normally occluded by the shadow. There are precedents for the liberal use of alcohol in some Eastern traditions. Under the influ-

ence of alcohol one relaxes one's defenses, and one's receptivity to spiritual influence can be enhanced. On the other hand, addiction reflects a craving for some early emotional nourishment. Shadow work explores the roots of such addictions.

Spiritual transformation involves *cathexis*—an alchemical process whereby primal energies that have been accessed on the path are allowed to arise and flood awareness without being acted upon. When these energies and those consumed in repressing these forbidden feelings are freed, they can all then be utilized for growth. This process, which is most clearly the aim of traditional *tantra*, cannot be effected while so called "lower emotions" remain repressed. Spiritual teachers have the knack for catalyzing the lower (and higher) aspects of self that are shrouded in shadow, bringing them to the light of awareness so they can be worked with. Perhaps many spiritual students need someone who will work explicitly with *samsara*, for there is no way for us to avoid direct contact with the neurosis surrounding money, food, and sex in the contemporary world. Western civilization virtually *requires* emotional repression of its members, and it is not possible for fundamental values of the traditional spiritual path (e.g., Hinayana and Mahayana levels of development) to be communicated through the culture in which we live—as may have been possible in Tibet or India.

The popularization of exoteric *tantric* practice in the West, and the misunderstanding of esoteric concepts, has created all kinds of possibilities for so-called practitioners—both students and teachers—to irresponsibly act out repressed energies, rather than to free inhibitions to aware-

ness in a way that encourages transformation. As we discussed at length in Chapter 2, *tantra* may thus be used as an excuse for the self-indulgence of repeated catharsis, or acting out through disguised hedonism and decadent sexual promiscuity. Traditionally, the teacher should hold the context for genuine transformation through the activity he or she engages and by the work that is subsequently catalyzed in others.

How the Teacher Gets Help

The importance of openness to help from peers and more senior practitioners on the path has already been mentioned with regard to students. In times past, teachers, as well, would "test" their enlightenment through contact with other adepts. In this way, a teacher would have the opportunity to assimilate new input, and to receive confirming or disconfirming feedback on his or her realization and ability to teach. New input is necessary in order for any system to remain healthy. Even the spiritual teacher is not exempt from the need to remain open for growth to occur. In my opinion, such openness to feedback is necessary because everyone has a shadow that can be the source of one's downfall on the path. The way in which a teacher accepts and utilizes subtle or overt feedback from his or her own master or other peer teachers can indicate his or her ability to provide spiritual help.

P.D. Ouspensky, for example, was a well-known student of Gurdjieff, a writer and scholar of note, and a teacher in his own right. But he suffered mightily in his relationship to his teacher, and was unable to access the transformed state that Gurdjieff embodied and reflected to him because

of primal blocks he could not or would not work through. Gurdjieff addressed Ouspensky's weakness through numerous creative means, which Ouspensky, a brilliant, and prideful man, apparently had difficulty comprehending. In *Struggle of the Magicians*, Patterson (1996) contends that, at times, Gurdjieff's enigmatic and seemingly irrational behavior toward Ouspensky was meant to "jar Uspenskii [alternate spelling used by Patterson] into seeing the spiritual trap of power and pride that ensnares him" (p. 87). For example, Gurdjieff is said to have, on occasion, appeared totally disinterested in certain ideas of Ouspensky's; while at other times, he openly plagiarized them in his own lectures, apparently quoting whole pages of Ouspensky's books verbatim, but without attribution.

Despite Ouspensky's own facility with spiritual teaching, he was not open, due to his own projections, to Gurdjieff's communications, which challenged a central aspect of his character. Perhaps Ouspensky's difficulty was actually more of a struggle with his own shadow features than conflict over his teacher's apparent lack of conventional integrity.

Patterson states that Gurdjieff had given Ouspensky the nickname "Wraps Up The Thought," and that the nicknames he gave often pointed to a person's chief weakness (p. 201).

> What Gurdjieff saw was that when Uspenskii was asked a question, he would answer so completely that there was nothing left of the question. In effect, he demolished it. Answering in this way not only demonstrated, one could say also showed off, his great intellectual capacity, but also pointed to a need to control; a word he used quite often.

The Shadow On The Path

What Uspenskii was likely controlling was the emotional center.

Recall, as noted in chapter 2, that Gurdjieff referred to man as a three-brained being, with intellectual, emotional and moving centers.

While Ouspensky's ability to absorb and communicate spiritual teaching clearly had power, he was unable to fully live it, and therefore his ability to teach was hindered in a fatal way. Patterson refers to Ouspensky's "extreme individualism," which Ouspensky himself admitted "was the fundamental feature of his attitude toward life" (p. 201). This feature may have developed, at least in part, due to the emotional scarring Ouspensky experienced early in his life from the deaths of his father, grandfather, and mother, and later his sister. He was left, then, without a family. Thus, an aspect of himself was chronically self-protecting, controlling and interpreting experience, which left him isolated from parts of himself and from others. Such dynamics apparently blocked transformation of the emotional center, which could "plunge him into the death and chaos he felt as a child" (p. 203).

Though he continued teaching, Ouspensky left Gurdjieff, unable to resolve his primal difficulty (although some speculate that he was able to do so in the last days of his life). At one point he confessed that the System he taught (based largely on Gurdjieff's ideas) had become a profession rather than a way of life for him.

With respect to contemporary teachers who work in isolation from other teachers, I believe that they are more likely to be subject to and ruled by the shadow within themselves than are their peers who interact freely with other

teachers. Hence, despite deep personal understanding, iso-
lated teachers may distort the purity of the teaching in some
unseen way.

Finding Real Gold

The crises in contemporary spiritual communities have
all been precipitated by teachers' behaviors that many have
considered immoral. A common perspective on these cir-
cumstances assumes that the teacher, though highly re-
garded in some quarters by others on the spiritual path,
succumbed to the temptations that accompany power; that
the teacher's shadow-hungers, rooted in buried early needs,
got out of control; that the teachers deceived themselves
and rationalized their behaviors, and took advantage of
others for their own selfish reasons.

Through the media, the public tries to satisfy its hun-
ger for a taste of what has been hidden in the lives of indi-
viduals. In terms of the spiritual path, the media focuses
on those aspects that demonstrate the misguidedness of
alternate views of consensus reality. Scandals have there-
fore reinforced and substantiated the view that all spiri-
tual approaches are advocated by charlatans who simply
prey upon weaker, more naive individuals' susceptibility to
charismatic influences. In an October 20, 1997 *Newsweek*
article on "Why We Love Gurus," Wendy Kaminer presents
a stereotypical view of the motivations of teachers by writ-
ing that "no one who seeks worship, however covertly, de-
serves respect." By critiquing some of the most popular new
age gurus, she assumes that there is nothing to spiritual
teaching that is not explained by their drive for power,

inviting "identification and idolatry."

What is not perceived by the general public is the varying quality of teachers' understanding and inner motivation, based on the nature of the personal transformation they have experienced and the spiritual influences they have bonded to. Some "pop gurus" are altogether seductive and narcissistic, playing into the shadow weaknesses of followers in search of comforting philosophies. In this regard, I find much to agree with in Kaminer's (p. 60) assessment:

> Gurus often tell us exactly what we want to hear. "There is no death." That is the primary message of spirituality gurus. Better yet, this relief from fear of death is easily obtained. The spiritual peace and enlightenment offered by pop gurus doesn't require a lifetime of discipline. It requires only that you suspend your critical judgment, attend their lectures and workshops and buy their books or tapes.

But, as the mystic Rumi said: "Counterfeiters exist because there is such a thing as real gold." There are other teachers, both with and without formal traditional orientations, who have experienced growth, maturity, and, much more rarely, transformation of the identity—making such necessary ingredients available to practitioners on the path. Some have maintained a committed relationship to students they have been involved with sexually. Different degrees of self-aggrandizement may or may not be a factor in their presentations. In any case, the media reflects the projections of the mainstream culture's shadow features onto those in the teaching role: we ridicule in others the narcissistic, love-starved, power-hungry qualities that are actually within ourselves.

Referring to the crises that have occurred within her tradition of practice, Butler (1990, p. 16) states that she

> found the scandals heartbreaking and puzzling. I thought of Buddhism not as a cult but as a 2,500-year-old religion devoted to ending suffering, not causing it. I also knew that the teachers involved were not charlatans, but sincere, thoroughly trained spiritual mentors, dedicated to transmitting the Buddhist dharma to the West.
>
> As a journalist, I noticed that media coverage of the scandals seemed to reinforce secular America's deeply held suspicion of all religious impulses. The teachers came across as cynical exploiters; their followers as gullible fools.

On a mass scale, shadow features that form around early emotional deprivations show themselves in the need of the populace to assert its independence from *any* form of help, and to strongly react to any implication of being dominated or controlled. Repressed feelings around these matters are evoked by both pop gurus and authentic spiritual teachers. Authentic teachers and/or a traditional nondualistic spiritual context also magnify the false *persona* that hides our existential suffering. This magnification is provoked by the honest and ruthless reflection of our psychic reality.

The impulse to look deeply into our assumptions about life is highly feared; it is fundamentally repressed. Therefore, genuine teachers realize that what they are offering is not what the public is buying. The culture-at-large will never support a radical spiritual context. Western society has become increasingly focused on the outer (as opposed to the *inner*) world. The radical approach of acknowledging and becoming responsible for all aspects of self, including the

shadow as part of a process of unraveling and dying to the idea of separative ego identification, is diametrically opposed to mainstream values. This is most clearly evident in relation to *tantra*. Kane (1994, p. 334) notes that "while sexual and substance abuse behaviors are reframed by *tantric* discipline as a path to the highest good, they continue to be labeled as deviant by conventional moral standards."

The collective shadow is thus most dramatically projected onto those whose work most overtly challenges the mediocrity of unexamined life. By denigrating the spiritual perspective, we keep from having to look deeply at our suffering and its cause. If those on the path are shown to be immoral scoundrels and naive followers, then there is nothing about spiritual teaching that is worthy of consideration. Teachers who threaten to expose the shadow of the conventional life perspective are thus condemned, vilified, and made into scapegoats as a means of self-protection, and our ideas of ourselves can thus remain firmly and safely in place. Those who do not seem to do this may be regarded benignly (e.g., the Dalai Lama), but those whose work directly confronts unconscious forces are not understood—and therefore feared. Teachers whose presentation confronts the collective shadow may be neatly lumped by the mainstream media into a category of charlatans who lead cults.

Werner Erhard

Werner Erhard, founder of the Hunger Project, recipient of the Gandhi Humanitarian Award (1988), and the

creator of *est* and *The Forum*—two highly successful personal growth seminars experienced by over a million people in the past twenty years—is a classic example of a teacher who has been adversely portrayed in the media. Some dispute whether or not Werner Erhard is enlightened, or even a man of spiritual integrity. Regardless, the public response to him and the *est* organization seems indicative of the way the collective shadow is projected. In 1991, he received national media attention that effec-

Werner Erhard

tively created a stereotypi-
cal image of him as a mon-
ster.

In April 1991, accord-
ing to the *Daily News* of Los
Angeles, "Several IRS
spokesmen were reported
as saying that Erhard owed
millions of dollars in back
taxes; that he was transfer-
ring assets out of the coun-
try, and that the agency was
suing Erhard. The implication was that Erhard was a tax cheat."[1] In a *60 Minutes* segment on national television, he was accused by two of his grown children of abuse and physical violence—in addition to more general attacks on his character by disgruntled former associates. According to Jane Self (1992), the producers were in possession of evidence which demonstrated that the charges against Erhard were false, well before the *60 Minutes* show aired. The information that was disregarded included, in part, six sworn affidavits that contradicted the descriptions of a particular

incident of alleged physical violence and the results of a lie detector test administered by one of the leading polygraph experts in the world in which Erhard proved his innocence, along with an offer to take another test under the supervision of the CBS broadcasting network. "To the amazement of Erhard's attorneys, *60 Minutes* ignored the evidence and declined the offer" (p. 90). The allegations were aired anyway without specifically acknowledging the existence of contradictory evidence, nor Erhard's own explanations—namely, the hostility of an ex-wife who had had influence over their children throughout their lives; and his decision early in his public career to devote himself primarily to his public programs and not to family life. Erhard asserts that his commitment has been to his public programs as the arena through which he could make the greatest contribution to the world, rather than through family life. Following the broadcast, his children said that their interviews with CBS had been highly edited, with nothing positive that they had said about their father included; and that they had been prodded to reveal the "dirt" about him. Moreover, the *Los Angeles Times* reported facts supporting the position that another organization, whose founder considered Erhard an enemy, was involved in his character assassination in the media, including the *60 Minutes* debacle.[2]

Time Magazine and other publications subsequently reported that rumors of Erhard's tax fraud had proven to be untrue, and that Erhard had won $200,000 from the IRS as a result of spokesmen having made false statements to the media about him.[3] In 1992 the daughter of the *est* founder filed suit against a newspaper and staff writer, charging that her privacy was invaded and that she had been

tricked into distorting details of her father's life by being promised book royalties that would bring her $2 million.[4] Allegations of abuse (including incest), which had been widely reported in the media, were recanted by his daughter.

Erhard (in Self, 1992) makes a distinction between self-respect, reputation, and image. He believes that self-respect is based on relationship to one's own actions; reputation has to do with how others experience those actions directly and personally; and image relates to how one is viewed by those who have never heard of you, or who base their opinions on what others have told them. He holds that his self-respect and reputation are intact. Regarding image, he says he has little concern. "The media has seen to it from the beginning that I never had much of an image. And, for the most part, that didn't stop me from fulfilling the opportunity that people gave me to make a contribution (p. 26).

Ultimately, we must find our own answers. At the same time, this requires staying open to various sources of wisdom so that we do not delude ourselves and avoid critical aspects of work—and this may necessitate work with a teacher. If spiritual crisis is precipitated by a teacher's behavior, the most relevant questions to ask ourselves may be:

1. Does the teacher's activity obviate or preclude the spiritual value of association with him or her?

2. Are there shadow features that have been provoked through the crisis, challenging my own identity and assumptions about the path and about life, and calling for my attention in order to be acknowledged and transformed?

In dealing with the latter question, I believe, the former becomes more clearly answerable. Working with our

121

shadow features (whether catalyzed by a teacher or not), while maintaining whatever formal spiritual practice is inherent in our tradition, are the most productive ways to make use of a crisis on the path.

The Community
and the Shadow

Ego's separative assumptions and fixed psychic structure make work with others on the path a key element in the transformational process. Without this interaction, we can remain isolated—not only from others, but from aspects of ourselves. The energy and attention for focus on spiritual work can be sustained by a group, whereas in individuals, even those dedicated and committed to the path, it ebbs and flows. Regarding the need for group involvement, Gurdjieff stated (in Ouspensky, 1949, p. 289):

> You do not realize your own situation. You are in prison. All you can wish for, if you are a sensible man, is to escape.

> But how escape? It is necessary to tunnel under a wall. One man can do nothing. But let us suppose there are ten or twenty men—if they work in turn and if one covers another they can complete the tunnel and escape . . . An organization is necessary. Nothing can be achieved without an organization.

Shadow features that remain in darkness are brought to the surface to be faced and dealt with in relationship to others on the path. Working in a community can thus raise painful primal issues—but can also provide the matrix for the exploration of the search for truth on a much deeper level than we would otherwise ever engage on our own.

Gurdjieff orchestrated situations among students in ways that brought them into contact with their shadows. In *Boyhood with Gurdjieff*, author Fritz Peters (1980) relates his experience at the Prieuré in Avon, France, where the Institute for the Harmonious Development of Man was formally located for some time. Peters met Mr. Gurdjieff during his eleventh year and spent about four years at the Prieuré. He describes how, at one point, a reorganization of the school was made, and a Miss Madison was appointed as director to supervise students and their activities. She was to be treated, in Gurdjieff's words, "as if she were myself." Miss Madison decided that a military style of discipline should be established, and she began to dictate certain rules and regulations, including the requirement that a pass be obtained in order to leave the property. Thereafter, some individuals chose not to leave via the front gate, but secretively scaled the back wall when departing. Tension mounted, and it became known that Miss Madison, who

informed Gurdjieff of all developments as she saw them, maintained a black book in which records of misdemeanors were kept.

The young Peters had duties that included taking care of the chickens, which would occasionally escape from their coop and ravage a flower garden. After one such incident, Miss Madison decided that he, as responsible party, should not be permitted to leave the grounds for a week; and that, furthermore, if any of the chickens were to subsequently repeat the offense, she would kill any that she found in the garden. This happened, of course, and Miss Madison wrung one of the chickens' necks. Both she and Peters were called into Mr. Gurdjieff's office to discuss the matter. After speaking to them both about their actions (with Peters admitting to pulling out clumps of Miss Madison's flowers following the incident), Gurdjieff excused his director and spoke privately with the young boy. He said that "in life, the most difficult thing to achieve for the future, and perhaps the most important, was to learn to live with the 'unpleasant manifestations of others'" (p. 40).

This principle of bearing the inner emotional pain that arises in relationship to others is difficult, not primarily because of others' unconscious activity, but because of the shadow issues that are provoked in us. When we exhibit a primal out-of-control response, this should immediately cue us in to the fact that an issue that needs work is being triggered for us. Gurdjieff realized the value of utilizing people who, because of their own blindness, would bring others into contact with their unconscious shadows. At the same time, he seems to have always communicated a wry humor and ruthless compassion—indicative of the

transcendence of shadow forces within himself.

Communities can thus provide the matrix within which individuals can come to more clearly self-observe—a basic element of psycho-spiritual practice. But communities also have their shadows, and often fall into the trap of collective resistance. The shadow of the teacher may be adopted within a group, due to the fact that the teacher is a role model both consciously and unconsciously, and because individuals with specific characterological features may be attracted to aspects of the teacher's shadow. Working through the group shadow may be a particularly important aspect of a practitioner's process.

Community as Fetter

W. Brugh Joy, a widely-respected healer, discussed his experience with the shadow in the Findhorn community in his book *Avalanche* (Ballantine Books, 1990, p. 199). Shortly after its inception, Dr. Joy addressed the Findhorn group and received a positive response to his reflections about the effects that an influx of people and business concerns might have on the soul of the organization. Five years later, when asked to speak to the community again, he raised issues that the group was apparently not so interested in considering:

> I said that the forthcoming period was to be a time for contraction and for the release of physical assets. The community had enjoyed a phase of increase and abundance, but the counterphase of that cycle was approaching , , , I talked about the consequences of feeling "special" and how the battle against the "evils of the world" not only creates the

"enemy," but is actually a projection of the darker aspects
of the community onto the world screen ... Needless to say,
the talk was not popular and I was fast falling into the "un-
welcome guest" category.

Joy describes being the target of a public attack at the
community meeting that followed his presentation. The
resident poet ("whose function is to give voice to the col-
lective") berated him with "venomous poetry" and "wrath-
ful righteousness." Brugh Joy notes the obvious contradic-
tion between the disowned primal feelings and the com-
munity *persona* that was generally characterized by love and
light. He states that the poet's tirade continued for some
time as community members expressed a wide range of
emotions, but ended more true to form with a consoling
gathering around those who had organized the event.

Thus, a community shadow may show up in terms of
accepted ways of "group-think" that condescends, dis-
counts, or disallows other perspectives—a banding together
in a way that makes the group right and others wrong, as
community becomes a matter of "us versus them." Adopt-
ing the exclusive ideology of a group can mask an underly-
ing drive for ego security through group identification. In
this way, one can get lost in the crowd while having the
imaginary assurance of being taken care of by the group or
teacher. Spiritual experience in this case can be, as Freud
maintained, an attempt to return to the womb, and feel-
ings of betrayal can result when this childish perspective is
turned on its ear during times of personal or community
crisis. Conversely, practitioners who isolate themselves,
while maintaining an aloof style of involvement may

appear as lone warriors, within or outside of community structures. While such individuals may rightly assume that spiritual truth is accessible within each person, they may use this rationalization to avoid dealing with their own shadow features and attendant psychic distortions—blind spots that would become painfully apparent if they did not hold out from relationship with others. Avoiding relationship through maintaining the stance of the lone warrior (and perhaps criticizing the shortcomings of others in community) encourages spiritual bypass. The spiritual community potentially offers the environment in which one's inner process, including work with the shadow, can be supported.

But community members can also create a dark, oppressive atmosphere that encourages defensiveness, hiddenness, and judgment. Within the sphere of spiritual life, all the conventional drives for power, control, safety, recognition, success, approval, perfection, etc., are as active as in worldly settings. A critical group-superego may dominate community life at various times, and it is the challenge of group work to acknowledge and deal with the roots of such dynamics. The community is thus an alchemical laboratory, and a wise and mature group can evolve by working through the various stages of a spiritual organization's growth. With the dedicated intention of a majority of individuals to expand beyond their static identities (a key being the willingness to explore the shadow, individually and collectively), a bonded group can form that is greater than the sum of its parts. The effort required to build such an authentic, open, and cohesive group can be long and arduous, but its joy and value undeniable and unique.

Communities in Crisis

The experiment of spiritual community is challenged in the midst of community crisis. Primal feelings are tapped in the psyches of practitioners, and ardent devotees may find themselves entrapped in never-imagined issues of faith. With the unleashing of shadow forces, it is difficult to accept the possibility that such inner and outer disturbances may be *needed* in the process of continued spiritual development. Nonetheless, the shadow features that surface bring us into contact with aspects of ourselves that may need to be integrated in order for the work of transformation to continue at deeper levels. In this section, critical events in four contemporary spiritual communities—the San Francisco Zen Center, SYDA Yoga, Vajradhatu, and the Rajneesh community—will be discussed. Additional situations involving the Dawn Horse, Los Angeles Zen Center, and Kripalu Ashram communities will also be mentioned to further illustrate ways in which shadow forces have arisen within communities dedicated to spiritual life.

SAN FRANCISCO ZEN CENTER

Suzuki Roshi, who had come from Japan in 1959, had long thought that American people might be open to receiving Zen Buddhist teaching. In 1960, Richard Baker, who had attended Harvard University, moved to San Francisco. He had not as yet directed his energies toward any specific life discipline, but soon found himself drawn towards Suzuki Roshi and the practice of sitting meditation. In 1962, Suzuki Roshi established the San Francisco Zen Center, but it was Richard Baker, who had become his attendant,

Suzuki Roshi

who was actually responsible for the development of its physical structure.

Suzuki Roshi had the idea for a retreat location outside the city for concentrated practice, and Baker was responsible for procuring Tassajara Hot Springs, which became the first American Zen monastery. He was ordained there as a Zen priest in 1967, and then sent to Japan, where he spent most of his time in the study and practice of Zen for the next few years. In 1971, in the presence of many of the most notable Buddhist teachers in the Western world, Richard Baker received *dharma* transmission from his teacher, and was installed as abbot of Zen Center. Suzuki Roshi died a few weeks later. Before his death, the elderly Roshi apparently told his student, "I am so sorry for what I am about to do to you." Tworkov (1989) describes the much publicized crisis that this community endured.

Community businesses thrived under Baker Roshi. He proposed the purchase of a large tract of land in 1972. The board of directors was opposed to this action, but when Baker threatened to resign, the board acquiesced. Community members worked on the land—known as Green Gulch Farm—and marketed the produce in restaurants and health food stores. Yet beneath the surface success of the commu-

nity, trouble was brewing. For one thing, the presumed equality between lay non-residential membership and monastic membership—which involved residency and employment commitments within the community structure—began to be weighted toward the monastic relationship. Some saw this as conflicting with Suzuki Roshi's intention. Another issue evolved from the fact that people brought personal problems to *dokusan*, a formal meeting between teacher and student in which the teacher responds directly and intuitively to the student's mind, free of any reference to personal history or circumstance. For some people this entailed a growing psychological dependence on Baker Roshi, along with a growing hostility. Because he was the authority behind *all* activities, some students looked to him to fulfill their image of perfection, which he was unable to do. Problems increased as some practitioners used the Zen practice of silence, which was an aspect of the practice environment at the Tassajara retreat center, in the service of suppression of emotional turmoil. Furthermore, no psychological forum existed within the community for individuals to explore and work with their inner emotional processes.

Baker Roshi spent money freely, apparently unattached to it. In 1979, the restaurant "Greens" was opened in San Francisco. It was frequented by the rich and famous, and Baker regularly dined there with politicians and public figures. This may be explained as a way in which he attracted interest and support for the establishment of Buddhism in America, but some saw him as corrupted by fame and power. In 1980, Baker bought a BMW for his own use.

When it came to light a few years later that Baker Roshi

was having an affair with a married woman, Tworkov (1989, p. 238) notes that:

> All hell then broke loose with a bitterness that facts alone cannot explain. The news hit like a seismic bolt that blasted out from the undercurrents every trace element of rage. . . This was California 1983, and Zen Center had responded with the hellfire damnation of the Puritan Fathers.

Many members heatedly insisted that Baker Roshi admit his wrongdoing. At one meeting, a Zen priest called him "a pile of shit." Baker Roshi ended his affair, which he has said he later regretted, referring to the woman he had become involved with as "the love of his life." Regarding accusations of sexual exploitation of other students, he stated that this "is generally meant to imply someone who is using his power with women who are very young or where there is a misuse of his authority. I have not done that" (in Tworkov, 1989, p. 240). He observed how, in Japan, people do not care about a teacher's personality—only about his role as an agent for enlightenment. Drinking or womanizing is not an issue in that culture when this is the case.

In the heat of the crisis, a Suzuki Roshi "revival" occurred, in which the late teacher was idealized by some members who were new to Zen practice, and others who hardly knew the founder. In actuality, this could be interpreted as a denial of Suzuki Roshi's authority, by undermining the *dharma* heir he had selected.

Baker Roshi acknowledged that he had disempowered students—by being unaware of his tendency. "There is a

certain passage to adulthood in our society that everyone has to go through or they feel defeated, and I interfered with that rite of passage" (p. 242). He maintained that the only thing scandalous that happened at Zen Center was the way he was treated. Tworkov describes how, in the midst of that situation, "people suddenly looked monstrous to each other and to themselves, and it was terrifying... However large and amorphous Zen Center had become, it responded to the crisis as though it were a traumatized nuclear family" (p. 242).

In the aftermath of the crisis, psychological professionals were brought in to work with Center members on communication and relationship skills. The traditional role of the teacher as the source of spiritual understanding was replaced as the role of the board of directors expanded. Baker Roshi resigned as abbot of the San Francisco Zen Center in 1983. He has maintained centers in Santa Fe, New Mexico and Crestone, Colorado, and currently teaches widely in Europe as Suzuki Roshi's *dharma* heir.

The manner in which Baker Roshi ran the San Francisco Zen Center had the effect of irritating early emotional hurt in practitioners. (I doubt that the situation could have happened if a large number of community members had felt empowered by their own upbringings.) Because of their issues around authority, some students felt discounted, ignored, manipulated and disempowered. Feelings of dependence, rebelliousness, hostility, abandonment and betrayal all erupted with the charges of sexual impropriety. The depth of the emotional conflict seems to have reflected the wounds of unresolved psychological issues which had been opened in the *sangha* (spiritual community), in

response to Baker Roshi as a figure of transference. His characterological qualities undoubtedly played into the situation. Beyond the story of the actual events, the shadow features and primal feelings buried within the inner lives of the students of the San Francisco Zen Center were certainly triggered by the crisis.

SYDA YOGA

In 1947, at the age of thirty-nine, Muktananda found his guru—Swami Nityananda—in his native India. Muktananda came to the United States in 1970, traveled extensively, and founded SYDA (Siddha Yoga Dham, or Home of Siddha Yoga)—which by the mid-1990s had grown to include approximately 550 meditation centers and ten ashrams worldwide. These included a large ashram in South Fallsburg, New York. Muktananda wrote over thirty books on the spiritual process and on the inner *shakti* energy of the body, which is activated by the teacher. The sexual energy is particularly important in this regard, and Muktananda recommended sexual abstinence, which was required during visits to his ashrams.

Swami Muktananda

Harris (1994) describes the salient events that generated a spiritual crisis for

many members at SYDA Yoga. In 1981, at age seventy-three, Muktananda, who was always assumed to be celibate, was accused of having sex with young ashram women. A detail of these stories was that the alleged liaisons involved non-ejaculation— understood by some as a *tantric* technique that conserves sexual energy. The matter of Muktananda's relationships, according to Harris, has always been denied by the organization. However, an article in a 1982 *Siddha Path* magazine told the story of a saint, Ranganath, who lived as an ascetic for most of his life, but at one point had a vision indicating that he should partake of worldly experience, including sexuality. The story communicated a traditional teaching lesson: a master's practice cannot be understood from the perspective of ordinary ego consciousness.

During 1981, Muktananda appointed a young Indian man, whom he had named Nityananda after his own teacher, to be his successor. Early in 1982, not long before he died, Muktananda appointed Nityananda's older sister, whom he named Chidvilasananda (also known as Gurumayi), as co-successor. When the young Nityananda was later accused of having affairs with several women, a community crisis began in earnest. Nityananda freely admitted to having broken his vows of celibacy between the ages of eighteen to twenty-three.

Harris (1994) relates the apparent attempts to hush-up members who had knowledge of some of Muktananda's alleged activities, and of the blacklisting of members who left or visited other teachers. She cited

> the intimidation of those who leave SYDA and who appear to threaten it—that has carried over to Gurumayi's SYDA and has continued to shadow the organization, especially

in connection with allegations about the treatment of Gurumayi's brother and co-successor, Nityananda. (p. 100)

During a commemorative ceremony at the SYDA Indian ashram in Ganeshpuri, Nityananda was allegedly held for eighteen days and beaten with a cane for three hours by the women he had been involved with—at Gurumayi's exhortation. During this period, he made a public appearance to announce that he was stepping down as guru. In an interview and in a note he wrote shortly following this event, Nityananda denied being mistreated and thanked his sister. He later explained these comments by saying that he made them in the hope that he would be harassed no further. He said that he had given up resisting the efforts to disempower him. In later published accounts, SYDA has disputed parts of Nityananda's story and, according to Harris, has portrayed him as an "inveterate liar."

In 1989, Nityananda decided that he really should teach, and renewed his vows of celibacy. Wherever he went, he continued to be badgered—picketed at airports and at public talks. While teaching in Ann Arbor, Michigan, leaflets were publicly distributed, which proclaimed: "Warning!!! The man you are about to see is a fraud. We know—he deceived us and ruined our lives" (in Harris, 1994, p. 108). SYDA has disclaimed any involvement in such activity, saying that people who demonstrate against Nityananda do so at their own volition. Harris notes that "local press accounts and police files registering complaints against overenthusiastic picketers mark the trail of his travels" (p. 106), and that a series of Nityananda-bashing panel discussions

occurred following his resignation from SYDA. She states that

> even if one accepts SYDA's own version of its history—as a tale of two perfect beings whose tradition has been sullied by an all-but-demonic transgressor—one has to wonder why so little effort appears to have been put into the task of overcoming the rage directed toward Nityananda and moving on. In other contexts, that is what SYDA teachers advise devotees to do all the time. (p. 109)

The SYDA followers who picketed and harassed Nityananda appear to have been holding onto years of anger that, as a therapist, I can only assume has its roots in inner conflicts traceable to early childhood. Quite unintentionally, Nityananda brought the issues of sex and power to the psychological surface of the community. These had remained hidden, for the most part, until the end of Muktananda's life. Repression of sexual and related emotional needs may have been reinforced through the ways in which strict sexual disciplines were valued. Primal urges which had been relegated into the shadow could not be contained forever, and Nityananda, as the catalyst for unleashing them, has been identified as the problem and miscreant.

If true, the alleged suppression of information within the organization implies a different motivation than that of employing discretion about sensitive matters. Suppression may serve the maintenance of the superego's image of perfection, keeping shadow issues from erupting and more people from questioning the validity of the idealized path;

yet relating with the shadow, in oneself and in others, is an integral part of the spiritual process. Individuals who have used Nityananda as a scapegoat may have done so in order to keep their own issues, stirred by his behavior, out of awareness, and to keep a spiritual fantasy in place that avoids the reality of the path.

Vajradhatu

Chogyam Trungpa Rinpoche was born in Tibet, the 11th incarnation of the Trungpa *tulku*, and head abbot of the monastery at Surmang. After a dramatic exodus from

his native Tibet following the Chinese invasion, and some period of time in India, Trungpa Rinpoche attended Oxford University in England. While there, he became committed to the cause of bringing Vajrayana Buddhism to the West, and clearly decided that he would give up his monastic vows in the process. When Trungpa arrived in America in 1970,

Chogyam Trungpa Rinpoche

Fields (1992) notes his response to the many who were curious and interested in jumping immediately into *tantric* work: "Please sit; sit a lot" (p. 309)—this refers to meditation practice and the need to create a well-grounded matrix for traditional spiritual understanding. He was invited

to teach at the University of Colorado, and decided to settle in Boulder where a community of students formed around him.

Although Trungpa worked closely with students, his work also had a public dimension. In 1974, he established Naropa Institute, open to Buddhists and non-Buddhists, with a secular curriculum but an underlying spiritual orientation. Later that same year, the XVI Karmapa (the head lama of the Karma Kagyu order to which Trungpa belonged) visited, and more of the traditional form and intent of spiritual teaching was communicated.

Trungpa Rinpoche's teaching methods were annoying, confrontive and radical. Often he was hours late for talks, a fact that required that individuals deal with the same boredom that came with meditation practice. He held wild parties that lasted late into the night, after which students were always expected to attend sitting practice the next morning.

After several years of preparation work with his students, Trungpa began to introduce them to *tantric* Vajrayana practice, warning them that "working with the energy of Vajrayana is like dealing with a live electric wire" (in Feuerstein, 1990, p. 73). A story that damaged his image came to light following a party that had served as the occasion of a teaching demonstration. Guests who had insisted upon experiencing *tantric* teaching, despite being discouraged from attending, were required to strip and dance along with other community members. When it was reported, this distressing and morally questionable circumstance sent shock waves throughout the Buddhist community. For some, trust in Rinpoche was shattered. "What was

Trungpa's point?" they asked. "Was he cutting overly ambitious seekers down to size, or had he just lost it?" Students were more or less left to their own devices to interpret the event and deal with feelings that had been unearthed.

Trungpa Rinpoche's use of sex and alcohol was unfathomable to many, yet the fact of his many relationships and his extensive drinking were always kept out in the open.

Butterfield (1992) notes that *tantra* is an accelerated path, which is not for everyone, but that its aim is the same as that of other lineages—realizing the essential state of unity beyond egoic identification. "Tantra does this by using and transforming neurosis instead of rejecting it, and by preparing the student, through devotion, for unity with the guru's mind" (p. 49). Many students came in contact with powerful unconscious forces through their involvement with Trungpa on the path. Some behaved in the same way that individuals who are not interested in a path of spiritual or personal development might, wanting "to be part of the inner circle, where the action is, and sleep with the figures who had the power" (p. 51). The *tantric* process encouraged students to work openly with the neurosis of mind rather than deny its existence.

A good number of community members became heavy drinkers. Butler (1990) notes that some joined Alcoholics Anonymous in the early 1980s, observing that this admission of the need for help with their addiction seemed to threaten some practitioners. By the mid-1980s, she states that over 250 Vajradhatu members had joined Al-Anon, and that these were mostly wives of alcoholic husbands.

The psychoanalyst Alan Roland (quoted in Butler,

1990), states that "the need to have a figure to respect, idealize and imitate is a crucial part of every person's self-development. But Eastern cultures are far more articulate about that need and culturally support it" (p. 19). In the West, early unmet needs result in repression and incomplete developmental maturation, and seem to make individuals more susceptible to a superficial mimicry of the form of their ideal. In this way, underlying childish emotional patterns and ways of abnegating rather than assuming responsibility can remain disguised. Some people may be inclined and able to undergo the trials that accompany growth, and be open to varying degrees of transformation through the intensity of association with a spiritual teacher. Others may not.

In 1987, at the age of forty-seven, Trungpa Rinpoche died of heart failure related to terminal alcoholism. Numerous accounts exist of the equanimity and power of his presence in his last days, and many believe that whatever the reason for the form of his activity, he lived and died for the purpose of bringing others to the realization of Buddhist spiritual understanding. A message written by Trungpa Rinpoche and read after his death declared (in Fields, 1992, pp. 360-361):

> Birth and death are expressions of life. I have fulfilled my work and conducted my duties as much as the situation allowed, and now I have passed away quite happily ... On the whole, discipline and practice are essential, whether I am there or not. Whether you are young or old, you should learn the lesson of impermanence from my death.

The Shadow On The Path

Osel Tendzin, formerly named Thomas Rich, had been installed as the Vajra Regent, Trungpa Rinpoche's lineage holder in 1976. After Trungpa died, it was announced that the Regent had AIDS, and while knowing that he had the disease had infected an unsuspecting person. Osel Tendzin later acknowledged that he had acted as if he were operating under some kind of spiritual protection. An emotional split occurred in the community. Some blamed Tendzin for all of the organization's problems; others seemed to manifest denial, while a great many fell into what was called "the heartbroken middle." The Vajradhatu board of directors called for the Regent's resignation, which he would not give. Tibetan teachers were consulted, and Osel Tendzin went into retreat, where he died in 1991. Osel Mukpo, Trungpa's eldest son, was consequently installed as leader of the Vajradhatu community.

Many observers have criticized Trungpa for his lack of ethics, for poor decisions such as the appointment of his Vajra Regent, for being in denial about his alcoholism and human limitations and for scandalizing the expression of Buddhism in the West. Others believe that his teaching demonstrations were founded in a compassion that is not understandable from ego consciousness, which created lessons that brought them to relate to life more directly, appreciatively, and without their habitual defensive structures. Butterfield (1992, p. 51) states that

> His outrageous style enabled me to accept myself as I am and relieved me of the burden of having to justify myself to anyone ... In my personal life, I chose not to model my actions on those of Trungpa and Tendzin ... I am free to make

this choice honestly and responsibly because the man who taught me the most about loving was free to give his teachings as he saw fit, and for no other reason. If I had thought he was not genuine, I was free to leave him.

Writing about the "fall" of Trungpa Rinpoche, Fields (1992, pp. 367-368) states:

Psychologically, it underscored the responsibility that the phenomena of "transference" placed on therapist or teacher. And spiritually, it stripped away the veil of dependency on teacher and group, bringing practitioners back to the critical self-awareness and self-reliance crucial to the teachings of the Buddha, who said, "Do not believe in anything simply because you have heard it. Do not believe in traditions because they have been handed down for many generations. Do not believe in anything simply because it is found written in your religious books. Do not believe in anything merely on the authority of your teachers and elders, but after observation and analysis, when you find that anything agrees with reason and is conducive to the good and benefit of all, then accept it and live up to it."

Vajradhatu practitioners seem to have been intentionally invited to relate to all aspects of life, including the experience of shadow features, through exploring the path of *tantric* Buddhism with Chogyam Trungpa Rinpoche. Primal feelings were exposed in the process, and students presumably decided to what extent they would become responsible for them. Some attempted to access their teacher's power through imitating habits such as drinking, becoming part of the inner circle, and engaging in sexual

relations. Students who participated on these levels may have been driven by a variety of real and/or shadow urges— e.g., to vicariously share in a power lacking in themselves, through association with Trungpa or the Vajra Regent (Tendzin). Experiences that brought shadow features to the surface were a way for some to acknowledge and take responsibility for aspects of their lives that had been hidden from awareness. For others, underlying primal issues and the persistence of destructive patterns were not resolved.

THE RAJNEESH (OSHO) COMMUNITY

Bhagwan Rajneesh (now referred to as Osho) began his public life as a charismatic university professor in India. When he began to function as a spiritual teacher, he was seen as quite scandalous, and was called the "sex guru" because he talked openly about sex and the spiritual process. In the puritan-like climate of mainstream Hinduism, his up-front position on the divine nature of sexuality was held in disrepute. From early on, devotees felt a need to protect Bhagwan when he made public appearances, as threats and hostility toward him were common.

Rajneesh's organization grew quickly despite (or perhaps partly due to) the controversial nature of his teaching. Westerners flocked to India to become his

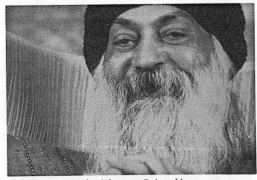

Osho (Bhagwan Rajneesh)

sannyasins—a name generally reserved for Hindu renunciates who typically don saffron-colored robes. Of particular significance was the arrival of a dynamic Indian devotee named Sheela—a woman with a more typically Western inclination toward money, power, and material objects. According to Franklin (1992), some felt that Sheela was never particularly drawn toward the whole community scene going on around Rajneesh, but rather saw in the situation the possibility to set herself up in a position of power and control over people and resources. It is speculated that Bhagwan may well have known her nature and intentions, and may have given her authority as a kind of teaching lesson to his *sannyasins*. Yet, some also argue that in the end even he had underestimated the intensity of her shadow features and drive for power.

Franklin (1992) discusses the crisis that surrounded the Rajneesh community. One of the first big scandals to hit the press focused on the sex and violence that reportedly went on under the guise of psychotherapy in the encounter groups held at the community ashram in Poona, India. Incidents of broken bones, group sex, and even attempted rape have been recounted. Theoretically, the perspective was held that individuals came to the ashram with a lifetime of violence stored up inside them, and that only by acting it out in a supportive atmosphere could they release it. Franklin's experience (p. 110) was that

> people played with each others' bodies with an innocence that felt more nurturing than exploitative. Even the occasional violence that I saw seemed more therapeutic than harmful . . . On a tantric path like Bhagwan's, nothing in

life was to be denied. Everything was to be used, transformed, transmuted; an inner alchemy: changing the lower into the higher. It seemed to work. People had satoris [spiritual experiences] in the groups; they became more sensitive, loving, alive. As dramatic and intense as the therapy groups were, a broken bone was the worst thing that ever happened to anyone. It could happen on a ski slope. It was no reason not to go skiing.

The violence in the groups was officially stopped following negative press. Rajneesh's secretary at the time, Laxmi, publicly announced that this activity had served its purpose, and that such encounters were no longer necessary.

The beginning of the end of the Rajneesh saga was marked by his move to America. The illicit activities that Sheela took to almost unheard of extremes on "the Ranch" in Oregon, however, actually began in Poona. According to Franklin, troublesome *sannyasins* were poisoned in the ashram medical center—generally by overdoses of the wrong drugs for real or induced illnesses. It is rumored that Sheela poisoned Bhagwan himself—who was ill for months before she supposedly talked him into making the move to the States. (She argued that India was not only hostile but also physically unhealthy for both Rajneesh and *sannyasins*, who were regularly ill with various maladies common to that country.) Whether or not this is true, many saw Bhagwan's move to the West as inevitable. In India he had confronted the culture with his renegade views on sex, and in America he seemed destined to do the same through his emphasis on and apparent abuse of money and power. At Rajneeshpuram in Oregon he had a fleet of Rolls Royces,

numerous gold wristwatches, and armed guards in his meditation hall.

The initial move to America was to a property referred to by *sannyasins* as "the Castle," a large mansion in New Jersey. Not long after, Sheela secured the huge tract of land in Oregon that became known as "the Ranch." Ranch residency was at first by invitation only. This left many former ashram dwellers stranded and separated from the group, sometimes after years of living a renunciate lifestyle focused on Bhagwan as spiritual master. Later, in the final years of its existence, all *sannyasins* were invited and encouraged to live there.

The story of life at the Ranch developed like a fast-paced spy novel. According to Franklin (p. 287) Sheela's repertoire of alleged illegal, unethical activities expanded to include

> attempted murder, embezzlement, bugging people's living quarters (including Bhagwan's), sabotaging the vehicles of Oregon politicians, attempting to poison the water supply in a nearby town, the salmonella poisoning of a restaurant salad bar in the same town, a fire that had caused $65,000 worth of damage in the local planning board's office, etc.

But, what is perhaps most relevant in terms of shadow features on the spiritual path is the fact that so many *sannyasins* participated in the nazi-style hierarchy established by Sheela—thereby making these crimes possible. Those in charge, whether of the kitchen or the espionage corps, were taught to be controlling and abusive to their underlings in order to function in their position. Such an approach was employed even in dictating to former and longtime friends and intimates.

The Shadow On The Path

Franklin (p. 291) addresses the question of how much Rajneesh knew about and condoned what Sheela was doing, and how much he didn't know:

> While she'd clearly censored all information that reached him, it was a scenario he'd presumably set up himself; he'd obviously wanted it that way.

But when asked later about why he had allowed the activities that Sheela was behind to continue, Rajneesh commented on the fact that others had permitted this as well. While he created the circumstance out of which such dramatic events occurred, others consented to play their roles in the experience that arose from the collective.

Rajneeshpuram evoked shadow features in the personal and collective psyches of *sannyasins*. The bizarre events that occurred on the Ranch could not have happened without the complicity of many individuals. For many, the utopian dream was undoubtedly based on a yearning for some joy or fulfillment that was not part of their early lives. But, these same people probably innately knew that spiritual liberation, the transcendence of suffering, is only available in the present. This promise of paradise seems to have been undermined by primal entanglements—particularly as they relate to issues of power. Nevertheless, many practitioners who participated in the Rajneeshpuram experience attest to the fact that they underwent tremendous growth in their lives as a result—in part by having to acknowledge and relate with the shadow parts of themselves.

ADDITIONAL SHADOW ISSUES
IN OTHER SPIRITUAL COMMUNITIES

In the 1980s and 1990s many other spiritual communities experienced crises that called the teacher's integrity into question, while at the same time exposing shadow elements of community members. Da Free John (now Adi Da), whose understanding and teaching methods have been compared by some to that of crazy wisdom teachers of the East, and who was referred to by Ken Wilber—on the back cover of a book by Da (1978)—as "the first Western Avatar to appear in the history of the world," was the subject of front page coverage in the *San Francisco Chronicle* on April 4, 1985. Headlines read "Former Members of Cult Sue Guru Da Free John." Anthony, Ecker and Wilber (1987) discuss some of the contentions of the $5 million suit, filed by a disenchanted female devotee. A student between the years 1976 and 1984, she charged that she had been beaten and "forced to consume alcohol . . . and was required to partake in various sexual acts commanded by 'the Master'"; and that she was unlawfully held "for eight days on Da Free John's Fiji Island in March, 1984" (p. 23).

While the circumstances surrounding some of Da Free John's activities may be uncertain, Feuerstein (1990) observes that many of his students "do not really want to think about them, preferring to remain ignorant of the details lest they should prove too upsetting" (p. 95). Feuerstein also notes that Master Da, while preferring privacy, has criticized some of the distorting and sanitizing of his public image by his community, which had the effect of misinforming people about his style of crazy wisdom teaching.

At about the same time, in 1983, Maezumi Roshi of the

149

Los Angeles Zen Center entered an alcohol treatment center. He also admitted having sexual relationships with female students. According to an account of one member of the L. A. Zen Center, which Butler (1990) relates, many students became co-alcoholics. Fields (1992) notes that following his treatment, Maezumi commented that he had learned a lot not only about himself but about American culture as well. Several other respected Zen teachers have found themselves in situations in which a difference in cultural and moral perspective has added to the confusion around the transmission of spiritual teaching.

Yogi Amrit Desai, a professed celibate and the spiritual leader of Kripalu Ashram in Lenox, Massachusetts, was asked to step down in 1994 by the board of directors after admitting to sexual involvement. His resignation punctuated a movement already underway among his students to "shrink the guru" function. Various therapeutic models had recently been introduced into the community to help individuals "deal with emotional and interpersonal issues that years of dedicated *sadhana* (spiritual practice) had left largely untouched" (Cushman, 1994, p. 78). Following his resignation, pictures of Yogi Desai were removed from the ashram walls, and some were smashed by angry residents. Perhaps the basis for the rage had been formed much earlier and therefore, it could not be dismissed as easily as the teacher.

Holding an idealized image of the teacher, entering into co-alcoholism with the teacher, and the eruption of hostilities such as smashing the teacher's pictures demonstrate the tip of an iceberg of repressed emotional issues that has been hit in various spiritual communities. While each of

the events demonstrates a unique situation, involving different teachers, circumstances and communities, each points to the fact that shadow areas have not been deeply explored among many groups of practitioners despite years of work on the path.

Taking Responsibility

The shadow is a human phenomena. It hovers over those areas of the psyche that we would like to keep out of awareness, and makes itself evident in the tendency to judge, attack, or blame others who bring our own primal issues to our attention. It is evident in all walks of life—including politics, the media, and mainstream religions. In Catholicism, for example, Jason Berry (1992, p. xix) reports that, "in the decade of 1982 to 1992, approximately four hundred priests were reported to church or civil authorities for molesting youths," and that "by 1992, the Church's financial losses in victim's settlements, legal expenses, and medical treatment of clergy—had reached an estimated $400 million."

The shadow also exists on the esoteric spiritual path and on this point I have attempted to stress the importance of acknowledging and working with the shadow *as* spiritual practice. The shadow can be transformed and made workable by developing a conscious relationship to it. Unexamined, the shadow lurks in the unconscious, perpetuating suffering and inevitably blocking one's openness to further spiritual unfoldment on the path.

Some teachers may be moved to use the shadow (rather than being used by it) in work with others. Whether or not the community crises that have been described were

triggered by the arising of a teacher's untransformed shadow features or were examples of conscious work with the shadow is ultimately irrelevant: on the path, regardless of what catalyzes our primal issues, we are stuck if we do not accept and work with the shadow within ourselves.

Others' perceptions may differ from our own—i.e., everyone sees the same event in somewhat different ways based on his or her own experience and interpretations. There may not be one "true" way to view a circumstance, but there is a way for each individual to relate with each situation more wholly, or authentically, based on an integration and acceptance of all aspects of self, including the shadow. From this perspective, the essential truth of a situation is available to all. As we deal with our own primal issues, and as these become more workable, we become more able to sense when distortions are present in others. The less distortions and self-deceptions govern our own perceptions—the more our shadow features are accessed, acknowledged, accepted, and integrated—the more we are able to sense when others' activities are trustworthy. We can trust our own sensing and check the results, learning about ourselves and others in the process, rather than drawing conclusions based on appearances only, or being fearful about entering into situations that do not conform to our own familiar psychological landscape. A basic goodness underlies our primal conflicts, but this can never be known when we are hiding a core part of ourselves that has developed out of our earliest experience and that we assume to be bad or unacceptable.

Thus, the greatest obstructions we encounter on the

path are our own. To truly explore the inner world, as others in the spiritual traditions have done, biases and assumptions must be suspended—including those about ourselves and the path. In fact, reliance on a phenomenological perspective (one that uses personal experience as a source of information), in which all fixed assumptions about reality are transcended, could be said to be a definition of enlightenment!

CHAPTER 6

Therapeutic Methods, Spiritual Aims

While much of Western psychotherapy is oriented toward fixing a damaged or wounded ego, the spiritual traditions have for the most part downplayed or minimized the need for psychological work on the path, given the understanding of ego as an illusory mental construct. Problems within many contemporary spiritual communities, nonetheless, highlight the existence of the shadow on the path, demonstrating that it may not be so easy to bypass the issues and feelings that reflect the emotional deprivations of early childhood and incomplete ego development. In fact, exploring the ways in which the fixed character defends and compensates for early hurts may be an essential aspect of the spiritual process, requiring direct encounters

with the primal psychological pain we have repressed in the process of identification and personality development. Authentic spiritual transformation (as opposed to a new-age "pop" facsimile of it) may not be possible without relating to the ways we use identification as a defense, and with the ways we disown and disidentify ourselves from the shadow as a reaction of self-protection.

Despite rhetoric about ego's insubstantiality, the expression of enlightenment has historically been made *through* the ego personality. The concept of "enlightened duality" refers to the state whereby one experientially and tacitly realizes that he or she is, in essence, a hologram—a pattern of light in which every microscopic element is a representation of the macrocosm. The mystery of at once being the whole of creation and an individual person is, of course, inconceivable to the dualistic mind that sees itself as separate. But non-dual enlightenment—which according to the traditions is essentially true of everyone—may be experientially realized, expressing itself as universal Love, as distinct from love in a sentimental or romantic sense. When the awareness arises that the ego is not the exclusive and immortal identity, the enlightened individual may be moved to communicate to others the possibility of fully surrendering and opening to the life-force, rather than struggling to control reality and maintain the separative identity—which equals suffering.

The ego, however, does not disappear with transformation. The concept of spiritual annihilation is thus often misunderstood, as an ego (albeit a transformed one) is necessary for enlightenment. But, if ego is not integrated, if there are aspects of self that are repressed or denied, the

expression of any spiritual understanding that arises may be aberrant—an explanation for some of the more bizarre and destructive circumstances involving cults that have been led by psychotic individuals. In contrast to the emphasis of teachers in many nondualistic schools, Karl Durckheim (Western reinterpreter of Zen Buddhism, and founder of the Center for Initiatory Psychotherapy in the Black Forest in Germany) emphasized that a kind of work with primal psychology was an essential element of the spiritual process, as the enlightened communication is made through the ego, which must be integrated. Of the psychologically wounded individual on the path, Durckheim (1971, pp. 95-96) states that:

> We begin to see that by not dissembling his imperfections he gives evidence of the corporeal unity of that which is ordained and made possible for man ... Here we are confronted with a mystery. When a man, trying to do—and to be—what is right, simply accepts what he has become, he thereby grows transparent to his essential form even when he is not fully in accord with it ... And this can happen even when ... the life-body has been gravely wounded. Whenever a man struggles to be true to himself and at the same time stands simply and honestly by that which he has become, accepting himself in all his weakness and imperfection, his essential being inevitably shines through.

Spiritual psychotherapy explores the psychic defenses formed through object relations in early childhood from the perspective of the traditional spiritual path. Spiritual integrity (as opposed to the conventional ethics and morality of the separative ego) demands that awareness be

brought to our unconscious shadow motivations. Oftentimes, practitioners find that such psycho-spiritual work is necessary at a certain point—i.e., when brought into immutable contact with primal feelings they have never been able to resolve internally, and which they have tried to dispel. This may occur during periods of personal or community crisis. Katy Butler (1991, p. 147), in describing the perspective of her own involvement at the San Francisco Zen Center, relates that following the crisis there, she was moved to examine her personal history and the anger and self-righteousness she expressed when the scandal broke.

> I was among those who hoped to find a sanctuary within Buddhism for my personal wounds. But my culture and family history trailed me into my Buddhist community like a can tied to the tail of a dog.

While critical of her teacher's conduct, Butler seems to acknowledge that students also need to look at their own shadow features, which are discernable in the role they have played in the crisis. But even in the aftermath of the various crisis situations in spiritual communities that have been described, many students may have failed to recognize their part in the matter, or their own shadow features that have been exposed.

My contention is that, if students can come to terms with the powerful primal feelings that are rooted in the hurts of early childhood, inner and outer crises that are sure to erupt on the path become potentially much more workable—although the pain of a situation might remain.

The pain can then be used as an element in the process of transformation, rather than as a way of feeding a reaction or justifying a position. This can happen through *cathexis*—the willingness to accept and embrace *our own* pain, rather than blaming it on a teacher or a circumstance. Prior to such acceptance, attempts at *cathexis* simply do not work, and amount to suppression of feelings that must eventually find some outlet for release.

Spiritual psychotherapy regards a certain kind of psychological work as spiritual practice—i.e., work that leads to willingness to allow "what is" in our experience. Such practice effectively challenges the separative ego's worldview and its pursuit of self-validation as the exclusive identity. Our egos cannot handle "what is," because we have substituted our dreams and illusions for stark reality. In spiritual psychotherapy, we allow the intensity of underlying unconscious pain to come forth and propel us into the emotional reality of "what is"—and this undermines the illusion of the egoic identity we have tried to maintain. When we come to own these shadow aspects of ourselves, an even deeper level of spiritual truth can reveal itself. Though we may have random experiences of surrender and union, the shadow will continue to make its presence known until it is acknowledged, accepted, and integrated. As my own therapist would often say: "Whatever you resist persists." With the intention to discover the truth about ourselves, and with faith in the ultimate truth of the *dharma* (spiritual teaching), we may come to relate with our shadow feelings free of the defenses we normally employ. The opportunity then arises for contact with the innate healing, transformational capacity of the psyche.

The Four Steps

The process of spiritual psychotherapy focuses on bringing awareness to areas of unconsciousness that have their roots in underlying early hurts. It may be described in terms of four steps: exploration of shadow features, acknowledgement of primal feelings, acceptance of primal feelings, and integration/opening of the heart.

Exploration of shadow features involves bringing attention to those behaviors that indicate the existence of and defense against primal emotional pain. For these underlying feelings to be contacted, the static ego must relax the unconscious habit of maintaining the *persona*. This will not occur unless we have a deep necessity to deal with the suffering that comes from not being fully ourselves. While most of us seek to fill a sense of emptiness with compensations from outside, the spiritual path underlines the fact that resolution to the dilemma of life is possible only through uncovering the truth about ourselves from within. We must risk opening to whatever we find in our inner world. There must be a desire for true healing, a willingness to drop the *persona* that holds our false sense of self together. An essential aspect of this involves bringing awareness to our shadow features. We observe the ways our weaknesses and childishness manifest in our lives. This can oftentimes be observed in our intimate relationships—i.e., with those we look to for satisfaction of our needs. In spiritual psychotherapy we explore and bring awareness to any area where we sense that primal feelings are operant beneath the surface.

The next step involves **acknowledgement of primal feelings**. We recognize emotional aspects of ourselves that

we have always hidden and sought to avoid—even though we have somehow known of their existence. We allow ourselves to courageously uncover what is really there. Perhaps we have been largely unaware of deep feelings of rage and hurt that we are not generally in touch with emotionally or physically. Part of us remains split off, repudiated into the shadow despite our spiritual practice, even after we have analyzed and intellectually understood the early origins of our shadow features. We allow these parts of ourselves to have expression, permitting a weak and childish side to show itself more fully in therapy. We take this approach as opposed to trying to kill it off, or convince ourselves that we are handling it or working with it. We try what we may have never tried before—i.e., to acknowledge and allow our inner weaknesses and childishness, just to see what happens. After all, nothing else we have ever done has worked. One of the things we acknowledge is the critical self-judgment we have about our primal feelings. In the course of our work, we may organically grasp our core issue or chief weakness—the primary way we learned to cope with childhood hurt, and the way we still defend ourselves from reality today.

Acceptance of primal feelings follows, whereby we relate to the shadow aspects of ourselves with the intention of being non-judgmental. We realize that we are human, just like everyone else. We see that, like everyone else, we have always attempted to disown our emotional weaknesses. We are now faced with the opportunity to become vulnerable and "make friends with" our chief weakness, the core issue formed out of early object relations, and perhaps brought into our present life from past *samskaras*. Viscerally

accepting this level of primal pain may be profoundly disturbing. We bite off, swallow, and digest the work slowly, over time.

At first, this process may seem like death, the last thing we would ever want to do because we are accepting parts of ourselves that have always been wholly unacceptable, and therefore repressed. This kind of shadow work challenges the idea of our self-image. But a tremendous freedom is also possible at this point, as we surrender the need to unconsciously hold anchors of our identity in place. We realize that our shadow features developed quite naturally and rightly as a means of defending ourselves from early hurts we experienced chronically in the childhood environment. Primal feelings arose by themselves in response to certain unbearable stimuli from object relations. The undeveloped ego was overwhelmed and could not handle these at the time, and creatively devised ways of surviving the situation through repression and the development of a particular character structure. Nevertheless, as a result of the process being described, we may now be able to slowly relax our defensive strategies, and feel the inner emotional pain we have kept walled off all of our lives. Until we are able to relax our deep and unconscious style of defense, we are blocked in our spiritual progress.

With responsibility for the shadow, the fourth step—**integration and opening of the heart**—becomes possible. The primal feelings and features of our personality do not disappear, but become more flexible—they become eccentricities rather than primal blocks. These inner conflicts may reassert themselves at times, but never with the same power that existed before acceptance. Our ability to feel may

be cleared in ways that we have not experienced as adults. A wellspring of "higher" possibility may open to us, as a passionate, full relationship to life and a connection to a sense of true self and inner direction are re-sensitized. We may become aware of unique ways in which we can make a contribution in life after we have done authentic shadow work.

What Shadow Work Looks Like

There is no set prescription for working through the psychic energy surrounding the shadow. The practitioner needs to do the work, with the therapist providing support, relying on his or her phenomenological sensing of how to relate to the person. The therapist's intention is to keep the individual in willing contact with what presents itself as the core issue—the idea being that to do so serves the possibility of that person's spiritual development. It is understood that there is resistance to opening to the core issue, but that if the practitioner comes to recognize the deep necessity to work, an inner commitment to this will have some lasting, substantive, transformational impact over the course of time. Hillman and Jung present perspectives on work with the shadow that are sympathetic with work on the spiritual path. Hillman (1967, pp. 75-76) states:

> The cure of the shadow is on the one hand a moral problem, that is, recognition of what we have repressed, how we perform our repressions, how we rationalize and deceive ourselves, what sort of goals we have and what we have hurt, even maimed, in the name of these goals. On the other hand, the cure of the shadow is a problem of love. How far can our love extend to the broken and ruined parts of ourselves, the

disgusting and perverse? How much charity and compassion have we for our own weakness and sickness? How far can we build an inner society on the principle of love, allowing a place for everyone? And I use the term "cure of the shadow" to emphasize the importance of love. If we approach ourselves to cure ourselves, putting "me" in the center, it too often degenerates into the aim of curing the ego— getting stronger, better, growing in accord with the ego's goals . . . But if we approach ourselves to cure those fixed intractable congenital weaknesses of stubbornness and blindness, of meanness and cruelty, of sham and pomp, we come up against the need for a new way of being altogether, in which the ego must serve and listen to and cooperate with a host of shadowy unpleasant figures and discover an ability to love even the least of these traits.

On the spiritual path, a ruthless honesty about one's dark side and self-deceptions must be accompanied by a compassion for human failings and weaknesses. Our deepest weaknesses are obscured in the shadow, and are most difficult to work with. In one of his letters (in Wilmer, 1987, p. 101) Jung wrote:

> It is a very difficult and important question, what you call the technique of dealing with the shadow. There is, as a matter of fact, no technique at all, inasmuch as technique means that there is a known and perhaps even prescribable way to deal with a certain difficulty or task . . . If one can speak of a technique at all, it consists solely in an attitude. First of all one has to accept and to take seriously into account the existence of the shadow. Secondly, it is necessary to be informed about its qualities and intentions. Thirdly, long and difficult negotiations will be unavoidable. Nobody can know what the final outcome of such negotiations will

be. One only knows that through careful collaboration the problem itself becomes changed ... It is rather a result of the conflict one has to suffer. Such conflicts are never solved by a clever trick or by an intelligent invention but by enduring them.

In this, we can glean the distinguishing feature of spiritual psychotherapy: we work to experience our inner reality as it is, *without seeking change*. As long as we remain cut off from our psychological reality, or seek to alter it, psychological work will be spiritually ineffective. We can hope to disempower our shadow features in many different ways, but the core issue will not go away. Personal wounds and family history will stay with us in the unconscious, waiting to be activated by the appropriate stimulus. Even theoretically understanding this principle, a very mature and intelligent practitioner may, in subtle ways, seek to avoid shadow aspects that are intensely rejected.

When change is consciously or unconsciously sought, spiritual work cannot touch on the deepest levels of a person's inner reality. Early hurts may be sidestepped but never really faced, remaining as frustrating primal blocks on the path.

Traditional spiritual teaching holds that the Divine exists as present reality, and that life is a process leading to that mystical understanding. This is difficult to apprehend given the apparent imperfections and chaos of the world. Yet even personal or community crises can be considered in this way: perhaps nothing is wrong, and the spiritual process, as unfathomable as it seems, is occurring as intended (although we are not relieved of responsibility for our actions). This principle is reflected in the approach of

spiritual psychotherapy that holds that the client, though perhaps confused or troubled, is inherently whole. Furthermore, it is the spiritual psychotherapist's wish for the practitioner to come to accept himself or herself as he or she is—as opposed to the way the person would like to be or thinks that he or she should be. With this attitude anything is possible, and the process may use our uniqueness and innate abilities for its own purposes. Transformation, as both Hillman and Jung assert, begins with this self-acceptance. It is a great challenge to us all.

The Therapist's Task

The therapeutic process begins with the therapist's acceptance of the client. This arises out of an understanding of the existence and meaning of the shadow, and of the tacit truth of basic goodness. (The fact that basic goodness is not accessible in some individuals does not mean it does not exist—though it may be deeply buried. Such individuals, of course, do not commonly enter into therapy.)

Through contact with the therapist, the client can come to believe in him- or herself as he or she is, as parts of self that have previously been unacceptable are now accepted. This can involve coming to terms with the many difficult and hidden feelings that show themselves along the way. If true self-acceptance occurs, change happens naturally and of its own accord.

The spiritual psychotherapist utilizes skills of attending, listening, and reflecting in helping the practitioner to explore the primal feelings that come up around a core issue. Corey (1986, p. 308) notes that "the therapist does not reflect content but the subtle messages underlying the con-

tent." While attention is given to *content*—the specifics of what the client is actually saying—it is the *process* of what is happening for the person during therapy that generally provides a more useful focus. This includes observation of affect (the emotions and underlying feelings that may be accessed or suppressed); and energetics, which reflect the potency of any issue and the direction for therapeutic focus. Bringing the client's attention to such elements can help individuals enter into contact with obstructions to present reality. Primal feelings may more vividly show themselves in unconscious ways such as facial expressions, body postures, tone of voice, and other subtle cues that may then be effectively explored with a willing client.

Feelings may arise in the client-therapist realtionship that are reminiscent of those feelings experienced in regard to significant others in one's past. Obviously, the therapist's ability to work with such transference and countertransference depends largely on having engaged and worked with his or her own shadow issues. Only in this way can therapists allow clients to project onto them and not become "hooked" into counter-transference dynamics, including those in which the therapist unconsciously looks to have his or her own needs met through the individuals who come to work. The therapist understands that in terms of needing to address the shadow we are all in the same boat, while holding the possibility for each individual to embark on the voyage into his or her own underworld. As the process is ongoing, the opportunity for therapists to continually deepen their own work is constant.

Studies have demonstrated that successful therapy is linked to the qualities of the therapist, rather than to a

specific methodology. I think it is also true that virtually any method will work when the client is "ripe"—i.e., acutely in touch with an internal suffering that must be worked through. If a practitioner is genuinely willing to explore his or her pain, to tear down the psycho-physical walls of defense that keep parts of self out of awareness, that person will find a way to do it—with or without therapy. Many methods, when employed by a skilled, compassionate therapist who has engaged in significant personal work, and who therefore understands others' needs, can provide useful tools for spiritual psychotherapy. For example, energetic methods with the potential to open individuals to repressed feelings held in the body may create more workability in some sessions than just "head talk." But, in the end, it remains the individual's responsibility to shed defensiveness, relate nakedly with his or her inner reality, and utilize the feelings and realizations that are uncovered.

It is the job of the spiritually-oriented therapist, then, to create the space in which the client can, if he or she so chooses, undertake a ruthlessly honest exploration of highly defended parts of self. The therapist holds the intention for the person to enter his or her authentic experience, and may instinctively arrange circumstances that allow this to happen. The possibility exists for the centers to align to their rightful places in consciousness, rather than to function in chronically defensive ways. Such work challenges the character structure.

Most individuals, of course, are not interested in using therapy long-term to unravel character structure—although some form of in-depth process of self-exploration may be necessary to get beyond primal blocks to a more essential

spiritual reality. By nature, we generally seek a "quick fix" from problems—a way of avoiding pain rather than of opening up to it, a way to maintain or build up our egoic sense of self rather than call it into question. Given the predominant set of our culture's values, therefore, various kinds of "brief therapy" flourish. However, it is unlikely that such an approach to treatment can produce the full and lasting results that may ultimately be sought. To work with the deepest areas of defense erected in the early years and structurally reinforced throughout the course of a lifetime will take more than a few sessions. These defenses protect the most sensitive parts of the person. Many individuals do pieces of work over time, returning to address issues at deeper levels at timely intervals in their lives.

Everything we encounter catalyzes our growth in some way. Psychotherapy may not be necessary for this process, which moves on eternally, but there is no reason psychotherapy cannot be an aspect of the path, given the traditional perspective that everything we do can be contextualized as spiritual practice. A comprehensive review of our personal history—the feelings and events that molded us into the characters we are—can be intensely valuable. We remember so many facets of ourselves that we have forgotten, but that play a major role in our unconscious lives. After we have reflected upon, felt, and grieved our past, we can put it behind us and move on freely.

No one truly wants to open up old wounds, but we are nonetheless drawn by a universal spiritual process toward a more full alleviation of suffering—the deeper understanding of who we are and what our purpose is. Toward this end, the potential value of five therapeutic methods aimed

at integration of disowned shadow aspects of ourselves in the body will be discussed. This is done in theoretical fashion, with the presentation of many ideas. It is important to remember, however, that spiritual psychotherapy is a living process. Theories and *dharmas* on the other hand, are ultimately imaginary constructs, which can act as springboards to support our leap into an unknown and future possibility. The potential for opening to the experience of the real Self exists in the present when self-maintained restrictions are authentically released. But this experience comes with the payment of a heavy price—the disassembling of the fixed ego image we have of ourselves. The methods that will be considered in this section include Core Energetics, Gestalt, Enneatype Psychology, Family Constellations and Lyings.

Methods of Accessing and Working with Early Hurts

Five therapeutic methods are presented here because of their potential resonance with the context or understanding of spiritual psychotherapy. That context involves acceptance of reality as it is (including the most repudiated and painful parts of ourselves), for without this, real transformation is not possible. The five methods I have included approach the process from five different angles. They are, respectively, the body (Core Energetics); present reality (Gestalt); chief feature or weakness (Enneatype Psychology); systemic and generational approach (Family Constellations) and our suffering or pain (Lyings).

CORE ENERGETICS—WORKING WITH THE BODY

Alexander Lowen and John Pierrakos, both students of Wilhelm Reich, built upon Reich's ideas in creating the Bioenergetic approach. Lowen is currently director of the Institute for Bioenergetic Analysis and Pierrakos of the Institute of Core Energetics. A split between Lowen and Pierrakos occurred due to philosophical differences, with Core Energetics aligning with a more spiritual approach—that will be discussed shortly; but first, some of the fundamental ideas of both methods of the energetic psychotherapy process will be outlined.

Lowen (1972, pp. 80-81), who did most of the writing during the years when he and Pierrakos worked together, describes a fundamental idea that Reich discovered: the principle of psychic-somatic unity as demonstrated by the body's role in the suppression and repression of painful feelings.

> The word "suppression" means that the impulse is pushed down under the surface of the body, below the level at which perception occurs. One is no longer conscious of the desire or in touch with the feeling. When the memory or thought of the impulse is pushed back into the unconscious, we speak of repression. Memories and thoughts are repressed, impulses and feelings are suppressed. The suppression of impulses is not a conscious or selective process like the act of holding back their expression. It is the result of the continual holding back of expression until that holding back becomes a habitual mode and an unconscious body attitude. In effect, the area of the body that would be involved in the expression of the impulse is deadened, relatively speaking,

by the chronic muscular tension that develops as consequence of the continual holding pattern. The area is effectively cut off from consciousness by the loss of normal feeling and sensation in it.

Energetic psychotherapy seeks to re-enliven areas of the body that have been deadened due to the suppression of impulses. Suppression begins in the early years, when children learn from their object relations that their activities or feelings are not acceptable or appropriate. For instance, the real or imagined threats of others—whose love is desperately needed—are dealt with by stifling self-expression in ways such as immobilizing the body through tensing the musculature and holding the breath.

Lowen (1989, pp. 575-576) notes that Bioenergetic Analysis made several changes to Reichian work, placing greater emphasis on pleasure than on sexuality; introducing grounding work; adding physical exercises; and insuring that analytic work occurs concurrently with energetic work:

1. Pleasure is emphasized more than sexuality, while the importance of sexuality is not denied. As mentioned, Reich believed that the life process produces surplus energy that is channeled into the sexual function. The function of the orgasm is to discharge this energy, and anxiety and neurosis result when full release does not occur. But a kind of Catch-22 exists as neurosis prevents the full orgasmic response; therefore, neurosis cannot be cured by working exclusively with the sexual function. Focus on both sexuality and on working with neurotic attitudes complement each other. With the release of psychic and muscular ten-

sions, for example, around shame or guilt, the pleasure associated with the natural freedom and spontaneity of responsible sexuality can occur. Unobstructed psycho-physical energy flow allows for the experience of emotional and physical pleasure on all levels of human functioning.

2. Grounding work has been introduced. Such work is effected by having the client breathe deeply while bending over at the waist, feet solidly planted on the ground, bringing energy into the pelvis, genitals, legs, and feet. The movement of energy often creates a sense of contact with the feelings and with the body that may not generally occur, fostering a connection to both the inner reality and the outer reality. Reichian work is conducted with a client lying down, through applying pressure to muscular rigidities. This releases the tensions of the unconscious habitual suppression of bodily impulses.

3. Physical exercises have been added. From the contact and feeling produced through various exercises and postures, a greater understanding of the relationship between the body-mind and the early childhood hurts may develop. These can then be more deeply explored in the potential unraveling of the binds of the character structure. A general consideration of different kinds of energetic exercises is made later in this chapter.

4. Psychotherapeutic work is done concurrently with physical work. "Talk therapy" is thus an important element in energetic work, as the client comes to contact and "own" feelings and cognitive insights that are revealed through the process. While energetic psychotherapy has its roots in psychoanalytic theory, its discoveries can be applied in con-

junction with other methodologies. Core Energetics questions some of the underlying assumptions of identity that are held by psychoanalysis, while utilizing some elements of Freudian insight and approach.

The basic principles mentioned are applicable in both Bioenergetic and Core Energetic work. Both approaches utilize a system of classification of character structures that Lowen and Pierrakos developed, based on Reich's original observations. The oral, masochistic, rigid, aggressive (also called narcissistic or psychopathic), and schizoid types have already been described in previous chapters.

Brennan (1993), who studied with Pierrakos, raises an important consideration for those whose aim is the unfoldment of the traditional spiritual path when she says that "character structure does not help you define who you are. Rather, it is a road map of who you are not" (p. 207). Lowen's Bioenergetic approach seems oriented toward the development of a healthy ego, able to experience pleasure, and identified with the body-mind. The focus of work in Core Energetics is, on the other hand, more aligned with the traditional path, and with what Reich called the "common functioning principle"—or the underlying unity behind seemingly diverse and unrelated phenomena. This approach has the stated intention of opening to "core" energy. It holds that behind the appearances of ego psychology we are all, in our present condition (e.g., therapists and clients) manifestations of this energy. Realizing our unique expressions of "the core" is the purpose of Core Energetics.

Pierrakos (1987) notes the difference in the underlying assumptions from which therapeutic work can take place:

Psychoanalysis ... regards the strengthening of the ego as primary importance so that human beings can adjust and fit into the environment in which they exist. Core energetics also stresses the importance of a healthy ego. But the purpose of core energetics is to align the ego with the core rather than adjust to the environment. In this way, it becomes possible to restore the ego to its proper functioning of choosing and discriminating rather than ruling the personality (p.112) ... As the servant of the core, the ego steps aside and allows the full force of the core to emerge. (p. 116)

Pierrakos uses a model, undoubtedly based on Reich's ideas, that conceives of three levels on which the psyche operates:

- The innermost level is the core. No duality exists at this level, from which everyone instinctively knows the pulse of life. "The qualitative characteristics of the core's movements are the primal positive emotions ... These can be summed up as one supreme expression: love" (Pierrakos, 1987, p. 25).
- The negative primal emotions such as rage, hatred, and terror are elements of the second level. Pierrakos does not regard these as aspects of the death instinct of the Freudian unconscious. On the contrary, these are seen as life-affirming emotions that first arise in response to the negation of the core. Our primal feelings are therefore not inherently reprehensible, deserving only to be judged harshly. They lawfully arose in response to the need to protect the exposed core of our being, vulnerable in the early childhood situation.
- The third level refers to the character structure and

mask, the level of distorted perception of reality. Patterns of defense block us from painful primal feelings. With the flow of energy obstructed as a result, the outer mind closes off from the core, and the core becomes closed off from the outer world. We are disconnected from inner reality, and from the true emotions of the first two levels.

This model may be compared with the layers of the psychic structure that had been described by Reich (1973, p. 233):

> On the surface, he (civilized man) wears an artificial mask of self-control, compulsive insincere politeness, and pseudo-sociality. This mask conceals the second layer, the Freudian "unconscious," in which sadism, avarice, lasciviousness, envy, perversions of all kind, etc., are held in check . . . Beneath it, in the depth, natural sociality and sexuality, spontaneous joy in work, the capacity for love, exist and operate. This third and deepest layer, that represents the biological core of the human structure, is unconscious, and it is feared.

Conger (1988, pp. 112-113) notes the similarities between Jung's description of the *persona* and Reich's first layer. He also observes that Jung stated that the shadow—his "personal unconscious"—corresponds to Freud's concept of the unconscious. In this way, Freud's *unconscious*, Jung's *shadow* and Reich's *secondary layer* may be equated, although in inexact ways. Conger states that:

> Jung saw the shadow as a part of the core of life within the nature of the God image in the human psyche. The dark side offers us a powerful entrance into the denied life of man

... But for Reich, evil is a chronic mechanism that denies energetic life and is a hindrance to the spontaneous, biologic core of man.

On closer examination of this matter, however, the perspectives of Reich and Jung are actually quite similar. Reich saw that challenging the secondary layer was the way to the core, and Jung valued the integration of the shadow as essential to individuation. They may have worked differently with clients, but they demonstrate consistency in regard to their understanding of the area of the psyche that obstructs awareness of a deeper sense of self.

Pierrakos' viewpoint holds that the primal negative emotions are life-affirming in that they arise in protection of core feelings. When love is denied, the child responds with rage, or other painful expressions that are repressed, crystallizing over time into the character structure. If these denied feelings are opened to and acknowledged as the creative defensive response of an open and vulnerable being, the energetic barriers to the core may relax. This perspective may help the therapeutic client in coming to accept, understand, and begin to take responsibility for shadow feelings as an adult.

Pierrakos (1987, p. 133) describes the process by which we initially lose touch with the undifferentiated condition of the core by using ideas associated with object relations theory. From parents and other object relations, the child develops a sense of self and ego ideal.

The child internalizes this ideal and tries to measure up to it all the time during adulthood. The internalized ideal is called an idealized self-image. It can never be fully attained

and probably differs substantially from the child's real po-
tentialities. In striving to become the idealized image, the
child (and adult) sells out the true self.

We cannot re-enter the core through an effort of
will. Yet, in engaging therapy with a spiritual intention, will
plays an important role. It is the individual who bears ulti-
mate responsibility for the character structure. Pierrakos
(1987, p. 104) states:

> While relations with the external world—principally parent
> figures—precipitate negative experiences in a child that can
> accrete into an armored character structure, they do not cre-
> ate that structure or the neurotic complexes it entails . . .
> The key to whether a life will advance in relative freedom or
> bondage is held by the organism itself.

Each individual, then, holds the key to his or her own
destiny. While we cannot open ourselves or relax our char-
acter structure through effort, we can hold the intention,
wishing deeply for an authentic, unbound relationship to
life. The body's natural intelligence desires to free itself from
the armor and muscular rigidity—and it knows how to get
there. A therapist can provide the facilitation necessary for
the individual to unravel highly sensitive aspects of self.
Energy from the core may then begin to flow unobstructed
in areas that have remained closed due to primal pain and
repression, thus informing and directing the individual in
creative ways.

First, however, it must be recognized that on some level "the outer will conspires in maintaining the mask and substratum of character armoring. Once this insight is gained, the person can begin to take conscious responsibility for his or her problems" (Pierrakos, 1987, p. 212). Perhaps this is not done because there is safety in the familiar, known self that we have become and identify as, and which we believe must be maintained for survival. On the other hand, resistance to the undoing of character seems almost to defy explanation as, from the traditional perspective, this process results in spiritual freedom. There is no permanence in ego identification anyway. Pierrakos mentions that the first indication that one has touched the core is when one has truly taken responsibility—assumedly for those characterological aspects of self that had previously been denied.

There are four stages to Core Energetics work:

1) *Penetrating the mask.* Expressive movements including kicking, striking, and vocalizing may be used as the individual begins to contact the repressed primal negative emotions underlying the character structure. The armored regions from the head to the pelvis are not addressed in a systematic way, as Reich did; but the person's psycho-physical situation phenomenologically determines the way for body-oriented therapy to proceed. Respiration is given attention from the beginning.

2) *Releasing the "lower self."* The primal negative emotions of the second level are contacted and released, realizing their initial function in protection of the core. The client is supported in his or her expression, with-

out criticism or judgment. Genuine positive feelings express themselves as well.

3) *Centering in the "higher self."* In the face of hesitancy and uncertainty, the individual realizes the healing source of the core. This stage is about developing trust, and meditation is a primary practice.

4) *Uncovering the life plan.* "What is my task in being?" is the question that is inwardly asked at this stage. Changes are frequently made in the direction of one's life. It is understood that the process of growth and personal unfoldment is endless. The spiritual urge is released at some point, revealed as a natural, instinctual aspiration of the core that has been buried. This begins to manifest as authentic compassion and the gradual transformation of perspective beyond the egocentric worldview.

Core Energetics adds an important dimension that can be useful in combining psychotherapy with traditional spiritual practice, namely, the focus on work with the body as part of the process. In this respect, the therapist may suggest numerous exercises when an individual is ready to explore disowned aspects of self. The therapist must be vigilant so as to help the person understand and integrate primal negative feelings that may be released. Along this line, no exercise should be employed in a therapeutic context with clients unless the therapist has had direct experience with the method himself.

Areas of the body where vital energy is blocked or suppressed can be enlivened to allow movement of the flow of energy. The specific emphasis of bodywork depends on the

client, and may involve working with chronic muscular tension in the chest, face (e.g., jaw, ocular region), throat, shoulders, pelvis, etc. Expressive exercises including vocalization may be used to contact anger and frustration, and the aggressive function when obstructed. Appropriate use of rage work can help a person reclaim his or her natural power. Fear and the tendency to hold back can be addressed through postures and physical work. Acceptance of one's physical nature, including sexuality and the possibility of integrating sexual energy with the energy of the heart, is assumed to be a key aspect of the work. Respiration and grounding are always emphasized.

In the course of therapy an individual may spontaneously create his or her own exercise. Allowing the body to do what it wants can be encouraged—especially when a person feels the impulse to "unknot" muscular tensions and related feelings. A person may feel the desire to stretch a particular part of the body that is encased in the body armor. Following energetic work, any feelings or insights can be explored. Such exploration will usually be of a non-conceptual nature, as it is well grounded in the body. Hints about what direction would be useful to pursue often emerge through such work, and sometimes the therapist will make recommendations to continue a particular exercise at home.

GESTALT: WORKING IN THE PRESENT

Gestalt therapy was founded in the 1940s by Fritz Perls—whose views largely developed in response to Freud. His publication of *Ego, Hunger, and Aggression* (1947)

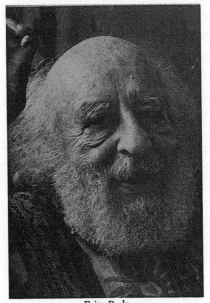

Fritz Perls

heralded the beginning of the method. Parts of the book were written by his wife, Laura, a major contributor to the approach.

Gestalt, a German word for which there is apparently no exact English equivalent, has at times been defined as "meaningful organized whole." It presumes a "field theory" perspective in which a whole is composed of parts that are essentially interrelated and responsive to each other.

More than any other methodology, Gestalt focuses on what is happening in the present—on the process that is occurring—rather than on the content of what is being presented by the client. Gestalt is phenomenological, in that it relies on human experience (rather than on theory or beliefs) as the source of data. It holds a basic trust in the individual capacity for organismic self-regulation. In this respect, Perls agreed in principle with the views of Reich, his analyst for eighteen months, who believed more in instinct than in the moral codes and values of civilization.

The aim of Gestalt therapy is awareness, requiring that one phenomenologically distinguish between the reality of the present moment and the interpretations and biases that one brings into the situation. Yontef and Simkin (1989, p. 337) describe awareness in terms of "knowing the environment,

responsibility for choices, self-knowledge, and self-acceptance, and the ability to make contact." The understanding of the method is that people are constantly changing, remaking, and discovering themselves, and that there is no end to this process.

The context in which an element comes into awareness is the "ground" from which a "figure" stands out as the focus. Correspondingly, traditional spiritual understanding views "nothingness" as the real ground from which form continually emerges. Our background is everything that has happened to us in the past, all past "karma," everything we have learned and become. Whatever captures our immediate attention becomes figural in the foreground of awareness. Awareness is thus important because the needs of the moment have to be recognized, and require a response in order to be met. Some action must be taken in order to bring about satiation of needs, allowing awareness to return to the background, and for the process to begin over again. However, because of patterns we have learned, we may be stuck, out of touch with needs or the kind of action needed and thus unable to take action; or unable to "take in" environmental feedback and be experientially fulfilled because of distortions in the way we perceive.

Perls (1973, p. 4) notes that "all life is characterized by [the] continuing play of balance and imbalance in the organism." He describes the homeostatic process, one by which an individual satisfies needs and returns to equilibrium, as a process of self-regulation. He states that psychological and physiological needs cannot be divorced from

each other; and that "needs can only be satisfied through the interaction of the organism and the environment" (p. 8). (The basic notion of the arising and satiation of needs has been referred to as the Cycle of Awareness, the Cycle of Experience, the Instinct Cycle, and the Contact-Withdrawal Cycle.) A simple model of a cycle of self-regulation is presented below:

AWARENESS CYCLE

Background

Satiation X X Foreground
 (Needs)

Action (Contact)

Gestalt asserts that human beings have the capacity for objective and accurate perception when they use their natural interconnection with immediate experience; and that such actual experience is to be trusted more than theoretical interpretation or dogma. Implied in the Gestalt approach is the necessity for people to risk and explore boundaries, since we grow through chewing on and digesting experience—thereby finding out what is nourishing and what is not. Perls saw maturation as the ability to shift into an inner responsibility for ourselves, as opposed to reliance on outside support. Therapeutic help clarifies what aspects

of self need to be owned in order for this step to be taken. In terms of the spiritual path, when we are able to stand fully on the foundation of responsibility for our own body-minds, movement to the next level becomes possible. Before this, such a step can only be imagined.

Having been emotionally deprived in childhood, many individuals have learned that it is not okay to have needs. From a background of such psychological wounding, spiritual practitioners may relate to spiritual teaching in ways that discount legitimate human needs. They may protect themselves from hurt by denying innate impulses they have learned were bad, wrong, or unnecessary. They may struggle with compensatory dynamics and addictions, assuming that their inability to maintain a practice of abstinence is further validation of "worthlessness," and a reason for self-loathing. The Gestalt process can clarify issues that have been bottled up for years, and allow individuals to explore the difference between essential needs and those neurotic needs that are attempts to fill psychological emptiness. Psychological flexibility and fullness can develop as they experiment and begin to work through obstructions by owning rather than rejecting their humanness—allowing the pleasure of satiation (as opposed to isolation or indulgence) through action (i.e., making contact with people or the environment). Without real contact, seekers remain in an imaginary relationship to the spiritual path—one detached from the universe through the misinterpretation of spiritual teaching. But, by becoming fully human, awareness of a higher need can become evident—i.e., in serving others and the spiritual process. With this, the joy from an authentic (rather than righteous, moralistic, or dutiful)

context can express itself at last!

Contact between therapist and client is the most important aspect of Gestalt psychotherapy. The therapist works by engaging the client in authentic dialogue rather than by attempting to move the client toward an assumed goal. Beisser (1970), in articulating the "paradoxical theory of change," observes that the more we try to change (by being something other than we are) the more we stay the same. In Gestalt therapy, it is assumed that genuine contact (e.g., with the therapist and with ourselves) evokes awareness. Spontaneous change then occurs by itself. The individual may come into relationship with what is in the inner world through relationship to the sounding board of the therapist—whose interactive communications reflect his or her own phenomenological experience. Talking about problems and advice-giving are not primary aspects of the work. Gestalt emphasizes the experience of the client as well as the therapist, who relate as equals—assuming the innate capacity of both to be self-responsible.

Therapeutic dialogue, according to Yontef and Simkin (1989, pp. 325-326) has four characteristics:

1) **Inclusion** relates to the therapist's putting of him or herself as fully as possible into the experience of the client without judging, analyzing, or interpreting, while still maintaining the individual self-sense.
2) **Presence** involves being with the client as fully as possible with free attention, and making regular, discriminating expressions as a model of authentic phenomenological reporting.

3) **Commitment to dialogue** requires surrender to the interpersonal process without attempting to control the outcome.

4) **"Dialogue is lived."** From a Gestalt perspective, moving from the position of talking about a problem to studying what we are doing is known as "working." "What are you experiencing, thinking, or feeling?" are simple but common interventions. The client may be asked to stay with and explore the feelings .

Experimentation is part of Gestalt therapy that may include enactment, exaggeration, guided fantasy, etc. Work on clearing relationships to others may be done in this way. Childhood experiences may be unearthed by relating directly to feelings in the present, without assuming that these define who we are. Such experiences provide a fertile arena for work. Each session is thus an opportunity for personal unfolding and creative interpersonal experience, as opposed to just talk or analysis. In spiritual terms, there is the intention to drop conceptual fixations and allow the truth of a situation to show itself, to shine forth "out of the ground of nothingness" or "out of emptiness." The possibility exists to see our primal difficulties for what they are, and to uncover a perspective from which we can accept and work with primal weaknesses. At times in session we may find ourselves in a unified state—having become more "real" through contact.

In Gestalt therapy, techniques are creatively engaged, determined by the opportunity that presents itself in the moment. Techniques, however, can be of little therapeutic worth when not associated with the Gestalt attitude and

relationship. It is the attitude of the therapist, then, that is key in the process. This attitude values presence, awareness, and responsibility—attributes that cannot truly develop without significant experience with personal work on self. Naranjo (1993, p. 17) observes that, since the learning that occurs for the client is experiential, the essential value of the process may be related to the passing on of an experience, and not the result of having participated in various Gestalt exercises.

> Much has been written on psychotherapy as technique—that is, from the standpoint of the *effects* upon the patient of the therapist's actions or interpretations. In discussions of this sort, the patient's experiences are always seen as *elicited* by deliberate choices of behavior on the part of the therapist. What is left out, however, is the notion that *experience may be passed on*, and that, as life proceeds from life, a certain depth of experience may perhaps be only brought about by the *presence* of another being partaking in that depth, and not by manipulations. If attitude is a deeper issue than technique, and if techniques issue from attitudes, experience is still a deeper issue than attitudes and constitutes *their* source. Without the appropriate attitude techniques become empty forms. Without experience even attitude becomes second-hand dogmas. Just as a dead organism cannot reproduce itself, mere dead attitudes cannot engender any corresponding attitude in another being. Experience, on the other hand, is self-duplicating. It creates the external forms that convey its pulsating heart.

Because of his or her experience with the shadow on the path, the spiritually-oriented therapist is often able to sense the shadow features of other practitioners that

obstruct their inner urge to more fully unravel ego identification. The client may thus be encouraged to relate with feelings that are generally repressed, resisted, and avoided through various means, including the pretext of spiritual practice. Ways in which the practitioner has assumed to be working spiritually for years may be called into question. For example, the client may have actually been unconsciously avoiding a primal issue by seeking to live up to a spiritual ideal. The client who is willing to work in the areas in which he or she is vulnerable will use the therapist with the aim of establishing contact with the wounded parts of him- or herself—acknowledging, accepting, and integrating the shadow.

Ways in which contact is avoided in Gestalt therapy are defined as *retroflection* (doing to oneself what one would like to do to others); *introjection* ("swallowing whole," accepting information from outside without discrimination); *projection* (attributing to others that which is within oneself); *deflection* (not giving or receiving feelings or thoughts directly); and *confluence* (neurotic fusion with others).

Obviously, the willful participation of the client is required for work to produce a useful psycho-spiritual outcome. Gestalt techniques, more than anything else, encourage us to relate with shadow parts of ourselves we do not have clarity about. If we establish contact with a stream of underlying primal feeling, finding that we can indeed bear its current, the therapist may find him- or herself in the role of witnessing the disassembling of the character structure in creative, original ways. But, this spontaneous experience requires integration. Many individuals do a piece of

work and would like to believe that it is done forever—as though we had gone to the dentist and had a decayed tooth pulled out by its roots. Most frequently, however, we will return again and again, at deeper levels of work, to the same basic issues, both within and outside of the therapeutic situation. Long and difficult negotiations with the shadow are often necessary, and spiritual psychotherapy provides a

training ground on how to relate with these hidden aspects of ourselves in life. Over time, we find that the issue and our focus has changed by itself—perhaps long after we have completed formal therapy.

Claudio Naranjo

Such work can be framed within a spiritual context in which we face psychological reality as part of the spiritual process. We do not lose sight of the traditional spiritual assumption that our true nature is beyond the ego identity and its associated character structure and repressions. We simply do not deny what is in consciousness in the present. Only by standing on this reality is contact with a deeper reality possible.

Naranjo (1993) discusses approaches that encourage the client to become aware of and relate with chronic, underlying feelings in the present moment by outlining: (1) suppressive techniques, (2) expressive techniques, and (3) techniques of integration.

Suppressive techniques involve restrictions on activities that keep us from present experience. According to Naranjo, these include repetition of one's story ("storytelling"), anticipation, "aboutism," "shouldism," and manipulation. *Repetition of one's story*, once told, or *anticipation* about the future may be indicative of resistance to working with feelings in the present. *Aboutism* refers to the search for causal explanations—as in developing insight "about" a problem, trying to figure it out so as to fix it. In contrast, Gestalt emphasizes awareness of feelings in the present, i.e., experience over interpretation. *Shouldism* involves a judgmental approach toward parts of ourselves that are considered unacceptable. It looms as a frequent conflict on the spiritual path, and in the spiritual community—in relationship to dogmatic beliefs, attitudes, and expectations of self and others. Many of us thus develop a fictional relationship with how we think we should be rather than a real relationship with how we are. *Manipulations* may take the form of subtly saying and doing the right things in an attempt to look good, to be a good boy or girl, or in order to attain a performance standard. The basic requirement of any therapeutic approach involves the client's willingness to honestly look at the issues that arise in his or her inner world, and to participate in an exploration.

Expressive techniques are aimed at increasing awareness through bringing out an impulse to be explored. Individual prescriptions may be given by the therapist, such as requests for the client to express aspects of self that are being suppressed. Intensification of a specific expression may be requested—through *exaggeration, acting, repetition,* or *giving words to* non-verbal manifestations. Directness may

be asked for when expressions are minimized or vague. Retroflections, in which a person directs energies inward, may be dealt with expressively through acknowledging feelings of conflict with something or someone outside of oneself. Conflicts with a spiritual authority, for example, may be turned inward or expressed through passive aggression. Some form of conscious expression that evokes the primal feelings, perhaps involving energetic work, may be useful in creating opportunities for individuals to work. Naranjo notes that there are two different expressive approaches taken in Gestalt. In the first, a communication of authenticity is directly sought, with the intention of taking responsibility for feelings in the moment. In the second, an individual may be asked to exaggerate some aspect of his or her negativity in order to bring awareness to that part of self, creating an opening for transformation.

Resistance, the unwillingness to engage fully in working, is generally unconscious, and the result of conflict between one part of the personality and another. By giving the resistance expression—*going with the resistance*—primal feelings can be unearthed allowing for clarity.

Topdog/underdog situations are often described in Gestalt therapy, whereby an apparently dominating superego berates the underdog that does not measure up to the topdog's standards. The underdog's passive resistance always wins out, and the cycle of frustration continues. Helping clients become honest with themselves, thus discouraging their attempts to disown parts of themselves, is an important aspect of spiritual psychotherapy that can produce highly beneficial results by creating a crack in the character structure.

Techniques of integration, according to Naranjo, include *assimilating projections* and *intra-personal encounter*. Perls, it might be noted, believed that everything is projection— i.e., all of our experience of the outer world is subjective. Projections are most dramatic when we disown a part of ourselves and see it in others, outside of ourselves. We are most highly magnetized or repelled by those whose characters accommodate our projections. In exercises aimed at assimilation, the client may be asked to act the part of the person being projected upon; or to pretend that the disliked qualities being attributed to another are really one's own. Intra-personal encounter involves allowing different parts of self to speak to each other. We allow the different "I's" that are in conflict with each other to fully have their say—and then open to a deeper intuitive knowing of how to relate with the difficulty. The client can explore the "yes and no" sides of self—a Gurdjieffian idea. The creativity of the therapist in designing a process that the client can productively engage is thus part of Gestalt work. Homework can be given that builds muscles of awareness and acceptance in areas of particular emotional weakness.

Zinker (1978), who works extensively with couples and groups, notes that creativity is an element that is uniquely practiced in Gestalt therapy. He observes that "the creative process is therapeutic in itself because it allows us to express and examine the content and dimensions of our internal lives" (p. 8). In working with couples, he follows a three-step intervention process (Zinker, 1994, pp. 109-110) which he uses with families. The therapist (1) observes data, and in particular, what a couple does well in relationship; (2) elucidates the underbelly, or psychological weakness,

in relationship; and (3) experiments, by creating situations for the couple to explore. Oftentimes, the underbelly or weakness of a relationship is seen at the same time as the intrinsic strength of the couple. Sometimes an individual's shadow is more accessible in sessions when catalyzed by the manifestations of a mate. A mutual understanding and willingness to explore and work with shadow dynamics can make all the difference in the world. It potentially allows for the deepening of relationship in mundane and spiritual ways that have been previously blocked.

Despite Perls' "anti-spiritual" inclinations, similarities exist in the practice of the traditional spiritual path and Gestalt therapy. (His position may have been the result of his perception that spiritual beliefs are frequently used as crutches.) Gestalt work is in principle similar to Buddhist Vipassana meditation, in which one practices present-centered attention. Meditation, of course, is an individual process, while Gestalt is practiced interpersonally. This is reflected in the aphorism coined by Simkin, describing the Gestalt approach: "I and thou, here and now." The willingness to rest in nothingness, from which experience arises, is a similar theme shared by this therapeutic method and the traditional spiritual approach. There is commonality with the Zen tradition with regard to an appreciation of non-conceptual spontaneous expression, when informed by wisdom. Naranjo notes how Perls functioned similarly to a Zen master, challenging ego with certainty, directness, and flair. The Gurdjieffian concept of "conscious suffering" is also consistent with the Gestalt attitude—which recognizes the relationship between the acceptance of suffering, and growth. Exercises of awareness and attention

focus the individual on his or her own process, through which perceptions of reality may be phenomenologically explored.

Perls referred to "holes"—underdeveloped or disowned aspects of self that exist in each person. Gestalt offers an approach to bring focus and attention to these holes within the individual. As such, it offers ways of working with the shadow on the spiritual path, and for the integration of disowned parts of self. While biases against cognitive understanding, tenderness, and spiritual philosophy were aspects of Perls' methodology, Naranjo observes that such elements can be effectively incorporated into an individual's work with spiritual psychotherapy without detracting from the usefulness that Gestalt offers.

ENNEATYPE PSYCHOLOGY
Working with Chief Feature

This method of transformation utilizes the ancient esoteric, geometric symbol of the *enneagram*, which first became known in the West through Gurdjieff. Enneatype Psychology, a way of characterizing central aspects of the personality, was developed more contemporarily by Oscar Ichazo and Claudio Naranjo. Enneatype Psychology defines a mandala of nine "lower self" character or personality types—each of which compensates for childhood deprivations in different ways. In early life, we learn that certain instinctual needs and expressions will not be nurtured or are not permissible. As a result of this emotionally-traumatic situation, feeling and thinking became distorted into what Naranjo has called the *passions* and *fixations*, respectively. A central passion becomes the hub of the personality, along

with an associated fixed mental pattern that may correspond with the Gurdjieffian concept of *chief feature* or *chief weakness*. Being so identified with our particular passion and fixation, we are blind to an underlying, skewed emotional and mental relationship to life. We do not see the specific way that we misconstrue reality—the manner in which our perceptions are filtered so that we experience a representation of the world rather than the world as it is.

The primary source of the major subjective conflicts we will face in our lives is reflective of such a weakness that has its roots in our early lives. Enneatype Psychology has the aim of bringing awareness and workability to the related primal feelings and defenses that have been relegated to a deep layer of the unconscious. By studying our manifestations, particularly the shadow features we glimpse from time to time, we may gradually develop a relationship with the primal issues that truly motivate us. The further we travel on the path, the more we will have to deal with these parts of ourselves that are most distressing, and that we may despise having brought to light.

Enneatype Psychology understands that the natural state of essence in the individual is one in which the instincts are free, functioning according to the principle of organismic self-regulation. But, with the demand to suppress the instincts in childhood, the passions and fixations develop and "contaminate, repress, and stand in place of instinct" (Naranjo, 1990, p. 4). Thus, the personality structure crystallizes in habitual, mechanical, and automatic ways. Spiritual psychotherapy has the potential to relax personality's rigid grip on the instincts, eroding the primal blocks that would otherwise prevent transformation of

lower passions and fixations into the higher functions that are possible for human beings.

The Enneagram symbol charts nine passions along the perimeter of a circle, with points 9 (indolence), 3 (vanity), and 6 (fear) connected in triangular fashion. Their prominent positions are indicative of the key roles they play in the personality structure.

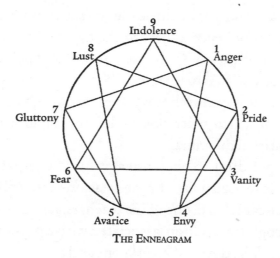

THE ENNEAGRAM

Points 1 (anger), 4 (envy), 2 (pride), 8 (lust), 5 (avarice), 7 (gluttony), are connected back to 1 again, illustrating "psychodynamic relations, so that each passion may be understood as grounded in the previous one" (in Naranjo, 1990, p. 11). It should be noted that, excepting fear and vanity, the above-mentioned passions correspond to the seven "deadly sins" of the Christian tradition. These two passions occupy strategic positions in the system, points at which shock must be applied in order to transition into a new level of growth. For a more in-depth study of use of

the enneagram in psycho-spiritual work, the reader is re-
ferred to Naranjo's writings.

Enneatype Psychology holds that all of the passions are
evident in each individual, while one of them is most over-
riding and predominant in the personality structure. While
the manifestations and experiences of the types is vastly
different—some apparently causing more or less harm and
suffering than others—the principle of the personality-
essence relationship is intrinsically the same. We are all in
the same boat of being subject to the dynamics of separa-
tive ego identification. Only the particular type of chief
weakness or chief feature varies from individual to indi-
vidual. In Enneatype Psychology, there are nine basic varia-
tions, one of which most closely defines the individual's
psycho-spiritual dilemma.

Corresponding to the enneagram of the passions,
Naranjo has revised a list of nine fixations originally pro-
posed by Oscar Ichazo, one of his teachers. Ichazo claimed
that each cognitive fixation, associated with a passion, may
be identifiable as the most prominent and defining feature
of the character structure—an articulation of the
individual's chief feature. Fixations proposed by Ichazo and
revised by Naranjo are: (1) perfectionism, associated with
the passion of anger; (2) false love, with pride; (3) decep-
tion, with vanity; (4) dissatisfaction, with envy; (5) detach-
ment, with avarice; (6) accusation, with fear; (7) fraudulence,
with gluttony; (8) punitiveness, with lust; and (9) self-for-
getting, with sloth. Ichazo coined the term "protoanalysis"
in relationship to work with enneatype character structures.
The first step in his method requires self-observation—the
study of oneself from which insight develops; the second

involves work with the compulsive aspects of the passions; and the third step entails undoing fixations or cognitive misunderstandings through practices including meditation. In this way the possibility exists for the passions to be transformed into higher virtues.

Variations in the ways that the passions and fixations manifest may be described in terms of sub-types, that sometimes more precisely define the characteristic style of separative relationship to life. The specific instinct that was most frustrated and problematic in childhood (self-preservation, social, or sexual—which refers to one-to-one relationship) gives an even more distinct flavor to the weakness in the individual. Each of the nine enneatypes may therefore be sub-divided into three sub-types, so that twenty-seven may be defined overall. It seems apparent that the deprivations experienced in childhood, and the coping decisions made at that time by the vulnerable young child, create the characteristic chief features that follow us throughout life. But, while Enneatype Psychology sees the circumstances of childhood as the influences that give rise to the character structure, that structure continues to be maintained in the present. In other words, at some level we keep the false personality in place by our own efforts.

The following is a brief overview of the nine basic enneatypes that Naranjo describes.

• **Enneatype I** is ruled by anger. The anger is maintained through perfectionism that suppresses its acknowledgement. The anger thus remains largely unexpressed, hidden within a controlled, deliberate, well-intentioned attitude. The "do-gooder" may fit into this classification,

presenting a virtuous *persona*, but demonstrating an underlying resentment through intellectual criticism of self and others. Excessive self-control and a personal striving for betterment are typical. Anger may show itself in demandingness and fault-finding with respect to others.

• **Enneatype II** is characterized by pride, and an attitude of false love. The need for self-elevation and aggrandizement of the self-image is demonstrated through flattery and egocentric generosity for those who gratify the person's pride; and disdain for those who do not. A sense of false abundance and independence exists in this type of individual, who may need to think in terms of his or her "specialness." This can mask an underlying neediness related to the lack of love experienced early in life.

• **Enneatype III** is the vanity structure that is maintained through deception. Mapped in the right hand portion of the enneagram with other narcissistic types, vanity is often associated with a denigrated self-image arising from the frustration, in childhood, of the need to be seen. Striving for wealth and status, the value of logical and scientific thinking, concern for appearance, and the ability to sell oneself as a way of compensating for existential emptiness are common—especially within individuals in American culture. Deception occurs with the belief in one's idealized image, and may be displayed in the way such an individual will inauthentically approach the marketing of *things*, which issues from the need to market themselves.

• **Enneatype IV** is the passion of envy, and the associated fixation is dissatisfaction. Naranjo describes envy as "frustrated vanity," in which a chronic craving for love, arising from inner scarcity, cannot be satisfied. The vain Type III

individual may identify with the idealized self-image, while the envious Type IV fails to do so. Envy arises out of the hole of low self-esteem, and such persons may feel worthless. Emotional types, such individuals are frequently addicted to love. Nurturing qualities are common, as one gives to get love and also identifies with the needs of others.

• **Enneatype V** is avaricious, relating to the world through the fixation of detachment. A retentiveness operates in which the individual holds back and holds in—as if giving of oneself would result in depletion. Lack of generosity relates not only to matters of money, but to time, energy, and attention. Pathological detachment and aloofness is a way of keeping oneself distanced from other people's needs or wants, fearing that one might be swallowed up by others. A compulsive avoidance of life is manifested in hoarding, introversion, and hiddenness.

• **Enneatype VI** is characterized by fear, with accusation defined as the primary cognitive deficiency. Fear may manifest through excessive striving and other forms of overcompensation. Generalized anxiety and a fear of making mistakes, of the unknown, of letting go, etc. are dominant themes. A cautious disposition manifested in insecurity, hesitancy, and indecision, along with traits of considerateness, gentleness, and obsequiousness may have developed in response to authoritarianism experienced as a child. The fixation of accusation may be seen in terms of the prominence of guilt and self-blaming—that may be preferred to confrontation with an outside force. The fear-type self-persecutes, but also turns his persecution onto others.

• **Enneatype VII** is characterized by gluttony that is associated with the fixation of fraudulence—a masking of

insufficiency with abundance. Gluttony is conceived as an insatiable desire not necessarily for food, but for more of anything. A hedonistic attitude incorporates traits of permissiveness and indulgence. Individuals may be interested in things that are unusual, extraordinary, or more than commonplace. A narcissism typified by a playboy mentality, in which a lack of discipline reflects the drive to experience and not postpone pleasure, is evident in this type. This type is often seen as happy, amiable, and seductively pleasing.

• **Enneatype VIII** is the lust type, whose fixation may be seen as punitiveness. The passion for excessive stimulation and intensity characterizes this individual, who generally seeks to compensate for early abuse and inner emptiness. It is not only pleasure, but struggle and conquest that provide satisfaction. Punitiveness refers to the trait that may have formed in response to the humiliation and impotence experienced in childhood. A rebellious and sadistic element, developed from early experience with authority, reflects the diminishment of tender and subtle qualities. The physical nature of the lust type predominates over the intellect and feeling aspects.

• **Enneatype IX** is characterized by indolence, and has the cognitive weakness that may be described as self-forgetting. The laziness or sloth of such individuals refers to the relationship to the inner life more than to outer functions, though such individuals may animate a comfortableness and relaxation that is the expression of psychological inertia. The indolent type does not want to see or be aware of inner experience. Resignation and over-

adaptation has occurred in such individuals, who are creatures of habit. Self-forgetting is evident in intentionally seeking distraction from one's psychological reality. One's sense of existence is experienced vicariously.

Work with enneatypes potentially brings us into contact with shadow aspects of ourselves that lie buried in the unconscious. Assumptions about our existence are threatened by awareness of these shadow features that are in opposition to the self-concept—the ideas we have and assumptions we have come to make about ourselves. It has been mentioned that Reich (1973), in developing his theory of character, noticed that his patients desired to be free of neurotic symptoms, but that work with the basic characterological attitude from which life was approached was resisted. Suzana Stroke (1995, pp. 45-46) discusses the general process of resistance to working with character:

> In general, the client begins to work with her most frequent and obvious character traits, which are rarely relevant to the central nucleus of her character, since, as is generally the case, the ego defends itself constantly and the person's most immediate desire is merely to escape from pain, from discomfort, and to return to or keep up the status quo with simply a little more control over her own mechanisms.

Some forms of therapy may seem to be successful in terms of strengthening an illusory egoic sense of self, but not in a deeper sense. Stroke notes that "therapies that apparently are failures can have the best [spiritual] results" (p. 46). In such cases, the ego may have lost its hold on the individual or been thrown off-balance through awareness

of characteristic passions and fixations. Through this, an individual may come to feel the necessity to engage in the exploration of self on a more profound spiritual level. There can be the acknowledgement that the person

> needs to continue this work on herself, that the road is long and constant, that she needs to pay a great deal of attention to the question of perceiving the more subtle aspects of her ego . . . and coherent action in her behavioral changes. The need for a spiritual guide and the support of therapeutically-oriented groups of a continuous or sporadic nature become the person's own choice and responsibility . . . In general, the results are revealed some months after the therapy, and sometimes even one or two years later. (pp. 46-48)

Enneatype Psychology can be applied within the framework of the therapist's methodological approach—be it Gestalt, Energetic psychotherapy, or even psychoanalysis. Naranjo (1993) mentions some of the ways in which enneatypes can be incorporated into Gestalt work. Particular features reflecting the passions and fixations, for example, may be exaggerated or inhibited. Therapeutic attention of this kind can bring an individual into closer relationship with primal feelings that are generally repudiated or amplified in the psyche beyond workability when provoked. Naranjo also mentions the idea of applying "antidotes" by observing that "one may work toward internal states contrary to the dominant passion and the corresponding fixation" (p. 265). Stroke has found that work that combines Enneatype Psychology with a methodology that she used (Hoffman Quadrinity Process, formerly the

Fischer-Hoffman Process) often reaches much greater depths. The Quadrinity Process involves exploration of one's family history, life patterns, and negative programs adopted in childhood. It aims to help individuals to move into self-acceptance, self-forgiveness, self-love, and the ability to listen to one's essence. It asserts that if one is not able to be open, loving, spontaneous, and honest in any moment, one is stuck within a pattern.

Enneatypes may give the therapist a sense of direction in work with the central issue of a spiritually-oriented client, even if the person has not formally been introduced to the approach. We learn "a way to be" in response to early pain, and it most aptly tells the story of our fundamental adaptation from essence to personality. Enneatype Psychology has the aim of focusing on the most fundamental psychological obstruction, the tangent point between the spiritual and psychological domains. While all the methods discussed in this section potentially do that, depending on the aim of the client and therapist, Enneatype Psychology does so explicitly.

Implied in Enneatype Psychology is that awareness and experience of our mechanical and defensive orientation toward life catalyze the innate urge to move beyond it. Naranjo (1990) suggests the writing of an autobiography in beginning self-study. The early, painful memories, if they can be accessed, tell the story of how character was formed in order to deal with one's trauma in childhood. Discrimination, of course, is needed by the therapist in working with clients who have weak or easily-fragmented ego structures. Strengthening parts of the undeveloped ego may be more appropriate for individuals who are not able or motivated

to look deeply at more central issues at the present time. Spiritual psychotherapy in any form is not for everyone.

Work with chief feature or chief weakness is a lifetime affair. We do not come to see it clearly overnight, and then proceed to fix it, as its underpinnings are our earliest and deepest hurts, hidden from awareness. In my experience, we put pieces together organically, and gradually, over time—generally over the course of many years. Shadow aspects reveal themselves in greater depth as our spiritual work evolves, as we come to a greater understanding of how chief feature operates in the present. We become more able to work with our primal weakness, and may eventually learn to use it to our advantage on the path, having it eventually become a strength.

FAMILY CONSTELLATIONS
Working with Systems and Generational Patterns

Family Constellation work as utilized by Bert Hellinger, a well-known psychotherapist in Europe, has added meaning and possibility to a family-systems approach. The work is based in the recognition that we cannot open our hearts to the Sacred (which is everywhere) until we have opened our hearts to our parents, partners, children, and the past generations from which we have come. Family constellations allow us to contact the love that remains obstructed in the hidden dynamics of intimate relationship systems. Hellinger's integration of methods in systemic psychotherapy rests on our seeing the reality of our situation, and listening to that inner authority (present in each individual) that innately orients us toward resolution. This approach

requires that participants have a necessity for healing, and are open to a new possibility that can emerge by facing the unique ways in which they have learned to emotionally relate to human experience from within their family's generational line.

This type of group work begins with the participant giving a brief overview of the problem to the therapist. The participant is then asked to set up his or her family constellation. He or she chooses other group members to represent individuals in their family. (As directed by the therapist, only those persons who belong in the system and who are needed for clarity about the problematic aspects of a particular family issue are represented.) "Family members," including an individual selected to depict the participant, are arranged based on their emotional relationship to each other. Thus an image is created.

Once the constellation is set, chosen members allow themselves to take on their roles and report on the feelings they experience *in* the configuration. No character descriptions of the persons being represented are given, as these are assumed to interfere with the spontaneous reactions that stand-ins feel. A serious intention is maintained and the focus of all individuals in the group creates a powerful environment in which the truth of the family and generational situation becomes clear. This allows obstructions to the healing process to show themselves and resolve.

The assumption is made that what constellation members feel is arising from within the participant's family system, not out of their own personal history, even though personal feelings may be touched. The participant allows him- or herself to experience the feelings that are expressed

by the representatives of family members.

After the participant has taken in the image from outside the constellation, he or she is brought into it to do the work that presents itself. Critical, unresolved circumstances that have occurred within the present family system or in past generations may be explored, clarifying how dynamics have been perpetuated. A new image is created as the therapist, relying on the constellation members' feelings and expressions of what *they* want to do, re-organizes the system as the work progresses. It is understood that a healing process may be initiated that may take several years to complete.

In *Love's Hidden Symmetry*, Hellinger (1998) describes principles of understanding and work with intimate relationship systems. Regarding the systemic view, he notes that "everyone is an integral part of the relationship systems in which he or she lives, and everyone has an equal value in the functioning of those systems—*everyone* in the family system is essential to the system" (p. 70). At the same time, the fundamental relationship within it is between the mother and father, and good parenting flows out of the couple's relationship. Hellinger states that without resolution of problems of attachment to their own parents, partners are unable to fully give themselves to each other. Unless this occurs, men cannot be men and women cannot be women. If we enter into relationship unconsciously looking for parents (as with a son seeking a mother, or a daughter seeking a father), the possibilities of mature intimacy cannot manifest and our difficulties will express themselves in our parenting and be passed on to our children. Love inevitably leads to disappointment when individuals relate

to each other as parental substitutes, since partners cannot and should not fulfill these roles.

Hellinger observes that "the work of family constellations frequently reveals patterns of harm and suffering crossing generations within families" (p. 111). One of his most powerful distinctions is the assertion that children act out of a bonding love that is blind to what parents have done or have not done. "Acting out of love, children follow their parents even in suffering, and although it's usually unconscious, they perpetuate their parents' misfortunes by copying them" (p. 113). Children's love is so strong that they cannot keep from attempting to care for their parents by taking on their suffering. Therefore, children carry a burden for the family that is not theirs. At the same time, "they also fear their fate. For this reason, children may outwardly reject their parents and strive to be different from them even while they secretly emulate them" (p. 112).

Hellinger identifies problematic patterns in parent-child relationships, which, if not resolved, have a pervasive injurious effect on the ability to love. These include: situations in which children do not accept their parents as they are, excluding one or both of them from their hearts for reasons that may even seem valid; parents trying to give and children to take what is harmful (debts, illnesses, burdens, obligations, privileges earned through achievements); and parents trying to take and children trying to give what is not appropriate given their roles. *Parentification* is an example of the latter case, in which children may assume some of the parental function—for example, in response to a parent's attempts to have their emotional needs met through their children, which is impossible. Distortions in

the natural order of parent-child giving and taking show up in the conflicts within intimate relationships, and in our ability to give and take from life.

According to Hellinger, single men and women and childless couples can certainly find love and meaning in their lives, but they may have special issues to face and resolve. The inability to experience intimacy can be, but is not necessarily, reflected in relationship patterns such as these. Whether as singles or couples, the importance of openness, bonding and the role of sexuality cannot be downplayed or ignored if spiritual transformation is desired. And even in relationships in which love thrives, "an incompleteness of the soul remains for each partner that the partnership cannot fill. Dealing with this profound and most human incompleteness leads us to the great mysteries of life, to the spiritual and religious dimension" (p. 54).

Obstructions to love that are rooted in family and generational patterns cry for resolution, leading us toward the possibility of intimacy and union with life itself, transcending human incompleteness.

LYINGS

Becoming One's Suffering

Lyings is both a spiritual and a therapeutic process, intuitively created in Bengal, India by a spiritual teacher, Swami Prajnanpad, in response to a need in his Western students. Prajnanpad had noticed that they were unable to fully engage in spiritual practice because of psychological obstructions. The most basic focus for the Lyings participant, according to instruction given by Swami Prajnanpad,

Swami Prajnanpad

is very simple: "Express what has been repressed," express childish emotions by letting them come out. Swami Prajnanpad regarded Freud as a seeker of truth, who without benefit of a teacher made many useful contributions that could be assimilated into work on the spiritual path. Swami Prajnanpad described the spiritual process in terms of four stages. In the first, there is "only self"; in the second, as the possibility of service begins to be discovered, there is "self and others." The third stage focus is on "others and self," and in the last stage there is "only others." "Purification of the unconscious" is necessary to move along the path, and is specifically addressed by Lyings work.

Lyings is an ingenious process that combines the psychological possibility of working through and integrating areas of deep repression in the psyche, and the spiritual possibility of losing oneself in the river of life. What this means is that, in addition to its therapeutic potential, the process itself actually encourages the spiritual experience of immersion in feeling, to the point of loss of assumed ego boundaries. In other words, the distinction between the one who is experiencing and the feeling itself may dissolve during a Lyings session. In this situation, the participant may have the opportunity to integrate not only the feelings that have been contacted, but also the spiritual

experience of ego transcendence. The Lyings process generally takes place over the course of many retreats, each of which is usually some weeks in length. It is offered through a few trained facilitators, who are all students of Arnaud Desjardins, who himself studied with Swami Prajnanpad. Desjardins is today among the most well-known and highly-esteemed spiritual teachers in France.

Lyings are generally, though not exclusively, offered in an ashram setting. The ashram/retreat environment takes practitioners away from ordinary ways of doing things, providing a contemplative framework in which they can more readily study and reflect on their lives, free of distraction. Silence is maintained, though not rigidly, and is an important element in the process. Meditation, household chores, and group meals for Lyings participants are part of the daily schedule. Everything is oriented toward the nurturance of the inner work generated through the actual process itself. A relaxed, yet intensely focused mood is created in the retreat environment by participants' intention to work. Lyings are currently offered only at retreat locations in France and Canada. Practitioners are encouraged to prepare themselves before their arrival, and before each session. This can be done by considering the necessity they feel around unraveling significantly problematic aspects of their inner life, and by holding the intention to approach their work in an open and vulnerable state that allows buried feelings to surface. The process is strong, and integrating it in an environment that supports the work is a key element. Many people return regularly, over the course of several years, in order to keep the process active.

Lyings are done on a mattress, in a simple room, with

the direction of a facilitator. Sessions are conducted daily in retreat settings, and less commonly on a weekly basis in some non-residential locations. It is understood that contacting a deep level of feeling is desirable, through whatever entry point leads there. The facilitator sits behind the reclined participant, in psychoanalytic fashion, encouraging the exploration of feelings. He or she artfully guides the individual to experience distressing inner feelings, more and more fully, until the participant is absorbed in them. When the participant has entered into the stream of primal emotions, a process of exploration and discovery is activated, moving of its own accord without ego's intervention. At such times, only the therapist's silent presence may be necessary. As contact with early painful feelings can be intense, some integration and discussion with the facilitator is often useful at the end of sessions.

The Intention

As Swami Prajnanpad discovered, a huge problem in the West involves the blockage and repression of feelings at an early age—a painful dynamic that manifests both individually and in the culture-at-large. To varying extents, this may be an inevitable part of the development of ego in the young child; and undoing the aspects of repression may be regarded as a subsequent stage to be engaged later in life, when psycho-spiritual inclinations may be activated.

Lyings attempts to directly address this dynamic of repression that has its roots in hurts experienced early in life. The process is completely about feeling, about disconnecting the mind from the emotions during the spiritual therapy. Desjardins has used the analogy of a telephone

switchboard in which the switch that is connected to the brain is unplugged and re-connected to the heart. The participant attempts to find an emotional doorway, an entry-point into his or her buried pain. Any doorway may be used, although there are usually a few specific ones through which primal feelings are most readily accessed. The facilitator supports the process, providing encouragement for the individual to stay in a feeling state. The emotions may change, but each participant attempts, through an effort of will, to remain with emotional intensity throughout the course of each session. Eric Edelmann, who has facilitated the Lyings process in France and in Canada, has observed that, "The pot needs to stay on the stove in order for the water to boil." If it keeps getting taken off, the water will never boil. The idea, presumably, is that in "boiling," the repressed contents of the unconscious become activated, allowing for vaporization.

In consciously feeling repressed pain, the possibility exists to regain the ability to feel, moment to moment. At this point it becomes possible to "lose ourselves in the stream of life," realizing our unity with creation hidden beneath primal disturbances that inhibit and drive us unconsciously. Most of us are not in touch with the depth of feeling that is possible in our lives, except when experienced in rare moments. We are also unaware of the power of repression that blocks the ability to feel. But when we have acknowledged and become open to painful emotional issues, character defenses lose their power and we find greater intimacy with ourselves and others. The intellectual function releases its hold on the psychic structure and falls into its natural relationship in the human system—thereby

allowing us to feel. The instinctual functions can be freed through such a process, and the ego (while maintaining its functional role) may align with essence.

The practitioner begins a Lyings session by focusing upon an emotionally painful aspect of life. But at times, the person may find him- or herself imaging or remembering, as opposed to feeling. Waves of emotion may rise and subside until an entry point is found through which he or she has no choice but to be authentic. By authentic I mean consciously consumed by the emotion, feeling it so strongly that there is no room for anything else, expressing feelings in an extremely pure way. The facilitator notices when this has occurred, acknowledging and supporting the practitioner's openness, vulnerability, and expression.

It is recommended that Lyings be engaged by being "actively passive": active, to enter the flow and stay with the emotional force that wants to leave; and receptive, or passive, once he or she is in the emotional stream. The psychic "muscles" that are being developed in the domain of the unconscious, building the ability to "be with" the pain, gradually strengthen. Tapping into this depth of emotion may be easier for some than for others. It may take a while, requiring some practice, while the facilitator waits and gently orients the focus of work.

We psychically defend ourselves from experiencing the underlying hurts that resulted in the formation of the character structure. First, resistance is generally encountered, and then fear. Then, depending on the extent of our need and the timeliness of engaging such work in our lives, the courage to proceed may happen quickly, may take several sessions, or may not occur at all. According to Edelmann,

the participant is able to tell that the process has been engaged by the energetics, i.e., the emotional energy, of the situation. This becomes potent as the individual experiences the primal emotion of imprints in the mind. Imprints may be likened to the Hindu concept of *samskaras* (which have been brought into a present incarnation), defined by Desjardins (1990, p. 182) as "subconscious latencies or tendencies, the weight of the past, deep impressions proper to each individual."

Once the client opens to the energy of their imprints, the work involves being willing to stay in those raw feelings. The facilitator's interventions are particularly important here, in encouraging re-entry into primal moods that the individual may unconsciously wish to keep from experiential awareness. A requirement for engaging the process is that the participant make no moral judgments about the feelings that are showing up. Work with the superego is necessary in order for the process to deepen, and the facilitator provides the support for this.

Beginners to Lyings may use an unconscious reflexive response to quickly divert themselves from this raw level of feeling. At times during my own Lyings process, I had the strong urge to return to the normal state of affairs, to "me" as a separate, known entity. Feeling as deeply as is provoked during Lyings is unfamiliar, and coincidentally requires losing the egoic sense of self. It involves a leap into the unknown—perhaps into the kind of intense feeling-state that young children experience. This can happen with the intention to let down defenses, so as to contact and stay with feelings that one has split off from because they are too painful. The possibility exists for the participant to

"become" his or her feelings by going deeply into them. The facilitator holds the space for this to occur. A return to the witness state, in which the person separates from the emotional experience through imaging and observing, is seen as the unconscious avoidance of the reality of our pain.

Through the process of Lyings, the participant can develop a much more tangible appreciation of the depth of the mind's unconscious resistance and suffering. Loosening imprints, or purifying *samskaras*, is a process more potent than most of us imagine—although life does this for us, ever so gradually.

In the creative, ongoing unfoldment and purification of the unconscious, surprises are likely to occur. Frequently, we do not expect to uncover the depth and force of emotion that is found—sourced as they are in our deepest traumas, e.g., around issues of extreme loss or of being deprived of love as a child, in a time of great need. Such feelings can be triggered by other life circumstances, but regardless of how we are brought into contact with them, it is this level of emotional reality which the person seeks to re-experience in him- or herself in Lyings. It is possible to be affected so strongly by the experience that we realize the necessity of cultivating an attitude of courage and deep acceptance of both pleasure and suffering, without avoidance. This is the basis for Gurdjieff's idea of conscious suffering, and it is a key element in Desjardins' teaching, which is given tangible meaning through the Lyings process.

From the professional perspective, the more a therapist has opened to and integrated primal emotional feelings, the more he or she is able to be present and support others who are working with them. If a client presents something

the therapist hasn't dealt with personally, the therapist will probably be unable to support the client in accepting the emotions in a way that allows the client to move through them. Lyings facilitation requires that one has personally undergone extensive work with the process.

During a Lyings session, a number of shifts in the types of emotions experienced can occur. The process is about staying with the emotions at a fundamental energetic level as they change course, without coming out of this "stream."

Desjardins believes that our "tapes"—the memories of our experience—do not change, and that it is possible to replay these at any time. Three types of memories can be referenced: physical, emotional, and mental. By accessing one kind of memory, others can be unlocked. (Core Energetics, for example, is a way of using the body to contact a physical memory—which can potentially open up emotional and mental files.) While our tapes do not change, the power our imprints have over us can change, organically, through the full acceptance of our repressed pain.

But Lyings is not a miracle cure, and the same emotional dynamics may continue to have power in practitioners' lives even after many retreats. This may occur because nothing happens if the process is engaged from the context of desiring change.

In Lyings, we are encouraged to nurture vulnerability and relationship to unacceptable, perhaps shameful aspects of ourselves, as opposed to habitually defending ourselves from their appearance in consciousness. Narcissistic emotions relating to grandiosity and egoic inflation may be explored as well. However, it is understood that these emotions may have developed out of a more basic problem

(e.g., as compensation for a childhood issue) which can be worked through in Lyings.

The Lyings process is one of agitation. It is activated internally when primal, repressed emotions that ordinarily lie dormant are stirred. Some people who use various forms of meditation may need to make major adjustments in order to participate in this form of work. If spiritual practice does not involve dealing with the emotions (i.e., if they are "meditated away" or allowed to settle through spiritual bypass), they will be agitated by Lyings. The process appears to be nothing like meditation—particularly if one's meditation involves watching the arising and disappearance of thoughts, without holding on to them. Some effort of will is used in Lyings, in order not to allow the emotional intensity the participant has contacted to subside. The individual intentionally goes back into the agitating stimulus, pulling the feeling back when the mind diverts its attention away from the psychic difficulty.

The process can be draining, and since Lyings are conducted on a mattress, the body is free to move, respond, or contort in response to the memories of feelings that are brought into the present. However, as the individual develops in the practice, actually returning to a natural feeling state, Lyings may in fact become a kind of meditation. At some point the facilitator and the client realize that the Lyings work is finished, instinctively sensing that the buried feelings have been sufficiently worked through.

Lyings work is more than an exercise aimed at dismantling repression by accepting the hidden shadow parts of our psyches. The possibility exists that in deepening the relationship to painful feelings the individual may actually

become the feeling in a session—consumed and overwhelmed by it as he or she was as a child. Separation between his or her sense of self and feeling diminishes. Here the participant may potentially cross a boundary between psychological and spiritual work. Lyings may be seen as a therapeutic process dealing with repression; but it is also an exercise in non-duality, holding the possibility of experience beyond ego reference, in which the practitioner may lose himself or herself in a feeling relationship to life. It is understood that the person can never feel fully while so vitally defended and identified. Buddha's understanding of suffering which relates it to identification with the separative ego (rather than seeing it just as physical and emotional pain) is of fundamental importance on the spiritual path. By focusing on becoming one with suffering, Lyings as developed by Swami Prajnanpad provides a context for piercing egoic suffering on both psychological and spiritual levels.

In Lyings work, the client approaches a line upon becoming immersed in an emotional reality with totality. Crossing that line is frightening because the participant may lose him- or herself in that reality. This is what literally happened for us as children, overwhelmed by the pain of a lack of total, unconditional love. The difference is that the child splits off or dissociates in the moment, not having the coping abilities of a developed adult ego; while an adult practitioner can work to remain conscious, and bear such consuming and overwhelming feelings. Repression of this pain was our only recourse as children and, as has been noted by Alice Miller, it has had profound implications in our individual lives and in the world-at-large. Suffering of

that intensity still exists for us at some level. Lyings would have us contact and transform it.

The value of an expert facilitator is his or her ability to guide the practitioner to encounter and stay with feelings that are contacted, and in a spiritual context which supports the individual's willingness to lose him- or herself in the stream of repressed feeling. The facilitator makes sure the individual "gets back" all right in the sense of being able to integrate the experience for psycho-spiritual growth. Once, when I had returned from contact with a deep level of pain that I had not known existed, a Lyings facilitator told me that "One can never be stronger than truth." There was comfort in this. The suffering that I experienced in my childhood was legitimate, intense, and real, despite my parents' minimalization and apparent unawareness of it. (They, of course, had been significantly wounded themselves in childhood, and passed this down through unconscious means.)

Childhood for me, as for many others, was emotionally horrifying and crippling, requiring that I deny the reality of my feelings. In later life, many of us downplay, forget, and sugarcoat that pain. Oftentimes, we try to convince ourselves that things weren't so bad, and attempt to orient our lives around illusion. From this defended place, a deeper level of truth is inaccessible, blocked by the roots of early hurts that remain deeply embedded in the unconscious.

Major crises can erupt when we contact such painful feelings on the path, in a way that we cannot avoid. But a crack in the emotional armor, however it is brought about, has the potential to bring the disowned feelings into the present, creating the possibility to feel more fully, and perhaps

awakening the intention to be with reality as it is. In acknowledging and working with our own pain, compassion for ourselves rightfully and surely develops. And, if we are willing to be compassionate towards ourselves, we will be able to feel genuine compassion for others—which can lead to a powerful and authentic desire to serve on the path.

Shadow Work with Practitioners

This chapter will detail four case studies of work on shadow issues by practitioners on spiritual paths. Of course, an infinite variety of issues may present themselves in spiritual psychotherapy in both individual and couples work. While each situation is different, and stimulates a unique, creative use of methods and approaches on the part of the therapist, the principles involved in such work are the same. These are understood more fully only through a real commitment to spiritual work, and to work with the shadow.

Individual Work / Case Studies

ALEX

Alex was a long-time student with a strong spiritual practice and connection to his teacher. For years he had been involved in managing several significant projects—for

spiritual education and financial support—within his spiritual school. While on the surface he appeared to be a self-assured practitioner, he was actually an Enneatype 6, whose fear-based relationship to life was hidden and masked. In his family-of-origin, his father had been away on business trips for extended periods of time for much of his young life. As a child, Alex had longed for his absent father, while also feeling the pain created by his father's demanding and authoritarian presence when he was home. His father was shut down to his own emotional needs and compensated for this by focusing on acquiring financial security. Alex's mother tried to secure her life by keeping everything in place at home, relying on her son to satisfy her own emotional needs.

In his adult life, Alex was driven to prove, validate, and firmly establish his sense of self by creating outer success. He brought this drive with him from his worldly life into his spiritual life by re-enacting the same primal dynamics in a spiritual environment. To some extent, this drive seemed fueled by a need system that grew out of early deprivations; while some of it also reflected his essential disposition: a passionate thirst for challenge and meaning in life. At some point, Alex felt the urge to establish his own business, as his father had done, while also leading a spiritual study group for his community. He pushed both his business and the group vigorously, as if his survival depended on their success. His relationship with his wife and child suffered, and his marriage eventually fell apart. This failure was a great shock to him, but it also opened doors to spiritual and psychological awareness that had previously been closed.

Alex moved into a household with other members of his spiritual community, and because of his unquestioned commitment and understanding of the teaching, he became the house manager. In that role, however, he was frequently isolated and emotionally absent, even while wanting kinship with others in the *sangha*, and speaking against the distance that some maintained. As far as he was concerned, people in the school never practiced hard enough, and always failed to meet his particularly high standards—both in worldly and spiritual affairs. Alex was hard on his teenage son, who lived with him, and was painfully in touch with the drive to control and judge his son's behavior. Internally, Alex was most critical of himself, believing that he had failed in most areas of his life.

As time went on, Alex was thrust into deeper confusion and doubt about his identity. Fearing that he was a loser, he was no longer certain of his role in life or in his spiritual school. In the struggle to maintain his fragile sense of self-worth, he was given to angry outbursts at others. He was particularly angry at his teacher, whom he felt had shown a lack of concern for him by allowing him to make decisions that had gotten him into trouble. Alex believed that he had swerved from the path, and had made unnecessary mistakes with respect to business and marriage that he now regretted and had to live with. He wrote to his teacher: "I feel betrayed by you, by this process, so distant. Like you could care less. I'm expendable, just a cog in the wheel." His shadow side was being exposed as his childish relationship to his teacher became more apparent, even as he was ostensibly looking to function independently in many ways. Alex was thrust into the spiritual crisis of having to relate

to the shadow of his fear of taking responsibility for his own life. He would now have to access his teacher's help in a mature way.

Many years of discipline and practice enabled Alex to engage in spiritual psychotherapy with great intention. Because he felt accepted in therapy, and due to his strong internal necessity, he willingly opened himself up to a flood of emotions that he had not felt comfortable discussing within the general community. The strong judgments he had of both himself and others were explored in Gestalt format, as he allowed his superego full expression of the ways in which he was an obvious failure, a terrible father and a disobedient student who made demands on his teacher while not really listening to him. The burden of having to live up to his idealized image of a spiritual practitioner became more and more apparent. He examined his "oral" expectancies, the needs that he had hoped his teacher would satisfy, and began to take responsibility for his life situation on a deeper level. As his shadow work progressed, he struggled less in his business, and even relaxed his attitude toward his son. In a powerful, emotional way, Alex expressed his need to learn how to play. His life had been about working to keep his fear at bay. While he had never lost an appreciation for his teacher's influence, he now began to appreciate him in a more mature way, seeing that his teacher pointed out a direction, but that it was the student's responsibility to live his own life. Alex was growing beyond the need to rely on his teacher as a father figure—a situation that could not have occurred without his willingness to relate more fully to his shadow side.

Through energetic work in releasing aggression

through hitting and vocalizing, Alex allowed himself to express his frustrations in sessions. A lot of anger is involved in being forced to grow, and Alex accepted this. Tears, gentleness, and inner strength lay buried beneath a hardened, defensive character structure. In a Lyings-type format, thinking about his son could always provide an entry-point into a deep primal sadness. His whole body wept as he recollected ways in which he had unconsciously played out the same judgmental and absent role towards his own son that his father had modeled for him. He remembered the feelings he had as a child by enlivening buried emotions inside himself. Alex allowed himself to bring back the emotions he had toward his ex-wife, owned the mistakes he had made, and let that part of his life go. Acceptance of his weaknesses further allowed him to relax the strong defensive posture he generally maintained. A quality of humility developed, that he said felt good to him, as he saw there was nothing for him to prove or live up to. A tender disposition began to surface with more consistent regularity in session, and became more accessible.

Shortly after terminating work, Alex married a woman in his spiritual organization who furthered his emotional resurrection. His relationship with his son continued to improve and become more heartful, and his ability to be more accepting and supportive of others in his community and in his household grew accordingly. Having faced more of the fear that motivated him, Alex began to resolve his business situation in a realistic way. The path that opened in his inner life led him to serve his *sangha* in his outer life by becoming the manager of the community bookstore. More fully committed to his teacher and school,

he also was able to stand more on his own, taking responsibility for a more authentic spiritual relationship to life.

KARYN

Karyn has been a spiritual practitioner for over twenty years. Despite her many strengths, she nonetheless experienced an inner emptiness and poor sense of self-worth. She had been married to a man in the same spiritual community, but the marriage had not worked out. When Karyn began spiritual psychotherapy she was still hurting over the failure of that relationship and struggling with the abandonment issues it brought up for her. She traced the severity of her anguish to her father's disappearance from her early life. As a result of this and other early emotional traumas, she had continually attempted to fill an empty hole in herself in different ways. Karyn is an Enneatype 8, characterized by lust, who misused food and various types of experience to quell unpleasant, disturbing feelings. Her decision to take up a renunciate lifestyle was her way of developing discipline around money, food, and sex. Her inner emotional difficulties, evidenced in a kind of desperate need to seek fulfillment outside of herself had plagued her for too long. Karyn hoped that by abstaining she might come to purify herself of the compulsions that obstructed her growth on the spiritual path.

Karyn found it extremely difficult to get along with various members of the community who provoked feelings in her that were associated with early issues. In several community projects she expressed strong competition with other women. In support groups, her low sense of self-worth

became more glaringly apparent over time, as she regularly sought attention and praise in unconscious ways in her community.

Karyn was ultra-sensitive to others' remarks, as if she was always anticipating a denigrating or hurtful comment. She felt beaten up in support groups when other women offered their feedback, which tended to provoke her sense of shame, bad feelings about herself, and an angry, defensive posture. She habitually returned a real or imagined critical comment with a disguised attack of her own in the attempt to shift attention onto others' weaknesses and away from her own pain. Although she was extremely insightful, an aggressive edge often characterized the communication of her observations.

In spiritual psychotherapy, Karyn explored her relationship to her family-of-origin. Her mother had evidently overcompensated for elements that were missing in Karyn's life by showering her with material items. But, at the same time, her mother felt such inner emptiness that she often emotionally neglected her daughter as she compulsively sought the companionship of men. Anger and frustration were often indirectly taken out on Karyn, who felt denigrated and humiliated by subtle derogatory comments that regularly came her way as she was growing up. While this angered her greatly, Karyn feared that if she expressed such unacceptable feelings, her sole source of nourishment would abandon her.

Karyn found it difficult to express her pent-up rage through energetic processes. When asked to do so, she smiled and said that she had done this kind of work before and that it had never gotten anywhere. It was apparent that,

while this was true, she continued to judge herself harshly for having vengeful, raging feelings and was afraid of them herself. She had never allowed herself to accept or relate directly to the shadow part of herself that she buffered through indulgences.

After months of therapy sessions, Karyn walked in one day and seemed ready to work. In a Gestalt format she was asked to express, in whatever words or sounds came to her, coherently or incoherently, the angry feelings she had towards others, and the judgmental feelings she had about herself. At first, she fumbled with language and sought to evade the impermissible anger, but with some coaxing, she began to berate herself and others with a stream of disparaging expletives and negative commentary. Finally, she let out a blood-curdling scream of rage that no words can adequately describe. While she had certainly had the primal feelings associated with this expression regularly, she had always suppressed them, quickly succumbing to a deep sense of inner shame. But, through the cumulative experience of opening to repressed feelings, some of her defensive character structure was eroding. In therapy, therefore, she started to give herself permission to express primal feelings in spontaneous, creative ways—through physical movements such as stomping, stretching constricted parts of her body, and vocalizing.

Karyn began to pay attention to situations in which shadow feelings were likely to be unearthed, noting what feelings were being roused beneath the psychological surface and what needs were leaking out when she surreptitiously sought attention in her community. She questioned whether she could allow herself to really experience these

feelings, knowing that to deny them or to try to change them would not allow any possibility for resolution. She began to consider the idea of accepting herself as she was, and to become aware of how she kept herself from being vulnerable to feelings that frightened her so as to develop the capacity to experience them.

Karyn was able to contact a deep sadness in herself in a Lyings-type format. She wept bitterly, allowing the primal feelings of loneliness and rage that she began to contact regularly. Certain childhood experiences were revivified, re-experienced more fully, and released. As she acknowledged and accepted her psychological shadow issues, they became more workable. An aspect of Karyn's being was integrating in a way that allowed her to more fully commit and contribute on her chosen spiritual path. Her relationship to other women in her community improved, and she became a more supportive and helpful presence for others in women's groups. As she accepted and worked through her own feelings, she was learning to accept those of others. Rather than offering incisive insight about others' shortcomings, she was more likely to allow others to express and explore their own shadow features without subtle criticism and judgment.

While in the midst of working with the shadow, within and outside of formal therapeutic sessions, Karyn experienced a tremendous breakthrough in that she felt freed of all of her inner conflict. She rested in blissful states for days and weeks at a time, having opened to the source of spiritual inspiration (her teacher) more fully, and enjoyed an equanimity she had not experienced before.

A cycle of integration of experiential states eventually

completed itself. Karyn stood more strongly in herself and in her spiritual focus. She expressed heartfulness where before she had known mostly emptiness in her life. Karyn seemed able to trust the process of spiritual work, and to be confident in her ability to discriminate about the direction she should take in her own life. She continued to engage a renunciate lifestyle, sensing its rightness for her at the present time.

A Word about S-E-X and Couples Work

Our relationship to sexuality tells us a lot about our primal issues and weaknesses, as our emotional-sexual attitudes and behaviors are influenced by whatever deprivations occur within our interconnected mind-body in childhood. A correspondence exists between early emotional wounding and sexual fantasy—i.e., the imaginal ways through which we seek to fulfill early emotional needs through sexuality in adult life. Of course, acting out sexual neurosis cannot bring about the healing we seek. At the same time, attempting to keep a sexual impulse suppressed, possibly feeling ashamed and wrong because of our problems, has the effect of blocking and constricting the sexual and emotional energies that are needed for transformation.

We begin to deal with emotional-sexual issues on the path as we accept ourselves as we are. This requires opening up to the primal feelings that are at the root of the self-protective life strategy we learned as children. Work in the sexual domain can occur indirectly through engaging a therapeutic process that may not necessarily focus on sexuality. In some cases, however, direct discussions of emotional-sexual issues and the nitty-gritty of sex therapy

can help an individual move through blocks of shame, guilt, anxiety, or fear of intimacy.

Difficulties in relating with sexual addiction (in various forms, such as excessive masturbation or promiscuity), homosexuality or lesbianism, impotence, premature ejaculation and other issues are as apt to occur in the lives of spiritual practitioners as in those who grew up under similar conditions but are not on a spiritual path. In opening up to what we find in our inner world, emotional-sexual issues that seek resolution can surface strongly. Since primal dynamics remain throughout a lifetime, it's probably best to learn to relate with them in a gentle way. Through acknowledgement and acceptance of our inner reality, problems become workable.

Strong sexual attraction toward a particular type of individual is often based on an inner need to access in the other an essential quality disowned in ourselves. By considering the magnetizing aspects of those to whom we are drawn, we may recognize the need to enliven a part of ourselves, rather than seek to complete ourselves with something from the outside. The shadow is particularly murky around the need for intimacy in one-on-one relationships, and sexual urgency can be consuming in a way that blocks awareness of what is really motivating us. The "urge to merge" is extremely powerful! In the end, men usually end up marrying their "mothers" and women their "fathers." In this way our choice of partners brings us into contact with our early primal dynamics. Such dynamics can only be relaxed and worked through over time, and with the help and intention to do so.

For those on the spiritual path who are married or

partnered, couples work can intrinsically offer transforma-
tional possibilities. There seems to be an immutable law of
attraction: those we find ourselves paired with have some
essential quality to offer us, if we will open to it. Addition-
ally, our intimate counterparts must inevitably provoke the
shadow in us, exposing the primal feelings and chief weak-
ness that originated in early childhood—the time when we
were most intimate with life. Yet often we assume that hav-
ing our chief weakness exposed or magnified is bad or
wrong, and that we must deny, suppress, or avoid it, per-
haps by leaving the relationship. Most marriages, of course,
end in divorce, often due to the partners inability to work
through shadow issues—but the same problems recycle
themselves in their next relationships. This occurs through
what Freud referred to as repetition compulsion (i.e., that
phenomenon demonstrated by people all of whose human
relationships have the same outcome) and what Eva
Pierrakos described as the compulsion to re-create and over-
come childhood hurts. Of those couples who stay together,
probably only a small percentage actually deal with primal
issues, including the roots of co-dependency, in an effec-
tive way.

 With regard to co-dependency, the problems that we
have with our mates often reflect problems we have with
our own inner masculine or inner feminine. We are really
enmeshed in a struggle with ourselves. The qualities that
we find distasteful in our partners can show us something
about our own issues. In order to be able to separate in
healthy ways, we need to have been able to attach in healthy
ways. If we can go beyond the superficial level of conflict
with our partner we may potentially come to terms with

early issues around attachment and separation that continue to plague us in the present through the shadow. Such issues often go unresolved in relationship, and can be reflected in the stagnancy of many couple's sexual lives—a frequent indication of the avoidance of shadow issues. A committed, coupled relationship in which sex is regularly, passionately, and emotionally engaged makes it difficult for the shadow to be bypassed over time. Coupled relationship on the spiritual path offers the opportunity both for shadow work that is potentially transforming, and for the experience of joy and union that can then be brought forth into the world.

Bringing sexual passion and energy to one's mate—if one is in a coupled situation—can nurture intimacy, bonding, and transformation. This can practically be arranged by setting aside a regular time each week in which to leave the kids with a friend and put the errands and responsibilities on hold. By giving time and attention to working with intimacy, a priority that sometimes falls by the wayside in busy spiritual lives, we do not overlook or avoid the arena in which our most primal issues and perhaps greatest psychological and spiritual opportunities can be accessed.

A practice of sexual communion can potentially open individuals to transcendent experiences of union, not just with a mate, but with existence as a whole. If two people manage to achieve the natural bodily and emotionally fulfilling expression of sexuality in a life-positive coupled relationship—in and of itself quite an aim in the contemporary world—they may be instinctively pointed towards spiritual possibilities associated with sexual intimacy.

Conservation of orgasm—recommended in many yogic, Taoist and *tantric* paths—is a particularly seductive spiritual practice. Even without ejaculation, sexual energy can still be misused. One may mistakenly assume that the mere technique of the *cathexis* of sexual energy can bring about transformation of the body—but this is a viewpoint that should be questioned. The goal of a rigid practice of conservation of orgasm is generally not useful, and may be associated with an immature view of the spiritual path. At the same time, the repeated draining of the life force through orgasm will deplete energy that is needed by the process, and to fuel our particular spiritual intention. Consequently, at some point on the path the practice of retaining or regulating sexual energy may become a consideration for some couples. Any consideration of the higher spiritual possibilities of sexual relationship presumes having engaged shadow work—including work on repressed emotional-sexual issues with a partner.

In some schools, celibacy may be a particularly useful practice for some period of time. However, I believe that, in general, a full and passionate emotional-sexual life in a coupled relationship offers a milieu in which shadow issues can be worked through, preparing the ground for further transformational work. Ultimately, it is useful to remember that sexuality is mostly a private matter—one that we will continue to work with throughout life; and a doorway through which the truth of non-separative existence can reveal itself.

Couples Work—Case Studies

JAY AND RACHEL

Jay had many oral and masochistic characteristics (see Chapter 1 for a description of energetic types) that affected his relationship to his female partner and to his spiritual school. His mother had been invasive and dominating, and he grew up craving for the excessive attention she gave, while being repulsed and enraged at her controlling, overbearing manifestations. In moving far away from his family and joining a spiritual community, he sought to become independent and to engage in a search to find himself; but he also sought to distance himself from his family and the discomforting childhood feelings that close association could easily trigger.

When he started a relationship with a woman in his spiritual community, Jay found himself up against the same issues. Motivated by the primal need to receive the flattery and narcissistic gratification of a woman's transfixed attention, he was also chronically angered by her dominating response to his childish emotional needs. This kind of dynamic was the result of not being able to own his natural power or deal with life situations decisively. As a child, much of Jay's behavior had been met with judgment and criticism, and he resolved that it was better not to assert his life force and creative energies. In his adult relationships, he held back and held in his feelings, but his anger leaked out, getting back at his woman-friend in passive-aggressive ways, e.g. by not doing things that she requested or demanded. A pattern of self-sabotage followed him, as he could not give himself fully to life in relationship. He regularly broke commitments he made in his

intimate relationship and in his involvement in his spiritual school. Jay frequently felt depressed and beaten, isolating himself further by withdrawing from personal interactions and tasks he had agreed to. Although he resented getting reminders from others, he nonetheless could not be counted on to fulfill responsibilities he had agreed to.

Jay began to think about getting together with another woman—an escape that had been a regular pattern for him. Fortunately, he was willing to consider that his desire for a new relationship might be motivated by resistance to working through his own issues and not because he and his current partner were incompatible. In recognition of the potential value for both of them, they each decided to engage in individual and couples work.

Rachel, Jay's partner, is a strong and competent woman. She can be counted upon to take care of worldly responsibilities. Rachel ran the landscaping business they owned together, paid the bills, bought groceries and kept their shared living space neat. After all, she had had a lot of practice, having cared for her younger sister and their childhood home while their mother was working. However, Rachel's rigid *persona* was characterized by perfectionism. Many *shoulds* ruled her life, and indeed, as a child she had to align with her mother's expectations or experience her wrath. In front of others in her spiritual school she generally appeared pleasant and self-controlled. Beneath the surface, however, an aggressive, somewhat scary energy lurked, and leaked out whenever it became too trying for Rachel to keep her world together in the way it was supposed to be. Rachel was disciplined and responsible, but from a righteous, demanding context.

Through many therapy sessions their dynamic did not change. Jay receded into his chair, staring blankly, sometimes saying little or nothing, while Rachel seethed internally. Her criticism plugged Jay into an early defensive posture in which he "went away." She was often unable to hear what Jay said when he did speak, and would retort by arguing and fighting back. She could become extremely animated and defensive if it was mentioned that she did not seem to be listening to what her partner was saying—whether what he had to say was an exaggerated distortion or a useful observation. And then, on one occasion after a session had ended, Rachel broke down, pleading with Jay to come back and talk to her. She asserted that she wanted to be open, that she did in fact want to hear about her part in their mutual dynamic. Rachel was in such pain that she literally could not see clearly. Inspired by this departure from her usual stance toward him, Jay slowly began to open up as well, and to genuinely communicate his struggle and pain to her. They both visibly relaxed and ended up weeping together, with a mixture of sadness, relief and mutual caring.

Over time, their ability to communicate improved. At times, they intentionally engaged in exercises in which they yelled and pounded pillows in front of each other, willfully expressing their own shadow sides. Sometimes they ended up crying and holding each other, and sometimes not. Each slowly began to acknowledge how the other catalyzed core issues in them, and that the issues were about themselves, not the other. They began to listen more and to empathize with one another's situation. Their mutual willingness to go into the shadow with each other produced an opening

and a shared bond that began to transform their relationship. They began to "reframe" each other's faults, realizing that each offered the other something crucial for their own spiritual process. Jay began "showing up" more responsibly, in the relationship, in his spiritual community and in their business; and Rachel began "softening up," becoming more gentle and flexible. Having made serious inroads into their shadow issues, Jay and Rachel felt ready to consider marriage and the possibility of raising children together from a genuine spiritual context.

RICHARD AND ALICIA

Richard is a practitioner and an author who has lectured extensively and run workshops on spiritual topics for many years. He is an "aggressive" type who grew up with an authoritarian father and co-dependent mother. While he rebelled against his father as a child, he also modeled his father's approach to life. Richard was admired for his confidence and strength, as he provided a useful perspective to many on the spiritual path. His personal life, however, was a wreck. His wife and children clamored for his attention, and he struggled to balance responsibilities to his work and his family. Though Richard is extremely knowledgeable concerning spiritual principles, applying these to his own shadow issues was a more difficult task.

Conflict between Richard and his mate escalated as he traveled for long periods of time. Alicia, his wife, was overwhelmed with the responsibilities of children and often found herself feeling depleted and depressed. However, this was more than a matter of her circumstance. Alicia's whole

relationship to life was animated out of legitimate need systems that had not been nourished in her childhood. She operated out of a sense of inner scarcity and abandonment, and was tenacious in trying to get her mate to satisfy her need for love and care. Arguments between them frequently became heated and generally ended up with Richard becoming verbally abusive (e.g., reminding her in a biased and demanding way of her lack of practice around neediness), and with Alicia in tears. In order to get back at him for his absences, she would battle, criticize, and try to exact a "pound of flesh" from him. When he was at home, she tended to complain and express her dissatisfaction in a way that pushed him farther away—magnifying her sense of loneliness and making it impossible for her to get what she wanted from him.

Alicia's neediness created the most difficulty for Richard. He simply could not stand it, and in session he reacted negatively to any expression of emotional weakness or legitimate need for intimacy that she exhibited. Richard recoiled from the equality and degree of intimacy she offered. Though they had both longed for family life, the addition of children had only heightened their struggle. When Richard and Alicia came to spiritual psychotherapy, they were at the lowest point in their relationship. Fortunately, they were also committed to their transformational work and to resolving the conflicts between them. Yet, they just could not see how things could be different.

For many weeks they continued to fight and blame each other in session, until a point when each of them gradually became willing to lose, to yield to the other. In other areas of their lives, they acknowledged the truth of egolessness,

of "being no one," but it was much more difficult to put this understanding into practice in their relationship. Here the primal issues were too strong to simply drop. Alicia needed the attention she had fought for but never received as the youngest child in a household of five children; and Richard felt he needed to protect himself from being swallowed up by his wife's needs and demands, responding aggressively in self-defense.

They began to consider the Gurdjieffian idea of "bearing the unpleasant manifestations" of the other—allowing the painful feelings that they sought to avoid in themselves to be catalyzed and experienced. Richard began to bring attention to times when he could sense that his shadow features were operative: what feelings was he having when he was being critical, judgmental or abusive towards his wife? He was encouraged to "do nothing"—to relate to his own disturbing emotions when they arose by intentionally bearing whatever was unearthed in him by Alicia's requests for intimacy. Despite the spiritual rhetoric he was well familiar with, Richard had never considered accepting such feelings in his mate and in himself as a way of dealing with the crisis between them.

Alicia felt badly about herself, and believed that she was wrong for having needy emotions. She felt she somehow had to change these. Richard confirmed this viewpoint through his overt or covert criticism at the slightest hint of her expression of these emotions. But, try as she might, Alicia could contain her feelings for only so long. Eventually, they leaked out, and the conflict between them would begin anew. Alicia started to practice acceptance of her own feelings by giving up fighting them. She realized that she

had to do this *by herself*, because she was not going to change her man. The most she could do was to become responsible for her own primal dynamics. She saw that she had been blaming him for her own pain—and an insight that she had only conceptually known beforehand now became a shocking reality. Alicia now endeavored to work with accepting everything in Richard—his various positive and negative aspects—from the ground of her own self-acceptance.

Richard began to realize that he reacted so strongly to Alicia because she triggered an inner injunction that he had introjected and fully identified with—that, as a male, he was responsible for being able to handle and fix any situation. The psychological burden was so heavy that it could not be met even if he were to give all of himself to Alicia. She reminded him of his own inadequacy, which was unbearable for him. This situation was exacerbated by the fact that he felt driven to live up to an ego ideal in other areas of his life, and this consumed so much of his attention that he had little left for intimate relationship. Richard gradually began to relax his own underlying needs for outer approval and success, and over time became much more human and accessible, both to his wife and to others he interacted with in his work of writing and lecturing. He began to listen to Alicia and became able to genuinely provide support, "doing nothing" about whatever inner difficulties that he saw she was experiencing, trusting that she could work her way through them. Richard and Alicia began to enjoy their relationship and negotiate more successfully around their individual needs, whereas previously such discussions had created emotional upheaval.

The Shadow On The Path

Alicia was an Enneatype 4—the Envy Type—and now for the first time she began to relax her recoil to the relatively visible role Richard had assumed as an author and speaker. Previously she had been threatened by his status, since it implied that she was not equal in worth to him. She also feared that she would have to live without the love, intimacy, and attention she needed from him, since he gave so much of himself to others. Alicia began to contemplate options she had never been able to seriously consider before. She thought about accompanying Richard and perhaps participating in his work when family circumstances permitted. Meanwhile, she began to rest in the fullness of the work she had been given as a mother, and ideas began to occur to her about how she might use her own artistic talents in this context. The couple's inner and outer work was flourishing. Their relationship was producing fruit on the path.

CHAPTER 8

Shattering Illusion and Opening the Heart

Illusion is shattered when a long-standing belief system about oneself, serving the function of character defense, is exposed and unmasked. One goes through shadow feelings that have been repressed since early childhood and comes out a different person. Remembering the events themselves that led us to establish the defense is not the important thing; more essential is the ability and willingness to experience and go into the primal feelings that we sought to avoid as children, finally coming to terms with them as they arise in the present.

This final coming to terms is not a common experience, even for those on the spiritual path. Jung spoke about the possibilities of transformation through shadow work in

mid-life, and in my observation of individuals with a spiritual practice, mid-life seems to be the time when we are usually ready to engage in such work. Ripening to the point of readiness generally takes many years. Though everyone's path is different, many serious practitioners go through predictable stages in their work. The following is a general outline of a psycho-spiritual process that I have seen occur for some individuals who have experienced an inner necessity to move through the shadow on the path.

Stage 1. Infancy

We may have stumbled upon the spiritual path while searching for a "cure" for the individual experience of inner suffering. Having "heard" or understood the teaching for the first time can shake the foundations of the ego structure, producing wonderment and hope. Could it be that the answer to our dilemma is the understanding that there is no essential distinction between self and other, that there is only God (or no-God)? We may sense the joy of release from the pressure of ego's struggle to survive, and desire the freedom that is implied by the spiritual traditions.

Stage 2. Honeymoon

We may feel courted by the spiritual path, seduced by its attractiveness and the attractiveness of those who represent it. But, we still tend to view our new-found spiritual life from the perspective of a child, not really knowing what we are getting into. We are naïve about what we will need to face in ourselves in order to enter into a real relationship to the path, and what trials we will have to undergo in order for transformation to occur. It is easy to feel that we

will be taken care of forever, relying on our interpretation of the magic of the *dharma* or the teacher, and to feel that our blissful swoon will never end, or will lead to a heavenly illusion that we identify with enlightenment.

STAGE 3. RIGHTEOUSNESS

Having committed to the path we have chosen (or that has chosen us), ego has now begun to use the teaching, rather than allowing itself to be obviated by it. Our way is held to be the right way, which, if followed according to the rules we have righteously adopted, will lead to the conceptualized spiritual goal. The lightness and fluidity of our initial resonance dissipates, and has gradually been replaced by the overlay of the superego. The dark aspects of our character begin to show themselves, and (if we are not in denial) we may begin to struggle with these problematic expressions. We may believe that we are in the process of fixing what is wrong with our minds—adjusting our thinking in the way that everybody should. There may be concern with rank, position, and status on the path; and overt or covert criticism of others for primal issues that we see in them as a projection of the repulsion we feel about our own submerged shadow.

STAGE 4. DOUBT

Over time, it has become obvious that our commitment to the path as we have followed it has not produced the fantasy outcome we imagined it would. In our struggle, we may question if the path, our teacher, or group is flawed in some fundamental way. The shadow associated with our chief weakness—which we do not see (or want to see)—

hovers over us. It is becoming apparent that conflict within ourselves and with others reflects a pervasive primal issue, and that we have thus far been unsuccessful in doing anything substantive about it. We have yet to acknowledge our immature and illusory view of ourselves and of the path. We may feel frustrated at not having done things that we have wanted to do in our lives, believing that the path has been restrictive and without options which may in fact exist. Frustration intensifies as the remedy expected to be provided by the path, the teacher, or the group has not occurred, although our childhood dilemma remains.

Stage 5. Despair

For some of us, the pressure to resolve a long-standing primal conflict that we have managed to avoid most of our lives can increase to the point that we are brought to a crossroads in the unconscious: we either have to acknowledge the shadow for what it is (and take real responsibility for it) or put it out of our awareness. Neither alternative is attractive, and we experience a lot of turmoil in coming to a decision about how to proceed. We find ourselves forced to either relate with those parts of ourselves that are most painful and uncomfortable (*understanding* that we have to face the shadow is a lot different from actually *doing* it), or leave the path, even though we have seen the essential truth of spiritual teaching and put a lot of time and effort into cultivating a relationship to it. Our work of developing openness and surrender has in fact allowed for the opportunity of this stage, which is characterized by the inability to manage the primal feelings that have been released. Going deeper into our work means going deeper into the

shadow, and being thrust into a kind of subjective "dark night" from which there seems to be no escape. Avoiding the process, perhaps by leaving the path, will leave us with nothing—fundamentally in the same place we have always been.

STAGE 6. BREAKTHROUGH

If we are able to take responsibility for the roots of our primal conflicts, allowing ourselves to experience the underlying emotional pain of our situation, we may find ourselves in touch with a much more powerful level of feeling, and with a compassion that has only genuinely existed in random moments in our adult lives. Compassion for others grows out of a compassion for ourselves and our individual difficulty, realizing that we have not been wrong for our defensive character structure and underlying feelings that arose in response to our early environment. Breakthrough occurs with an organic acceptance and ownership of our weaknesses—making friends with "what is" in a way that allows us to integrate the wounded parts of ourselves into our spiritual life. After an uncertain and seemingly interminable amount of time, purification, and struggle to accept the unacceptable aspects of ourselves, it is possible for our despair to lift and for the clouds to clear. This requires a willingness to persist and to rely on the help available on the path while not shirking responsibility. Although dealing with the shadow is not a once-and-for-all affair, we may be brought through the occlusion of primal defensive energies that block the experience of the heart. Depending on disposition, our outer expression during this transition may be more expressive or quiet, but the inner experience

of the process is always tumultuous. I am told that a Sufi teacher, when asked if such difficulties were necessary, responded after some thoughtful moments by saying, "I'm afraid so." Through the process of shadow work, the possibility exists to re-enliven the feeling state we experienced as children. Illusory defensive binds, that nonetheless have exerted power over us throughout our lives, are relaxed.

STAGE 7. ORDINARINESS

We may not be enlightened in the sense of having realized the truth of non-duality, but some deep illusions about ourselves have been shattered and we have a more real sense of what we are working for—individually and collectively—on the path. A desire and ability to be responsible for ourselves, and to work for others in an authentic way now predominates. We have not attained anything, but glimpsed the heart that moves those who have been enlightened, moving in service to the universe. Our focus becomes finding the unique way in which we ourselves are meant to serve, whether ordinary or perhaps extraordinary, and moving into this way as the path is cleared of primal blocks. We can afford to wish others well, and aim to return what we have received on the path with appreciation.

STAGE 8. FULFILLMENT OF ONE'S DESTINY

We do not really know what our destiny is, as life is a creative journey into the unknown and we do not know how we will be used by it. At this point, however, we are much more open to what the universe might provide, rather

than interested in controlling how everything turns out so that we can maintain distance from certain primal feelings. Much spiritual transformation lies ahead, perhaps leading to states described in the traditions as Emptiness, Union, Divine Love. But the path is blocked in some critical ways if we bypass shadow work. We must pass through the shadow at some point, and engaging it can be a major turning point on the path. In this regard, Swami Prajnanpad observed that "you cannot jump from the abnormal to the supra-normal." If not successfully engaged, shadow material is further repressed until future opportunities arise—perhaps in other lifetimes. Material that is exposed on the path must either be worked through or put back "in the box" to be dealt with at another time.

Contact with the shadow generally intensifies gradually during the course of our spiritual work. What enables us to work effectively with it is our own intention and the support and understanding of the environment we find ourselves in, which can quicken the process. As has been illustrated in Chapter 5—The Community and The Shadow, the activity of a spiritual teacher is one catalyst that has propelled individuals on the path into an encounter with the shadow. Individual or group crises that have resulted through such circumstances have always been viewed by the conventional mind as indicative of the teacher's selfish motivations and manipulative intentions, while practitioners have struggled to resolve cognitive dissonance, relate with primal feelings, and make difficult decisions in the wake of crisis. Nothing less than radical acceptance of what is can truly resolve any spiritual crisis—whether it involves

a teacher or not. This does not require that we reject our ability to discriminate; it requires that we come to terms with our primal psychology.

My contention has been that, regardless of whether the teacher is moved purely in service to the Divine process or is kidding him- or herself, there is learning in the exploration of our own shadow material that can show us something about the illusions we have about ourselves, reality, and the spiritual path. A central aspect of this involves working through whatever projections (attributing our own unacceptable thoughts, feelings, and behaviors to the teacher) and transferences (responding to the teacher as if he or she were a parental figure) are operative on the path. The psychological function that the teacher, living or dead, serves in the maintenance of our own assumed separative identity is then potentially undermined, leaving us without a key mental construct upon which our illusion is based. Working through such reference points of ego is no small accomplishment in our work, and is potentially liberating. Swami Prajnanpad, for example, is quoted as saying, "to be free is to be free from father and mother, nothing else." Work on the spiritual path can bring us to the point of having to be responsible for our existence in the vastness of the unknown.

Spiritual teaching asserts that the existential dilemma results from identification with the passing phenomena of life—fear, anger, joy, sorrow, bliss, happiness, shame, whatever arises—when in fact we are pure consciousness and not any of that. The American master Lee Lozowick speaks about the practice of self-observation, which he says occurs "in the space between who we are and who we have

identified ourselves as in the passing flow of phenomena. When we are in the space between who we are and who we have identified as, our vision is instantaneous." He notes that "from this place we do not have to act out the phenomena." This is not possible if we are out of touch with the repressed feelings, the phenomena of the shadow. Our unconscious, primal response is instead instantaneous.

The focus of this book has been on the necessity of examining primal psychology on the spiritual path. In this regard, therapeutic work with an unbiased and supportive human being who has had personal shadow experience may be an invaluable asset at certain junctures. Illusions and repressed feelings can be reflected, brought into awareness, and clarified if a practitioner is willing to engage in this difficult work. The process of spiritual psychotherapy becomes a creative and unknown experience that can reveal primal blocks constructed on early childhood repression, from a context in which they can become potentially workable. But the therapist is not responsible for the practitioner's growth. The individual does the work through authentic involvement in the process. The approach is necessarily person-centered in the sense that it assumes that the practitioner has his or her own answers and the capacity to utilize them, which can be accessed when primal blocks are removed. At the same time, it is understood that work with the shadow is particularly tricky, and extremely difficult without consistent, knowledgeable, individualized feedback and support of a personal nature.

A review of the patterns and background issues of one's life can be extremely useful on the spiritual path—especially if there is unfinished business to complete before the past

can be released. Such unfinished business often becomes evident in spiritual groups when early patterns are re-enacted in relationship to the teacher, other members, and circumstances reminiscent of family and early childhood situations. Emotionally enmeshed or disengaged styles in groups can be explored in the process of working towards superordinate goals, which require joint efforts in order to reach higher spiritual aims. Shadow work is no less relevant for those who are not involved in group work. In fact, it may be more relevant.

In my opinion, work with primal psychology is an essential part of the spiritual process and can be effectively integrated with spiritual work. There does not appear to be any reason why the traditional and mystical context cannot encompass the contribution offered by Western psychological awareness—that is culturally understandable and accessible to the Westerner practitioner. This is especially true when an individual is brought into contact with the shadow during the course of involvement on the path. Shadow work is, in fact, required in order to make a pure and full commitment. A strength and heartfulness that makes the journey joyous rather than a chronic struggle comes with having worked through primal psychological issues. We come to express these qualities most naturally and genuinely after having done significant work with the shadow on the path.

And finally, our ultimate destiny may not be an idea about personal enlightenment, but (as remote as it seems), it may be about the Being that is expressed in the statement by the Indian master Yogi Ramsuratkumar:

I do not seek for happiness. I only want to do my Father's Work. If even one being has benefited from my life, that is enough. It has been worthwhile. And if this body dies, the soul that may remain, may it be born again to do my Father's Work.

Endnotes

CHAPTER 1
The Shadow and Western Psychology

[1] denying force: Bennett (1973) defines this Gurdjieffian idea by stating that "...in the limitations imposed by the conditions of existence in the universe there is present a denying force" (p. 199).

[2] basic goodness: Trungpa (1984) states that "Every human being has a basic nature of goodness, which is undiluted and unconfused. . . . It is the realization that we can directly experience and work with reality, the real world that we are in" (pp. 9-12).

CHAPTER 4
The Spiritual Teacher and the Shadow

[1] Huffstutter, P.J. (1996, September 12). Leader of Est Movement Wins $200,000 from IRS. Daily News (Los Angeles).

[2] Los Angeles Times, Dec. 29, 1991.

[3] Faltermayer, C. (1998, March 16) The Best of est? Time (Vol. 151, No. 10).

[4] Est Founders Daughter Sues Mercury News Over Articles. (1992, July 16), San Jose Mercury News.

CHAPTER 5
The Community and the Shadow

[1] Tulku. In the Tibetan Buddhist tradition, a being with no ego in the ordinary sense, who works on earth for the sake of others, is said to take birth as a tulku over a series of lifetimes.

CHAPTER 8
Shattering the Illusion, Opening the Heart

[1] Lee Lozowick spoke about this in a private community meeting at which the author was present.

References

Almaas, A.H. (1988). *The pearl beyond price*. Berkeley: Diamond Books.

Almaas, A.H. (1990). "Psychological work as spiritual practice." *Journal of Contemplative Psychotherapy, VII*, 35-44.

American Psychiatric Association. (1994) *Diagnostic and statistical manual of mental disorders* (4th ed.). Washington, DC; Author.

Anthony, R. & Ecker, B. (1987). "The Anthony typology: a framework for assessing spiritual and consciousness groups." In R. Anthony, B. Ecker, and K. Wilber (Eds.), *Spiritual choices* (pp. 35-105). New York: Paragon House.

Ariel, D.S. (1988). *The mystic quest: an introduction to Jewish mysticism*. New York: Schocken Books.

Arlow, J.A. (1989). "Psychoanalysis." In R.J. Corsini & D. Wedding (Eds.), *Current psychotherapies* (4th ed., pp. 19-62). Itasca, Ill.: Peacock Publishers.

Beisser, A.R. (1970). "The paradoxical theory of change." In J. Fagan & I.L. Shepherd (Eds.), *Gestalt therapy now* (pp. 77-80). Palo Alto, Calif.: Science and Behavior Books.

Bielecki, T. (1994). *Holy daring*. Rockport, Mass.: Element.

Berry, J. (1992). *Lead us not into temptation*. New York: Doubleday.

Bhagavad-gita. (1944). (S. Prabhavananda & C. Isherwood, Trans.). New York: Mentor.

Bennett, J.G. (1973). *Gurdjieff: making a new world*. New York: Harper and Row.

Brennan, B.A. (1993). *Light emerging*. New York: Bantam Books.

Butler, K. (1990, May/June). "Encountering the shadow in Buddhist America." *Common boundary*, (8)(3), 14-22.

Butterfield, S. (1992). "Accusing the tiger: Sexual ethics and Buddhist teachers." *Tricycle*, 1(4), 46-51.

Caravella, M.B. (1989). *The holy name: mysticism in Judaism*. New Delhi: Radha Soami, Satsang Beas.

Cohen, A. (1995, November/December). "More seekers and teachers" (Letter to the editor). *Yoga Journal*, No. 120, pp. 6, 8.

Conger, J.P. (1988). *Jung and Reich: the body as shadow*. Berkeley, Calif.: North Atlantic Books.

Conger, J.P. (1991). "The body as shadow." In C. Zweig & J. Abrams (Eds.), *Meeting the shadow* (pp. 84-88). Los Angeles: Jeremy Tarcher.

Corey, G. (1986). *Theory and practice of counseling and psychotherapy* (3rd edition). Monterey, Calif.: Brooks/Cole Publishing Co.

Coward, H. (1985). *Jung and eastern thought*. Albany: State University of New York Press.

Cushman, A. (1994, November/December). "Shrinking the guru." In *Yoga Journal*, No. 119, 76-83, 137-141.

De Laszlo, V. (Ed.). (1959). *The collected works of C.G. Jung*. New York: Random House.

Desjardins, A. (1994). *The jump into life* (K. Kennedy, Trans.). Prescott, Ariz.: Hohm Press. (Original work published 1989)

Desjardins, A. (1990). *Toward the fullness of life*. Prescott, Ariz.: Hohm Press.

Durckheim, K. (1971). *The way of transformation: daily life as spiritual exercise*. (R. Lewinnek & P.L. Travers, Trans.). London: George Allen and Unwin Ltd.

Epstein, M. (1990). "Psychodynamics of meditation: Pitfalls on the spiritual path." *Journal of Transpersonal Psychology*, 22(1), 17-34.

Feuerstein, G. (1990). *Holy madness*. New York: Paragon House.

Feuerstein, G. (1991). "The shadow of the enlightened guru." In C. Zweig & J. Abrams (Eds.), *Meeting the shadow* (pp. 148-150). Los Angeles: Jeremy Tarcher.

Fields, R. (1992). *How the swans came to the lake*. Boston: Shambhala.

Frager, R. & Fadiman, J. (1984). *Personality and personal growth* (2nd ed.). New York: Harper & Row.

Franklin, S.B. (1992). *The promise of paradise*. Barrytown, N.Y.: Station Hill Press.

Free John, Da. (1978). *The way that I teach*. Middletown, CA: Dawn Horse Press.

Freud, S. (1964). *The future of an illusion* (W.D. Robson-Scott, Trans.). Garden City, N.Y.: Anchor Books. (Original version published 1953)

Fromm, E. (1980). *Greatness and limitations of Freud's thought*. New York: Harper and Row.

Gay, P. (1988). *Freud: A life for our time*. New York: W.W. Norton.

Goldbrunner, J. (1964). *Individuation*. Notre Dame, Ind.: University of Notre Dame Press.

Goldstein, J. (1993). *Insight meditation*. Boston: Shambhala.

Gordon, J.S. (1987). *The golden guru: The strange journey of Bhagwan Shree Rajneesh*. Lexington, Mass.: S. Greene Press.

Griffiths, B. (1982). *The marriage of east and west*. Springfield, Ill.: Templegate Publications.

Harris, L. (1994, November 14). "O guru, guru, guru." *The New Yorker*, LXX, 92-109.

Hellinger, B. (1998). *Loves hidden symmetry*. Phoenix, AZ: Zeig, Tucker and Co.

Hillman, J. (1967). *Insearch: psychology and religion*. Dallas, Texas: Spring Publications.

Homans, P. (1979). *Jung in context*. Chicago: University of Chicago Press.

Jacobi, J. (1973). *The psychology of C.G. Jung* (8th ed.). (R. Manheim, Trans.). New Haven: Yale University Press. (Original work published 1942)

John of the Cross (1973). *The collected works of St. John of the Cross* (K. Kavanaugh and O. Rodriguez, Trans.). Washington D.C.: Institute of Carmelite Studies Publications.

Joy, B. (1990). *Avalanche*. New York: Ballantine Books.

Jung, C.G. (1973). *Experimental researches* (L. Stein & D. Riviere, Trans.). Princeton: Princeton University Press.

Kapleau, P. (1980). *The three pillars of Zen* (Rev. ed.). Garden City, N.Y.: Anchor Press.

Kane, S. (1994). "Sacred deviance and AIDS in a North American Buddhist community." *Law and Policy*, 16, 323-339.

Keating, T. (1994). *Intimacy with God*. New York: Crossroad Publishing Co.

Kornfield, J. (1993). *A path with heart*. New York: Bantam Books.

Laing, R.D. (1977). "Madness as religious experience." In J. Needleman, A.K. Bierman, & J.A. Gould (Eds.). *Religion for a new generation* (pp. 95-98). New York: MacMillan.

Liebert, D. translator.(1981). *Rumi: fragments / ecstasies*. Santa Fe: Source Books.

Lowen, A. (1958). *The language of the body*. New York: MacMillan.

Lowen, A. (1967). *The betrayal of the body*. New York: MacMillan.

Lowen, A. (1972). *Depression and the body*. New York: Arkana.

Lowen, A. (1989). "Bioenergetic analysis." In R.J. Corsini & D. Wedding (Eds.), *Current psychotherapies* (4th ed., pp. 573-583). Itasca, Ill.: Peacock Publishers.

Lozowick, L. (1996). *The alchemy of transformation*. Prescott, Ariz.: Hohm Press.

Mahler, M.S. (1968). *On human symbiosis and the vicissitudes of individuation*. New York: International Universities Press.

Mahler, M.S., Pine, F. & Bergman, A. (1975). *The psychological birth of the human infant*. New York: Basic Books.

Maslow, A. (1964). *Religions, values, and peak-experiences*. New York: Penguin.

McDonald, M. (1995). "Of mud and broken windows." *Blind donkey*, 15(2), 12-15.

McGrath, W.J. (1986). *Freud's discovery of psychoanalysis*. Ithaca, N.Y.: Cornell University Press.

Merton, T. (1992). *The springs of contemplation*. New York: Farrar, Straus, Giroux.

Miller, A. (1981). *The drama of the gifted child* (R. Ward, Trans.). New York: Basic Books. (Original work published 1979)

Miller, A. (1990). *Banished knowledge* (L. Vennewitz, Trans.). New York: Doubleday. (Original work published 1988)

Miller, A. (1991). *Breaking down the walls of silence* (S. Worrall, Trans.). New York: Penguin. (Original work published 1990)

Naranjo, C. (1987). "Many inner lands." In R. Anthony, B. Ecker, & K. Wilber (Eds.), *Spiritual choices* (pp. 193-209). New York: Paragon House.

Naranjo, C. (1990). *Ennea-type structures*. Nevada City, Calif.: Gateways/ IDHHB.

Naranjo, C. (1993). *Gestalt therapy: The attitude and practice of an atheoretical experientialism*. Nevada City, Calif.: Gateways/IDHHB.

Ouspensky, P.D. (1957). *The fourth way*. New York: Vintage.

Ouspensky, P.D. (1949). *In search of the miraculous*. New York: Harcourt, Brace & World.

Patterson,W.P. (1996) *Struggle of the magicians*. Fairfax, Calif.: Arete Communications.

Pearce, J. C. (1977). *Magical child*. New York: Bantam Books.

Perls, F. (1947). *Ego, hunger, and aggression*. London: Allen and Unwin.

Perls, F. (1973). *The Gestalt approach and eyewitness to therapy*. Ben Lomond, Calif.: Science and Behavior Books.

Peters, F. (1980). *Boyhood with Gurdjieff*. Santa Barbara, Ca.: Capra Press.

Pierrakos, E. (1993). *Creating union*. Del Mar, Calif.: Pathwork Press.

Pierrakos, J. (1987). *Core energetics*. Mendocino, Calif.: LifeRhythm.

Prakash, S. *From duality to oneness*. (Unpublished manuscript)

Radhakrishnan, S. (1940). *Eastern religions and Western thought*. London: Oxford University Press.

Reich, W. (1973). *The function of the orgasm* (V.R. Carfagno, Trans.). London: Souvenir Press. (Original work published 1942)

Rickman, J. (Ed.) (1957). *A general selection from the works of Sigmund Freud*. New York: Doubleday.

Robinson, I. (1994) *Moses Cordovero's Introduction to Kabbalah*. New York: The Michael Scharf Publication Trust of the Yeshiva University Press.

Rosenthal, G. (1987). "Inflated by the spirit." In R. Anthony, B. Ecker, & K Wilber (Eds.), *Spiritual choices* (pp. 305-323). New York: Paragon House.

Rutter, P. (1989). *Sex in the forbidden zone*. New York: Fawcett Crest.

Self, J. (1992). *60 minutes and the assassination of Werner Erhard*. Houston: Breakthru Publishing.

Shah, I. (1970). *The way of the Sufi*. New York: Dutton.

Shankara (1947). *Crest-jewel of discrimination* (S. Prabhavananda & C. Isherwood, Trans.). Hollywood, CA: Vedanta Press.

Sharaf, M. (1983). *Fury on earth: A biography of Wilhelm Reich*. New York: De Capo Press.

Speeth, K.R. (1976). *The Gurdjieff work*. Berkeley, Calif.: And/Or Press.

Steindl-Rast, Br. D. (1991). The shadow in Christianity. In C. Zweig & J. Abrams (Eds.), *Meeting the shadow* (pp. 131-133). Los Angeles: Jeremy Tarcher.

Stroke, S. (1995). "Enneatypes in the Hoffman quadrinity process." In C. Naranjo (Ed.), *Enneatypes in psychotherapy* (pp. 44-57). Prescott, Ariz.: Hohm Press.

Sullivan, B.S. (1989). *Psychotherapy grounded in the feminine principle*. Wilmette, Ill.: Chiron.

Suzuki, S. (1970). *Zen mind, beginner's mind*. New York: Weatherhill.

Tart, C. (1992). *Transpersonal psychologies* (3rd ed.). San Francisco: HarperSanFrancisco.

Tart, C. (1986). *Waking up*. Boston: New Science Library.

Teresa of Avila (1961). *Interior castle*. Garden City, N.Y.: Image Books.

Trungpa, C. (1973). *Cutting through spiritual materialism*. Berkeley: Shambhala Publications.

Trungpa, Chogyam (1992). *The lion's roar*. Boston, Mass.: Shambhala.

Trungpa, Chogyam (1984). *Shambhala: the sacred path of the warrior*. Boston, Mass.: Shambhala.

Tweedie, I. (1986). *Daughter of fire*. Grass Valley, CA: Blue Dolphin Press.

Tworkov, H. (1989). *Zen in America*. Berkeley: North Point Press.

Underhill, E. (1974). [Original © 1955 World Publishing Co.] *Mysticism*. (12th Edition). New York: New American Library.

The upanishads. (1957). (S. Prabhavananda & F. Manchester, Trans.). New York: New American Library.

Vaysse, J. (1979). *Toward awakening*. San Francisco, Calif.: Harper and Row.

Wilber, K. (1980). *The atman project*. Wheaton, Ill.: Theosophical Publishing House.

Wilmer, H.A. (1987). *Practical Jung*. Wilmette, Ill.: Chiron.

Wulff, D.M. (1991). *Psychology of religion*. New York: John Wiley & Sons.

Yontef, G.M., & Simkin, J.S. (1989). "Gestalt therapy." In R.J. Corsini & D. Wedding (Eds.), *Current psychotherapies* (4th ed., pp. 322-361). Itasca, Ill.: Peacock Publishers.

Zinker, J. (1978). *Creative process in gestalt therapy*. New York: Vintage.

Zinker, J. (1994). *In search of good form*. San Francisco: Jossey-Bass.

Zweig, C. & Abrams, J. (Eds.). (1991). *Meeting the shadow*. Los Angeles: Jeremy Tarcher.

Zweig, C. & Wolf, S. (1997). *Romancing the shadow*. New York: Ballantine Books.

Photo Credits

The photos in this book are all used with permission of the photographer or licensing agency.

Sigmund Freud: Archives of the History of American Psychology.
 The University of Akron, Akron, Ohio.
Carl G. Jung: Archives of the History of American Psychology.
 The University of Akron, Akron, Ohio.
Wilhelm Reich: The Wilhelm Reich Museum, Rangely, Maine.
Werner Erhard: Our gratitude to Mark Kamin.
Suzuki Roshi: Zen Center archives, San Francisco, California.
Swami Muktananda: William Carter, Shanti Mandir, Pine Bush, New York.
Chogyam Trungpa Rinpoche: The Naropa Institute archives,
 Boulder, Colorado.
Osho (Bhagwan Rajneesh): Osho International Foundation,
 New York, New York.
Fritz Perls: Courtesy of The Gestalt Journal Press, Highland, New York.
Claudio Naranjo: Hohm Press archives.
Swami Prajnanpad: Hohm Press archives.

Index

A

abandonment 133, 228, 229

aboutism. See suppressive techniques

abuse
child 35, 38, 76, 110
emotional 242
physical 119, 121
sexual 33, 35

accepting "what is" 43, 47, 90, 159,
186, 190, 249, 251
See also life "as it is"

accusation. *See* fixations (cognitive)

addiction 37, 110-111, 140, 185,
201, 233

adepts 112. *See also* spiritual teachers

Adi Da. *See* Da Free John

affect 167

aggressive type. *See* Character Types
(Energetic)

aggression
expression of 229, 238, 242
instinct of 16, 71
passive 192, 237
working with 181, 226-227

AIDS 142

Al-Anon 140

alcohol, use of 110-111, 140, 143,
149

Alcoholics Anonymous 140

alcoholism 140, 141, 142, 150

Allah 63

Almaas, A.H. 8

Amrit Desai, Yogi 150

anal stage (of child development) 17

anger 158, 225, 227, 229, 237, 252
repressed 137, 150, 161, 177, 229,
230-231. *See also* aggression:
passive; repression
work 181

anger type. *See* Enneatypes

anima 25

animus 25

"Anna O.," famous case of 14

Anthony, R. and Ecker, B. 93, 149

anticipation. See suppressive techniques

anxiety 90, 172, 201, 233
and repression 15, 16, 26. *See also*
repression
separation 7, 10

archetypes 22-24

armor 22, 28, 30, 178-179, 181

"as above, so below" 69

"as it is." *See* life: "as it is"

ashram 134, 147, 150, 212

Atman 51, 53

attitude, Gestalt 187-188

authentic self 37

avarice. *See* Enneatypes

avatar 149. *See also* adept; spiritual
teachers

awareness 182-183, 186, 188, 205
cycle 184

B

Ba'al Shem Tov 57

Baker Roshi, Richard 129-134

basic goodness 29, 30, 47, 77, 152,
166, 257

Beisser, A.R. 186

Beloved 63. *See also* God: in Sufism

Benedictines 60

Berry, Jason 151

betrayal 33, 99, 127, 133, 225

Beyond the Pleasure Principle
(Freud) 16

Bhagavad-Gita 50

Bhai Sahib 71

bhakti (yoga) 50, 51, 67

Bible 55

Bio-Energetics 31, 34, 172, 174

Bioenergetic Analysis, Institute for
171

biological principles 16

bodywork 26, 30, 180, 181

bonding 7, 128, 209, 210, 235, 240
lack of. *See* roadblocks

ADDITIONAL TITLES FROM HOHM PRESS

ENNEATYPES IN PSYCHOTHERAPY
by Claudio Naranjo, M.D.

World-renowned Gestalt therapist, educator and Enneagram pioneer Dr. Claudio Naranjo conducted the First International Symposium on the Personality Enneagrams in Pueblo Acantilado, Spain in December 1993. This book derives from this conference and reflects the direct experience and lively testimony of notable representatives of a variety of therapeutic disciplines including: psychoanalysis, Gestalt, Transactional Analysis, bodywork, and others. Each writer describes how the Enneagram holds invaluable keys to understanding personality and its relevance to those whose task is helping others.

Paper, 160 pages, $14.95 ISBN: 0-934252-47-5

• • •

TRANSFORMATION THROUGH INSIGHT:
Enneatypes in Clinical Practice
by Claudio Naranjo, M.D.
Foreword by Will Schutz, Ph.D.

The Enneagram, an ancient system of understanding human nature, divides human personalities into 9 basic types (*ennea* means nine). Whether one is a newcomer to the field of Enneagram studies, or an experienced therapist using this material with clients, Dr. Naranjo's latest book will provide a wealth of invaluable data about the Enneatypes presented in a unique format which turns a scholarly text into a fascinating page-gripper. Each of the nine Enneagram types is illustrated by passages from famous pieces of literature, case studies by famous therapists, and a therapeutic dialogue between Dr. Naranjo and one of his own clients who demonstrates the type being considered. Claudio Naranjo is a world-renowned authority on the Enneagram.

Paper, 544 pages, $24.95 ISBN: 0-934252-73-4

**TO ORDER PLEASE SEE ACCOMPANYING ORDER FORM
OR CALL 1-800-381-2700 TO PLACE YOUR ORDER NOW.**

ADDITIONAL TITLES FROM HOHM PRESS

THE ALCHEMY OF TRANSFORMATION
by Lee Lozowick
Foreword by: Claudio Naranjo, M.D.

"I really appreciate Lee's message. The world needs to hear his God-talk. It's insightful and healing."—John White, author, and editor, *What is Enlightenment?: Exploring the Goal of the Spiritual Path.*

A concise and straightforward overview of the principles of spiritual life as developed and taught by Lee Lozowick for the past twenty years in the West. Subjects of use to seekers and serious students of any spiritual tradition include:
• From self-centeredness to God-centeredness • The role of a Teacher and a practice in spiritual life • The job of the community in "self"-liberation • Longing and devotion. Lee Lozowick's spiritual tradition is that of the western Baul, related in teaching and spirit to the Bauls of Bengal, India. *The Alchemy of Transformation* presents his radical, elegant and irreverent approach to human alchemical transformation.

Paper, 192 pages, $14.95 ISBN: 0-934252-62-9

• • •

CONSCIOUS PARENTING
by Lee Lozowick

Any individual who cares for children needs to attend to the essential message of this book: that the first two years are the most crucial time in a child's education and development, and that children learn to be healthy and "whole" by living with healthy, whole adults. Offers practical guidance and help for anyone who wishes to bring greater consciousness to every aspect of childraising, including:
• conception, pregnancy and birth • emotional development • language usage
• role modeling: the mother's role, the father's role • the exposure to various influences • establishing workable boundaries • the choices we make on behalf of our children's education ... and much more.

Paper, 384 pages, $17.95 ISBN: 0-934252-67-X

**TO ORDER PLEASE SEE ACCOMPANYING ORDER FORM
OR CALL 1-800-381-2700 TO PLACE YOUR ORDER NOW.**

ADDITIONAL TITLES FROM HOHM PRESS

THE ALCHEMY OF LOVE AND SEX
by Lee Lozowick
Foreword by Georg Feuerstein, Ph.D., author of *Sacred Sexuality*

Discover 70 "secrets" about love, sex and relationships. Lozowick recognizes the immense conflict and confusion surrounding love and sex, and tantric spiritual practice. Preaching neither asceticism nor hedonism, he presents a middle path—one grounded in the appreciation of simple human relatedness. Topics include: • what men want from women in sex, and what women want from men • the development of a passionate love affair with life • how to balance the essential masculine and essential feminine • the dangers and possibilities of sexual Tantra • the reality of a genuine, sacred marriage. . .and much more. The author is an American "Crazy Wisdom teacher" in the tradition of those whose enigmatic life and madcap teaching styles have affronted the polite society of their day. Lozowick is the author of 14 books in English and several in French and German translations only.

" ... attacks Western sexuality with a vengeance." —*Library Journal.*

Paper, 312 pages, $16.95 ISBN: 0-934252-58-0

• • •

UNTOUCHED
The Need for Genuine Affection in an Impersonal World
by Mariana Caplan Foreword by Ashley Montagu

The vastly impersonal nature of contemporary culture, supported by massive child abuse and neglect, and reinforced by growing techno-fascination are robbing us of our humanity. The author takes issue with the trends of the day that are mostly overlooked as being "progressive" or harmless, showing how these trends are actually undermining genuine affection and love. This uncompromising and inspiring work offers positive solutions for countering the effects of the growing depersonalization of our times.

"To all of us with bodies, in an increasingly disembodied world, this book comes as a passionate reminder that: Touch is essential to health and happiness."—Joanna Macy, author of *World as Lover, World as Self*

Paper, 384 pages, $19.95 ISBN: 0-934252-80-7

**TO ORDER PLEASE SEE ACCOMPANYING ORDER FORM
OR CALL 1-800-381-2700 TO PLACE YOUR ORDER NOW.**

ADDITIONAL TITLES FROM HOHM PRESS

THE JUMP INTO LIFE: Moving Beyond Fear
by Arnaud Desjardins
Foreword by Richard Moss, M.D.

"Say Yes to life," the author continually invites in this welcome guidebook to the spiritual path. For anyone who has ever felt oppressed by the life-negative seriousness of religion, this book is a timely antidote. In language that translates the complex to the obvious, Desjardins applies his simple teaching of happiness and gratitude to a broad range of weighty topics, including sexuality and intimate relationships, structuring an inner life, the relief of suffering, and overcoming fear.

Paper, 216 pages, $12.95 ISBN: 0-934252-42-4

• • •

TOWARD THE FULLNESS OF LIFE: The Fullness of Love
by Arnaud Desjardins

Renowned French spiritual teacher Arnaud Desjardins offers elegant and wise counsel, arguing that a successful love relationship requires the heart of a child joined with the maturity of an adult. This book points the way to that blessed union. Topics include: happiness, marriage, absolute love, and male and female energy.

Paper, 182 pages, $12.95 ISBN: 0-934252-55-6

**TO ORDER PLEASE SEE ACCOMPANYING ORDER FORM
OR CALL 1-800-381-2700 TO PLACE YOUR ORDER NOW.**

ADDITIONAL TITLES FROM HOHM PRESS

THE SHADOW ON THE PATH
Clearing the Psychological Blocks to Spiritual Development
by VJ Fedorschak
Foreword by Robert Hall, M.D.

Tracing the development of the human psychological shadow from Freud to the present, this readable analysis presents five contemporary approaches to spiritual psychotherapy for those who find themselves needing help on the spiritual path. Offers insight into the phenomenon of denial and projection.

Topics include: the shadow in the work of notable therapists; the principles of inner spiritual development in the major world religions; examples of the disowned shadow in contemporary religious movements; and case studies of clients in spiritual groups who have worked with their shadow issues.

Paper, 324 pages, $17.95 ISBN: 0-934252-81-5

• • •

HALFWAY UP THE MOUNTAIN
The Error of Premature Claims to Enlightenment
by Mariana Caplan
Foreword by Fleet Maull

Dozens of first-hand interviews with students, respected spiritual teachers and masters, together with broad research are synthesized here to assist readers in avoiding the pitfalls of the spiritual path. Topics include: mistaking mystical experience for enlightenment; ego inflation, power and corruption among spiritual leaders; the question of the need for a teacher; disillusionment on the path...and much more.

"Caplan's illuminating book...urges seekers to pay the price of traveling the hard road to true enlightenment." —*Publisher's Weekly*

Paper, 600 pages, $21.95 ISBN: 0-934252-91-2

**TO ORDER PLEASE SEE ACCOMPANYING ORDER FORM
OR CALL 1-800-381-2700 TO PLACE YOUR ORDER NOW.**

RETAIL ORDER FORM FOR HOHM PRESS BOOKS

Name_____ Phone (_____) _____

Street Address or P.O. Box _____

City _____ State _____ Zip Code _____

	QTY	TITLE	ITEM PRICE	TOTAL PRICE	
1		THE ALCHEMY OF LOVE AND SEX	$16.95		
2		THE ALCHEMY OF TRANSFORMATION	$14.95		
3		CONSCIOUS PARENTING	$17.95		
4		ENNEATYPES IN PSYCHOTHERAPY	$14.95		
5		HALFWAY UP THE MOUNTAIN	$21.95		
6		THE JUMP INTO LIFE	$12.95		
7		THE SHADOW ON THE PATH	$17.95		
8		TOWARD THE FULLNESS OF LIFE	$12.95		
9		TRANSFORMATION THROUGH INSIGHT	$24.95		
10		UNTOUCHED	$19.95		

SURFACE SHIPPING CHARGES
 SUBTOTAL:
1st book ..$4.00 **SHIPPING:**
Each additional item$1.00 (see below)
 TOTAL:

SHIP MY ORDER

☐ Surface U.S. Mail—Priority ☐ UPS (Mail + $2.00)
☐ 2nd-Day Air (Mail + $5.00) ☐ Next-Day Air (Mail + $15.00)

METHOD OF PAYMENT:

☐ Check or M.O. Payable to Hohm Press, P.O. Box 2501, Prescott, AZ 86302
☐ Call 1-800-381-2700 to place your credit card order
☐ Or call 1-520-717-1779 to fax your credit card order
☐ Information for Visa/MasterCard order only:

Card #_____–_____–_____–_____

Expiration Date_____

ORDER NOW!
Call 1-800-381-2700 or fax your order to 1-520-717-1779.
(Remember to include your credit card information.)